Graffiti Art Styles

Graffiti Art Styles

A Classification System and Theoretical Analysis

LISA GOTTLIEB

McFarland & Company, Inc., Publishers
Jefferson, North Carolina, and London

ALSO OF INTEREST

Reading and the Reference Librarian: The Importance to Library Service of Staff Reading Habits
Juris Dilevko and Lisa Gottlieb (McFarland, 2004)

LIBRARY OF CONGRESS CATALOGUING-IN-PUBLICATION DATA

Gottlieb, Lisa.
 Graffiti art styles : a classification system and theoretical analysis /
Lisa Gottlieb.
 p. cm.
 Includes bibliographical references and index.

 ISBN 978-0-7864-3436-7
 softcover : 50# alkaline paper ∞

 1. Street art — Classification. 2. Graffiti — Classification. I. Title.
ND2590.G68 2008
751.7'3012 — dc22 2008029407

British Library cataloguing data are available

Cover image background ©2008 Shutterstock

Manufactured in the United States of America

*McFarland & Company, Inc., Publishers
 Box 611, Jefferson, North Carolina 28640
 www.mcfarlandpub.com*

Contents

Acknowledgments

I would like to thank the 11 graffiti art experts who enthusiastically shared their knowledge of, and love for, graffiti art; the 30 image cataloguers who willingly parsed images of graffiti art and provided valuable feedback on the classification system; the members of my dissertation committee at the Faculty of Information Studies, University of Toronto, who helped me with the research project on which this book is based; and my husband, Juris, who unfailingly supplies me with joy and confidence.

List of Tables

List of Figures

Preface

This book examines the relevance of graffiti art to the field of information studies from practical and theoretical perspectives. It presents a working model of a faceted classification system for graffiti art styles, the goal of which is to enable information professionals who have no prior knowledge of, or experience with, graffiti art to identify the style in which a graffiti art piece was created. At the same time, the conceptual framework of the classification system introduces broader issues concerning image access. The book uses the example of graffiti art to reconsider art historian Erwin Panofsky's model of iconographical analysis as a tool for providing subject-based access both to representational and to nonrepresentational or abstract art images. It suggests a different paradigm for applying this model — one which utilizes a new set of criteria for determining the suitability and scope of Panofsky's theories.

Both the development and subsequent testing of the classification system represent the results of a two-part study undertaken for my doctoral dissertation.[1] Data about the characteristics of specific graffiti art styles were collected from 11 graffiti art experts (practitioners and historians) using a series of questionnaires. Their insights, ranging from technical minutiae to personal reflections, appear throughout the book. I have transcribed their words verbatim: grammar and spelling have been corrected only if the meaning of the quotation was unclear in its original format. Quotations are attributed to individual experts using the letters "GREX" (GRaffiti EXpert) followed by an assigned participant number, 1 through 11 (e.g., GREX1, GREX2, and so forth). In addition to maintaining their anonymity, this code serves to distinguish their opinions from the views of other graffiti practitioners, cited from published materials and attributed to the names provided in those materials.

In the second part of the study, data on the functionality of the classification system were collected from 30 professional image cataloguers employed at universities, museums, and archives. In converting my disserta-

tion to book form, I have made substantial revisions and added new material. This book focuses on the theoretical framework and practical application of the classification system and its connection to Panofsky's model of iconographical analysis. As a result, descriptions of the research methodology and data analysis of the image cataloguer study have been curtailed. Readers seeking more detail in these areas should consult the original dissertation.

When I undertook this research, the combined topics of graffiti and image access elicited surprise. Why graffiti art? At the most basic level, I was fascinated by these striking yet, to me, completely incomprehensible aerosol artworks. I wanted to understand them. At the same time, both the relevance of graffiti art to image access and the improbability of this juxtaposition demonstrate the surprisingly protean role graffiti art plays in contemporary consciousness. It is seen by some as a cultural artifact, by others as urban blight. It is lauded in documentary films, reviled by city abatement programs, collected by hedge-fund managers. It boasts both the street credibility of the hip-hop movement and the esteem of fine art galleries and auction houses. And it is increasingly becoming a mainstream marketing phenomenon.

A number of factors separate graffiti art from its sanctioned cousin, the mural. Artists create murals; practitioners of graffiti art are generally referred to as writers.[2] Unlike murals, graffiti art is in most cases illegal, and its design usually incorporates stylized letters. Yet the distinction between graffiti and murals is often based as much on personal taste and artistic intent as on legality and composition. Contrast a City of Toronto by-law's definition of graffiti as "letters, symbols, figures, etchings, scratches, inscriptions, stains or other markings that disfigure or deface a structure or thing" with its definition of an art mural as something "for a designated surface and location that has been deliberately implemented for the purpose of beautifying the specific location."[3]

Many people would argue that graffiti art beautifies, rather than defaces — an argument in which this book takes no part. My purpose is not to champion or to condemn graffiti art but to examine it in a classificatory context. The relevance of this book to information professionals stems partly from the need for increased visual literacy concerning this visible and topical art form. While the classification system presented in this book can be used to identify the visual elements that define particular graffiti art styles, it also illustrates the applicability of graffiti art to the larger issues surrounding access to images of nonrepresentational or abstract art.

Given that the classification system is designed to assist image cataloguers in identifying the features and styles of graffiti art, it might seem curious that this book does not contain any images. The graffiti art experts who participated in the study provided sample images along with their questionnaire

responses, with the understanding that the images would be used for research purposes only. I had originally planned to photograph extant graffiti artworks in the public domain for use in this book. This idea was abandoned after reading an article in the *New York Times* describing a lawsuit filed by graffiti writers against an author whose book contained photographs he had taken of their work. The article notes that the author had not sought permission from the writers for the use of these images "because the murals were in public places, and that publishing the photographs was covered under fair use provisions of copyright law."[4] This interpretation of fair use provisions is (apparently) problematic.

In fact, this book is comprehensible without any illustrations, a reflection of the classification system itself — its theoretical basis, how it functions, and how it was tested by image cataloguers. While the system assists cataloguers in detecting visual cues in graffiti art, it does not contain actual depictions of these cues. Graffiti art styles are comprised of a consistent set of features, but, as in any artwork, the way in which these features are portrayed and interpreted will vary from artist to artist. Basing the identification of style on visual examples therefore does little to ensure an operable classification system.

This same issue of artistic interpretation underlies the copyright lawsuit just described. Emphasizing how the plaintiffs are "acclaimed artists" whose work needs to be protected, one lawyer remarks, "They are world-renowned. They've lectured at M.I.T. and exhibited at the Smithsonian."[5] Tats Cru, an organization of "writers-turned-muralists" involved in the lawsuit, was indeed invited by the Smithsonian Institution to create a graffiti-inspired mural for a New York–themed Folklife Festival in 2001.[6] Beyond the question of copyright protection, however, are the more personal issues of how the writers and their work were represented. Some objected that their pieces "were misidentified, misinterpreted or misattributed."[7] Another expressed displeasure "that some of the photographs are distorted or have colors that are slightly off."[8] Graffiti art is a complex expression of self-identity. At the core of the unique interpretations and perspectives that comprise a graffiti writer's personal style is a set of artistic conventions that express specific, iconic graffiti art styles. As this book will demonstrate, these iconic styles are as relevant to issues of image access as they are to individual graffiti artworks.

Introduction

Masterpieces from a Can

In June, 2000, the *New York Times* printed an article entitled "Up from the Subway, Graffiti Heads to the Auction House." The article featured a number of graffiti writers who, having retired from their illegal spray-painting of the New York City subway system, were auctioning more recent, canvas-based examples of their work. MICO, one of the graffiti writers profiled in the article, observes, "Graffiti is a denigrating term. If you look it up in the dictionary, it means to scrawl. I have never done any scrawling. I have written my name and developed masterpieces from my name."[1]

Most people do not equate graffiti with art, much less with art that can bring thousands of dollars at auction. As MICO's comments suggest, graffiti is more often associated with the magic-marker scrawls that "adorn" public washrooms and transit systems. Yet the writings and drawings that comprise graffiti are more varied and sophisticated than one might expect. The most literal translation of the word "graffiti" is "little scratchings," from the Italian verb *graffiare*, meaning "to scratch." Some of the earliest examples were the mélange of political commentary, real estate advertisements, lost-and-found notices, and quotations from Virgil and Ovid scratched into the walls of Pompeii.[2] Medieval graffiti often comprised inscriptions incised into churches.[3] While some of these medieval scratchings depicted symbols associated with a particular church's patron saint, others were secular in nature: one disgruntled master-mason criticized the poor workmanship at a church in Hertfordshire, England by writing "I spit at it."[4]

Like its ancient and medieval antecedents, contemporary graffiti attempts to communicate a message. These messages generally fall into broad categories — social or political commentary, or personal communications, as in the examples just cited. Graffiti art, which is known variously as aerosol art, New

York–style graffiti, spray can art, and subway art, differs from other forms of graffiti in that it conveys only one type of message — specifically, the "identity" of a graffiti writer. At the most basic level, graffiti art depicts the stylized signature of a graffiti writer's name. Of course, the writer does not use his or her actual name, but rather what is referred to as a "tag" or pseudonym. MICO, for instance, is the tag of writer J.J. Ramirez.

In addition to the type of message, the means of conveying this message is also unique to graffiti art. Just as important as the graffiti writer's name is *how* that name is rendered. Creating painted masterpieces from the act of writing one's name transforms the name from a simple verbal expression — a word — into a complex visual expression. The letters that comprise graffiti art masterpieces, more commonly known as "pieces," are often abstracted to such a degree that the name of the writer is virtually illegible. In some cases, even identifying the shapes as letters poses challenges for uninitiated viewers. Nonetheless, these pieces display established technical and aesthetic elements devised and applied by the graffiti art community. In fact, these abstracted names are visual expressions of specific graffiti art styles.

This book describes the development of a faceted classification system for graffiti art styles designed to enable non-experts to identify the style of a graffiti art piece by distinguishing certain visual characteristics. Why should information professionals be concerned with identifying style in graffiti art images? The answer to this question can be found in the myriad ways in which graffiti art intersects mainstream culture. To be sure, the evolution of graffiti art from street phenomenon to pop-culture artifact has as much to do with its connection to hip-hop culture as with any specific aesthetic qualities of graffiti writing itself. Hip-hop culture is generally associated with four forms of artistic expression: graffiti writing, break-dancing, rapping, and disc jockeying. Graffiti art's role in this culture was reflected in The Brooklyn Museum of Art's 2000 exhibit "Hip-Hop Nation: Roots, Rhymes and Rage," which included displays of original graffiti pieces and showed videos of subway-based graffiti writing.[5] Similarly, the company Hush Tours offers sightseeing tours of hip-hop landmarks in Harlem and the Bronx.[6] The itinerary includes the Harlem Hall of Fame (East 106th Street and Park Avenue), a (legal) display of some of New York's best graffiti art.[7] Older pieces are replaced with new writing at the Hall of Fame once a year — an event organized by the graffiti writer EZO.[8]

Joe Austin comments, "Although writing sustains its identity as an illegally practiced art form, through hip-hop culture writing has also found ways of making itself more acceptable ... (mostly by turning itself into a valued popular culture commodity)."[9] Indeed, the intersection of graffiti art and popular culture is taking place not only in forums that examine the core artis-

tic forms of the hip-hop movement, but also in the marketplace, where these forms are transformed into coveted merchandise. At one end of the spectrum is the sale of original graffiti art pieces as artworks. The winning bid at a 2007 Sotheby's auction for "an acrylic-and-spray-paint stencil on canvas" by the British graffiti writer Banksy was $200,000; that same year another of his paintings fetched a record $575,000 at a Bonham's sale.[10] These prices have led one contemporary-art specialist at Sotheby's to describe Banksy — an enigmatic yet ubiquitous figure in England — as "the quickest-growing artist anyone has ever seen of all time."[11]

At the other end of the spectrum is the injection of graffiti into the design and marketing of everyday objects. Renowned graffiti writers Stash and Futura have designed sneakers for Nike.[12] Likewise, seven writers were asked by Adidas "to decorate a fake subway car across the street from its store" in Manhattan.[13] Art Crimes, an online gallery and resource center dedicated to graffiti art, sells silk-screened T-shirts, coffee mugs, and mouse-pads featuring pieces by various writers. In fact, graffiti has become a means of selling or promoting that which has little (if any) connection either to hip-hop or to fine art. In September, 2003, then–United States Presidential candidate Howard Dean held a rally in Bryant Park, New York, which featured a prominent graffiti art piece as a backdrop. Dean's campaign had commissioned the graffiti writer Keo to create the piece "to appeal to young people in urban areas."[14] The English soccer team Chelsea FC lists among the amenities of their state-of-the-art training facility "artwork by Temper, one of the country's leading graffiti artists."[15]

As graffiti art enters the public consciousness as an icon of popular culture, its history, techniques, and styles are generating increased interest worldwide. For example, graffiti writers have been invited to teach their craft to urban high school students. Tracy 168, a seminal figure in the history of graffiti art, worked with students at the Urban Academy high school in Manhattan — a collaboration that culminated in a public viewing of their work in December, 2005.[16] Similarly, high school students in Toronto participated in "Groove and Graffiti, a program designed to teach the art of spray-painting."[17] And the "Culture Points" program developed by Brazil's Ministry of Culture in 2007 instructs youth in various fields of hip-hop production, including rapping and graffiti art.[18] By providing students with "tips on how to improve their graffiti techniques," as well as lessons on operating video and recording equipment, the program "hopes to channel what it sees as the latent creativity of the country's poor into new forms of expression."[19]

It is therefore not surprising that the once-specialized vocabulary of graffiti culture is entering the vernacular. A 2004 newspaper review for "Barbershop 2: Back in Business" notes that the film "wields its politics not like a

hammer but like a graffiti artist's spray can: It colourfully tags one taboo subject and then quickly moves on."[20] Likewise, Canada's *The Globe and Mail* printed a graffiti "primer" that summarized the predominant characteristics of various forms of graffiti art.[21] The classification system presented in this book takes this identification process a step further by enabling information professionals to distinguish graffiti art beyond simple form-based categories.

While a classification system for graffiti art styles addresses a burgeoning information need, the development and application of the system introduce broader, theoretical issues relevant to image access. This book uses the example of graffiti art to reconsider art historian Erwin Panofsky's model of iconographical analysis and to propose a new paradigm for applying this model as a tool for image access. But to understand what spray can masterpieces have to do with theories of iconography in Renaissance painting, it is first necessary to examine Panofsky's model of iconographical analysis.

Panofsky's Model

In 1991, Howard Besser presciently remarked, "In the next few years we can expect that digital surrogate images of fine art objects will be readily available outside their traditional environments (libraries, museums, educational institutions, archives)."[22] In fact, digitization and the ensuing proliferation of images have served as an impetus for a widespread reassessment of image access systems. One result of this reassessment is the focus on content-based image retrieval (CBIR) systems — automated systems that utilize algorithms to index images according to "low-level" or "primitive" features such as color, texture, shape, and spatial configuration. The term "low-level" refers to the initial stage in human visual perception. As Corinne Jörgensen points out, low-level visual perception "is a feature extraction process, where physical properties such as depth, color, and texture are extracted in parallel from the visual field. From these properties, edges and surfaces are generated."[23]

While CBIR systems have engendered increasing interest within the information studies community, the bulk of research in this area has emanated from the field of computer science. Heting Chu observes this disparity in her bibliometric study of image indexing and retrieval literature, noting that although CBIR research "is currently dominating" the literature, the research focus of individuals in the information studies field remains the "description-based approach."[24] In contrast to CBIR, the "description-based approach" (also referred to as "manual" or "human" indexing) is predicated upon the human designation of which features or attributes of an image should serve as access points for indexing and retrieval. Just as the low-level features

extracted in CBIR can be equated with low-level visual processing, the attributes identified in human indexing constitute the objects and concepts that emerge from mid-level and high-level visual processing. The emphasis placed on the description-based approach by the information studies community reflects the fact that the attributes identified and named through human, text-based indexing better address the needs of image-seekers than the low-level features associated with CBIR. As A.M. Tam and C.H.C. Leung note, "Searchers are more likely to be interested in the entities (people, objects, concepts) in an image, the relationships between them, and their attributes, than in colors, shapes, or textures."[25]

The translation of the objects and concepts within an image into access points for image retrieval has often been informed by Erwin Panofsky's model of iconographical analysis. Panofsky defines iconography as "that branch of the history of art which concerns itself with the subject matter or meaning of works of art, as opposed to their form."[26] Echoing the distinction between low-level and high-level visual processing, he equates form with the automatic perception of patterns of "colour, lines, and volumes."[27] When these patterns are identified and named by the viewer as distinct objects or events within an artwork, form gives way to subject matter. Panofsky's definition of iconography, however, refers to both subject matter and meaning. While subject matter suggests the simple identification of an object, the significance of that object within the visual context of the artwork and within a broader societal context contributes to the overall meaning of the work.

The separation between subject matter and meaning is shown in Panofsky's interpretation of "the removal of a hat as a polite greeting."[28] Both the motion of hat-raising and the human being performing this action can be identified as such by the viewer. But understanding this action "as a polite greeting" requires that the viewer "not only be familiar with the practical world of objects and events, but also with the more-than-practical world of customs and cultural traditions peculiar to a certain civilization."[29] Therefore, the distinction between subject matter (i.e., the naming of objects and events) and meaning (i.e., the understanding of what these objects and events represent) underscores the different interpretive processes involved in iconographical analysis. Panofsky explained these interpretative processes in terms of a three-level model, summarized in table 1.[30] Each level represents a distinct stage in the process of understanding an artwork's meaning and is therefore characterized by its own act, object, and means of interpretation.

Table 1. Panofsky's model of iconographical analysis

Level of Interpretation	Act of Interpretation	Object of Interpretation	Means of Interpretation
I. Pre-iconography	Pre-iconographical description	Primary or natural subject matter: A. factual B. expressional	Practical Experience
II. Iconography	Iconographical analysis	Secondary or conventional subject matter	Knowledge of literary sources
III. Iconology	Iconographical synthesis	Intrinsic meaning or content	Synthetic intuition

Although Panofsky divides the understanding of an artwork into levels, he also stresses that these levels, taken together, constitute a process. Discussing the model summarized in table 1, he notes that "we must bear in mind that the neatly differentiated categories, which in this synoptical table seem to indicate three independent spheres of meaning, refer in reality to aspects of one phenomenon, namely, the work of art as a whole. So that, in actual work, the methods of approach which here appear as three unrelated operations of research merge with each other into one organic and indivisible process."[31] Therefore, the three strata successively build upon each other, rather than operate as discrete categories. For example, successful iconographical analysis — the act of interpretation at the second level — is dependent upon the correct identification of primary subject matter within a pre-iconographical description — the object and act of interpretation at the first level.

The application of Panofsky's model of iconographical analysis has proved challenging, indicating a problematic interpretation of how this model can be adapted for use in image access. Iconographical analysis is based on the premise that the shift from the objects and events that comprise primary subject matter to secondary subject matter is not arbitrary, but instead depends upon the recognition of those objects and events as indicative of particular themes or concepts. The applicability of Panofsky's model therefore hinges upon the connection between the image to be indexed or classified and iconographic tradition. In this context, iconographic tradition signifies: (1) the presence of, and interconnection between, both primary and secondary subject matter; and (2) the substantiation of the relationship between primary and secondary subject matter outside of the context of the artwork itself.

Adaptations of Panofsky's framework in the field of information studies, however, tend to treat the pre-iconographic and iconographic levels of

interpretation as discrete units, rather than as a process. As Angelika Grund points out, "The analytic steps distinguished by Panofsky can only in theory be clearly distinguished. In the art interpreter's work they form a single process applied to the given work of art."[32] When applied by an indexer, as opposed to an iconographer or art historian, the analytic steps are extracted from the process as a whole. The difference in approaches can be explained, in part, by the fact that the goal of the indexer is user access rather than iconographical analysis. Therefore, pre-iconography and iconography are transformed from levels of meaning into levels of access, with the result that "primary subject matter" and "secondary subject matter" serve as de facto categories within an indexing or classification system. Indexers must then decide which category (level) should form the basis of subject access and which primary and secondary subject matter elements can and should be recognized. Furthermore, categories based on these levels are often dichotomous, requiring the indexer to make subjective judgments regarding what Sara Shatford terms the "ofness" versus the "aboutness" of the image; whether the subject matter is "generic" or "specific"; and whether the themes depicted are "concrete" or "abstract."[33]

The information studies community also has assigned a high degree of generalizability to Panofsky's model. Shatford comments that "Although he developed this theory in terms of Renaissance art, he based it on a more general analysis of ways in which one perceives and interprets experience. Panofsky's theory therefore seems capable of a broad application: it seems possible to apply it to any representational pictorial work."[34] On the one hand, this perspective does not account for the fact that not all representational artworks are amenable to the analytic processes on which Panofsky's model is based. On the other hand, the "broad application" of Panofsky's theories "to any representational pictorial work" notably excludes nonrepresentational or abstract works.

The Question of Nonrepresentational or Abstract Art

The terms "nonrepresentational art" and "abstract art" are often used interchangeably. Consider the following definition of "abstract art" from *The Concise Oxford Dictionary of Art Terms* (*CODAT*):

> A term which can be applied to any non-representational art (most decorative art, for example), but which is more specifically used, from the early 20th century onwards, to describe painting and sculpture which are deliberately non-representational. Implicit to abstract art is the notion that the work of art exists in its own right, and not necessarily as a mirror of reality.[35]

While this definition establishes that abstract art is nonrepresentational, the question remains as to what qualifies as nonrepresentational art. As its name implies, the concept of nonrepresentational art is best understood in juxtaposition to representational art. Representational art depicts elements such as objects, people, scenes, and events that are readily identifiable. Nonrepresentational art does not appear to depict these elements: it does not, in the words of the *CODAT* definition, operate as "a mirror of reality." Another way to consider this distinction is that nonrepresentational art does not present to the viewer an obviously discernible signifier for what the artwork signifies. A good example is Marcel Duchamp's *Nude Descending a Staircase, No. 2* (1912), a Cubist-influenced painting whose subject matter is conveyed by the title but which visually bears as much resemblance to a flattened accordion or windmill vanes as to a human form.

In fact, the term "abstract" can refer to either the visual appearance or the conceptual meaning of an artwork. For instance, an image of a flag itself would not be considered abstract. The idea of the image of a flag as a symbol of nationalism, however, takes us into the realm of abstract meaning. The concept of abstract meaning appears throughout the image access literature, a point that will be addressed further in chapter 1. This book employs the phrase "nonrepresentational or abstract" to denote an image or artwork that is *visually* abstract.

The topic of nonrepresentational or abstract art images is generally absent from discussions of how Panofsky's model can be applied to subject access systems precisely because subject-based elements such as objects and events cannot be readily identified. Therefore, images in these genres are considered to be beyond the scope of subject-based access systems. But what if the images in question were part of an iconographic tradition? Could Panofsky's model of iconographical analysis be applied as a classificatory framework for nonrepresentational or abstract art images that meet this criterion?

This book seeks to answer these questions, using the example of graffiti art. Chapter 1 takes a closer look at how Panofsky's model has been adapted to image access and the limitations of these adaptations. It also proposes a new paradigm for the application of Panofsky's theories — one that does not automatically exclude nonrepresentational or abstract art images. Chapter 2 discusses the applicability of Panofsky's model to graffiti art, examining this art form and the development of graffiti art style in a historical context. While the theoretical basis of the classification system presented in this book is rooted in Panofsky's theories of iconographical analysis, the actual content of the system is based on information collected from 11 experts (practitioners and historians) in the field of graffiti art. Chapters 3 and 4 describe the process of collecting and evaluating this information, as well as development of the sys-

tem itself. Finally, the latter part of the book addresses the functionality of a specific component of the system — one that was tested by 30 professional image catalogers who had no prior knowledge of graffiti art. Chapter 5 describes the results of this testing, while chapters 6 and 7 discuss the implications of both the development and application of the classification system.

The classification system presented in this book is a working model only. As will be outlined in greater detail in chapter 4, it covers 14 distinct styles of graffiti art pieces, breaking each of these styles down in terms of visual elements that can be readily identified by individuals outside of the graffiti art community. Just how readily these elements could be discerned was the question examined in the testing of the classification system. The system, however, is by no means exhaustive: it does not cover every known style of graffiti art and every possible visual characteristic. In other words, reading this book will not enable you to positively identify every graffiti piece you might encounter on a wall or flashing by on a train.

Presenting an exhaustive catalog of graffiti art styles is not the intent of this book, nor is it to persuade you that graffiti art is, indeed, "Art." Rather, its purpose is to propose a model for classifying images of graffiti art pieces according to their style — a model that is based on Panofsky's theories of iconographical analysis. In the process, you will be asked to consider (or reconsider) the scope and applicability of Panofsky's theories to the access of both representational and nonrepresentational or abstract images. You also will be introduced to specific styles of graffiti art and will be provided with the basic tools needed to understand the underlying visual elements of graffiti art pieces. In fact, you might not look at graffiti the same way again.

1

A New Paradigm for Panofsky's Theories of Iconographical Analysis

In describing the challenges of providing image access, the information studies community often relies on the adage "a picture is worth a thousand words." The significance of this statement is that, as Sara Shatford succinctly puts it, "a picture can mean different things to different people."[1] The challenge of choosing the "right" words to describe a picture that is subject to limitless interpretations is heightened in the context of general image collections — a category which encompasses everything from a local library branch to a vast online database. Users of general image collections comprise different backgrounds and have a similarly diverse range of interests in, and need for, various images. John Eakins and Margaret Graham point out that "some users have very specific needs (e.g. an art historian may want a particular painting by Van Gogh; a journalist may want a recent photograph of Tony Blair, not smiling; a social historian may want a picture of sewers in the 18th century; a theology student may want a picture of a female saint with red hair) whilst others will be more interested in material which conveys particular sensations or moods (e.g. happiness, concentration)."[2]

These examples illustrate a connection between a user's background (e.g., "journalist"; "theology student") and the type of image sought ("recent photograph"; "picture of a female saint"). Implicit in this connection is the idea that a user's background also influences the need for, and intended use of, the image. In his discussion of the information needs of art historians, Richard Brilliant identifies a "continuous gradient of an object from artifact to art, from the subject matter of history (or anthropology) to that of art history."[3] Describing artifacts such as an African mask and a Mesopotamian cylinder

seal, he explains that what the anthropologist examines as a piece of material culture, the art historian treats as a work of art. In other words, what often distinguishes groups of users is not so much what they study as how they study it. Each group would have not only its own vocabulary for describing a particular artwork, but also its own conception of what constitutes the most important aspects of that work.

Acknowledging the contextual specificity of user needs, the information studies community has focused its attention on providing user-centered access to images. The user-centered approach to image access is predicated on the realization that: (1) the context of the user — personal and professional background, the types of images required, and the intended use of those images — informs his or her information needs; and (2) individual information needs determine both the relative importance to the user of various elements in an image and the vocabulary used to describe those elements. Concomitant with the idea that different people interpret images differently is the recognition that images communicate their meanings not simply as gestalts but through the diverse elements of which they are composed.

It is against this backdrop of user-centered access that Erwin Panofsky's model of iconographical analysis takes center stage. Panofsky's model, as interpreted through Sara Shatford's widely influential adaptation, has been applied as a framework for determining which types of subject elements to index within an image. As Peter Enser observes, "The pre-iconographic, iconographic and iconological levels of analysis proposed by Panofsky and generalised by Shatford offer a convenient formalism for the notion that an image is not a single semantic unit but an amalgam of generic, specific and abstract semantic content."[4] Although Panofsky's "levels of analysis" framework centers on identifying and understanding the semantic content, or meaning, of a work of art, current applications in the field of information studies raise the question of the suitability of this framework for addressing the challenges of user-centered image access. Specifically, can Panofsky's levels of meaning accommodate the multitude of specific user needs that arise in the context of general image collections?

This chapter examines how Panofsky's theories have been interpreted and applied by the information studies community and discusses the limitations of Panofsky's theories as a user-focused level model for image access. This discussion serves to introduce a new paradigm for the application of Panofsky's theories of iconographical analysis. The paradigm suggested in this chapter is based on two interconnected concepts. The first is the use of Panofsky's theories as a *process* model, rather than as a level model. The second concept concerns the nature of what is depicted in the images themselves — in other words, an image's relationship to iconographic tradition.

"Ofness" and "Aboutness"

The application of Panofsky's theories of iconographical analysis to the field of information studies has been filtered through what is often referred to as "the Panofsky/Shatford model."[5] In order to assist indexers in developing or applying subject access systems to general image collections, Sara Shatford developed a framework — what she describes as "a theoretical basis for identifying and classifying the kinds of subjects a picture may have"[6] — that mirrors the first two levels of Panofsky's three-tiered model of iconographical analysis. Shatford's framework centers on two categories, "Of" and "About," which are defined according to Panofsky's distinction between primary subject matter at the pre-iconographic level and secondary subject matter at the iconographic level. Table 2 summarizes the correspondence between Shatford's and Panofsky's frameworks.

Table 2. Comparison of Panofsky's and Shatford's frameworks

Panofsky	*Shatford*
Pre-iconography: Primary Subject Matter	**Generic Of**: Objective Meaning
• Factual	
• Expressional	**About**: Subjective Meaning
Iconography: Secondary Subject Matter	**Specific Of**: Objective Meaning
	About: Mythical, Abstract, or Symbolic Meaning

As Shatford explains, "It is possible to describe Panofsky's first two levels of meaning as each having two aspects: *Of* and *About*."[7] Beginning with the *Of* aspect, she notes, "At the pre-iconographic level, the *Of* aspect is generic description of objects and events; at the iconographic level, it is a specific, or proper, appellation of those objects and events."[8] This distinction is evident in the example she provides of *Mrs. Siddons as the Tragic Muse*, a painting by the eighteenth-century English portraitist Joshua Reynolds. At the pre-iconographic level, the painting is of a woman (*Generic Of*); at the iconographic level it is of the woman depicted in the portrait, Mrs. Siddons (*Specific Of*). Furthermore, both *Ofness* levels constitute "objective meaning."

As with the *Of* aspect, Shatford examines the *About* aspect at both the pre-iconographic and iconographic levels. *About* at the pre-iconographic level is "a description of the mood of the picture" and thus represents "subjective meaning."[9] This definition echoes Panofsky's distinction between the "expres-

sional" and "factual" elements of primary subject matter (table 2). Using the scenario of an artist's depiction of St. Bartholomew, Panofsky explains that factual primary subject matter "implies the conscious intention of the artist to represent St. Bartholomew, while the expressional qualities of the figure may well be unintentional" and therefore subject to the interpretation of the viewer.[10] Shatford similarly underscores the subjective nature of expressional or *About* aspects of an image at the pre-iconographic level, noting that "people are more likely to agree on the description of an object or event than they are on the description of a mood or emotion, on the expressional meaning of a picture."[11]

The *About* aspect at the iconographic level also inhabits the realm of subjective meaning. Iconographic *About* "is an identification of mythical beings that have no unique and verifiable concrete reality, of symbolic meanings and abstract concepts that are communicated by images in the picture."[12] Returning to *Mrs. Siddons as the Tragic Muse*, Shatford explains that the painting is *About* the tragic muse, or, more specifically, about Melpomene, the Greek Muse of tragedy.[13] Although iconographic *About* is not concerned with the expressional features of an image, determining the *Aboutness* of an image at the iconographic level nonetheless is a subjective process: Shatford observes that "varying interpretations of the same symbols may produce different iconographical *Aboutness*."[14]

Table 3. Shatford's faceted classification of the subjects of pictures

Facet	Generic Of	Specific Of	About
Who	Kinds of persons, animals, things	Individually named persons, animals, things	Mythical beings; Abstractions manifested or symbolized by objects or beings
What	Actions, conditions	Individually named events	Emotions; Abstractions manifested by actions, events
Where	Kind of place (geographic or architectural)	Individually named geographic location	Places symbolized; Abstractions manifested by locale
When	Cyclical time; seasons; time of day	Linear time; dates or periods	Emotions or abstractions symbolized by or manifested by time

In developing her framework, Shatford combines the two elements of the *About* aspect, thereby producing three categories: *Generic Of, Specific Of,*

and *About*. As illustrated in table 3, she then incorporates these three categories in a faceted classification system which divides the subject of a picture into the familiar questions of Who, What, Where, and When.[15] Each of these facets, in turn, can be examined within the context of the three categories she identified and extracted from Panofsky's model. Shatford points out that not all facets will be applicable to a given image. Similarly, within a given facet it might not be necessary, or even possible, to apply all three of the *Generic Of*, *Specific Of*, and *About* categories.

Shatford's framework is intended to assist indexers in identifying the layers of meaning in an artwork — or, as L. Hollink et al. note, to "structure *images* instead of *descriptions* of images" (original emphasis).[16] Applying the framework to an image collection therefore requires "principles to help us determine which of these subjects are most important, which ones should we index first, which ones should we index secondarily, and which ones should not be indexed at all."[17] These principles would vary according to the nature of the collection and the information needs of the users who access it. Determining which subjects to index has led the information studies community to address the question, "What is the range of attributes of images that are typically noted and described by humans in performing various tasks with images?"[18]

Limitations of Panofsky's Framework as a Level Model

Peter Enser discussed the challenges of delineating subject matter according to Panofsky's model, using the example of the Hulton Deutsch Query Analysis Project.[19] Analyzing 2,722 image requests submitted to the Hulton Deutsch picture archive, Enser found that mapping "these requests onto Panofsky's iconographic, pre-iconographic and iconologic modes met with little success."[20] He noted instead that the "queries fell quite naturally into a simple, dichotomous categorisation of those which could be satisfied by a picture of a unique person, object or event, and those which could not."[21] Enser further differentiated these categories of "unique" and "non-unique," distinguishing subjects that are "unique refined" and those that are "non-unique refined." Image requests for "unique" subjects included "Kenilworth Castle" and "Peter the Great." "Unique" requests were categorized as "refined" if they specified parameters relating to "time, location, action, event, or technical specification," such as "A young D.H. Lawrence" and "Edward VIII looking stupid."[22] This same distinction applies to the "non-unique" categories. "Non-unique" subjects included "Wooden signposts" and "Dinosaurs";

examples of "non-unique refined" subjects were "1950s 'fridge" and "Couples dancing Charleston."[23] Enser found that the plurality of queries (42 percent) fell within the "unique" category. Conversely, only 27 percent of queries were categorized as "unique refined," 24 percent as "non-unique refined," and 6 percent as "non-unique."

While dismissing the utility of Panofsky's three levels of analysis, Enser does not fully reject the Panofsky/Shatford model: his distinction between unique and non-unique requests and their degree of specificity echoes Shatford's division of general versus specific subjects. In fact, answering the question of which subjects to index has generated a number of studies focusing on the types of attributes users cite in describing and searching for images. These attributes are then sorted and analyzed by the researchers into categories that are based on the Panofsky/Shatford model. James Turner, for instance, examined whether individuals "distinguish between the pre-iconographical and iconographical content of 'ordinary' images."[24] Participants in his experimental study were asked to view and to provide words or phrases to describe still and moving images derived from film footage. Responses were then classified according to the following categories: "Ofness"; "Aboutness"; "Either Ofness or Aboutness"; "Neither Ofness nor Aboutness." His results show that 64 percent of the terms classified were assigned to the "Ofness" category, 7 percent to the "Aboutness" category, 28 percent to the "Either Ofness or Aboutness" category, and 1 percent to the "Neither Ofness nor Aboutness" category.

Rather than the "Ofness/Aboutness" dichotomy, other research has focused on Shatford's distinction between *Generic Of* and *Specific Of*. Karen Collins examined 187 user queries at two archival photograph collections in North Carolina.[25] Classifying the terms patrons used in their queries, she found that 86 percent of the requests dealt with subject matter, and that 57 percent of the queries included terms concerned with "generic subjects," as opposed to 42 percent for "specific subjects."

As these examples indicate, recent research offers a wide lens through which to examine the application of Panofsky's framework to current issues in image access. The scope of this research ranges from the analysis of user searching behavior in natural settings to the controlled environment of study-based tasks; from specialist to non-specialist participants; from descriptions or queries of images representing one academic discipline to those covering multiple subject domains; from image samples comprised of a single format, such as photographs, to those consisting of a variety of formats. These disparities make it difficult to compare results from one study to another — a challenge compounded by the question of how the image descriptions/queries were classified by the researchers.

Consider the analysis of user image queries conducted by Youngok Choi and Edie Rasmussen.[26] Graduate students and faculty were asked to provide natural language search requests for images on the topic of American history. These participants also indicated key words that best described relevant images retrieved using their search terms. Both search terms and descriptors were classified by the researchers using the following categories: "Specific needs"; "General/nameable needs"; "General/abstract needs"; and "Subjective needs." The first two categories correspond to Shatford's *Specific Of* and *Generic Of*, respectively, while the last two are roughly equivalent to the *About* category.

Although search terms and descriptors encompassing specific time periods and geographic locations addressed many of the participants' information needs, Choi and Rasmussen found that 60.5 percent of participants' requests and 64.84 percent of their key word descriptors nonetheless fell within the "General/nameable needs" category. The researchers define "General/nameable" information needs as those "which could be expressed in key words," such as a request for "a ruined castle."[27] In contrast, "General/abstract" information needs "might involve abstract concepts rather than concrete objects," such as "a busy street scene."[28] Yet one could make the argument that "a busy street scene," while not an object per se, is no more abstract an information need than "a ruined castle." Adopting the perspective that "a busy street scene" expresses the same idea as "a busy street," this particular information need "could be expressed in key words" and mirrors the general-term plus qualifier syntax of the request for "a ruined castle." Indeed, if these two image queries were examined within Peter Enser's four-category framework, it is plausible that both would fall within the category of "non-unique refined."

The point of this example is not to suggest that one set of categories is superior to, or more accurate than, another. Rather, it demonstrates that terms and concepts which are treated as discrete levels of subject matter in one set of categories could theoretically be collocated within another set. This, in turn, indicates variations in how the different levels of meaning in the Panofsky/Shatford model — generic, specific, of, about, primary subject matter, secondary subject matter — have been applied and interpreted. Although classificatory frameworks might share the same foundation in the Panofsky/Shatford model, the question arises whether the levels and categories delineated in these frameworks are equivalents, and whether they have the same criteria for inclusion. On a broader scale, it also calls into question the suitability of classificatory approaches based on Panofsky's theories. Researchers have acknowledged the limitations of translating Panofsky's theories, with Enser concluding that "Panofsky's categorization does not present itself as a convenient tool for pictorial information needs analysis."[29]

One of the most often-cited limitations is the issue of subjectivity. As Deirdre Stam observes, "Almost all words used to describe works of art represent attributed characteristics — often the interpretations of their catalogers — rather than inherent properties of the object."[30] In adapting Panofsky's theories to image access, the issue of indexer subjectivity arises most often in the context of iconographic meaning/secondary subject matter, or what is referred to in Shatford's framework as *About* (table 2). Panofsky defines "the act of identification" as "description" at the pre-iconographical level and "analysis" at the iconographical level,[31] and researchers have made a similar distinction between *identifying* what an image is "of" and *interpreting* what an image is "about."

The interpretive role of the indexer is magnified in the context of general image collections. This magnification results from the association of "aboutness" with both the affective elements of an image (i.e., emotion) and abstract concepts as they relate to such elements as time, locale, actions, and events. As shown in table 2, Shatford defines the *Of* aspect of an image as "objective meaning" and the *About* aspect as "subjective meaning." This distinction also applies to her faceted classification of subjects. Indeed, examining the scope of the *About* aspect for each of the four facets (table 3) reveals that both the "What" and "When" facets concern "emotions." Moreover, the *About* aspect of all four facets focuses on "abstractions," such as "abstractions manifested by locale" ("Where" facet) and "abstractions manifested by actions, events" ("What" facet). Unlike concrete objects, the determination of these abstract concepts requires subjective judgment on the part of the indexer.

This connection between "aboutness" and abstractions is reinforced in research on user image descriptions and image queries. Hollink et al.'s study of image attributes provides one example.[32] Participants created free-text descriptions for a variety of general subject domains. These descriptions were then classified by the researchers according to one of three broad classes or levels of attributes: "Non-visual" (i.e., metadata about the image); "Perceptual" (i.e., low-level features such as color, shape and texture); and "Conceptual" (i.e., objects and scenes in the image). The "Conceptual" level was further divided into the categories "General"; "Specific"; and "Abstract." Results showed that 87.2 percent of the elements in participants' image descriptions (irrespective of the particular exercise) were at the "Conceptual" level. Moreover, 74.4 percent of these elements were characterized as "General," as opposed to 16.4 percent as "Specific" and 9.2 percent as "Abstract." The substitution of the term "Abstract" for Shatford's "About" underscores the perceived interchangeability of these concepts. At the same time, Hollink et al. acknowledge the role of indexer subjectivity in the categorization of descriptions as "Abstract," explaining that they considered a description "frag-

ment to be abstract if the level of subjectivity is so high that differences in opinion about the interpretation are possible."[33]

The relationship between "about" and "abstract" and the subjective nature of this level of meaning are also evident in the pyramid framework developed by Corinne Jörgensen et al.[34] Expanding Shatford's model, the framework is configured as a 10-level pyramid intended "to guide the indexing process."[35] The first four levels at the top of the pyramid encompass syntactic image content, while the remaining six levels treat semantic content. The semantic content levels (levels 5–10) are: *Generic Object; Generic Scene; Specific Object; Specific Scene; Abstract Object;* and *Abstract Scene.* As one moves down the pyramid, the increasing length of the semantic content levels reflects the increasing dependence on "specialized or interpretative knowledge about what these objects represent."[36] Jörgensen et al. note that the *Abstract Object* "indexing level is the most difficult one in the sense that it is completely subjective and assessments between different users may vary greatly."[37] Likewise, the *Abstract Scene* "level refers to what the image as a whole represents, and may be very subjective.... Examples at the abstract scene level include sadness, happiness, power, heaven, and paradise."[38]

Despite their inherent subjectivity, there is a reluctance to disregard "about" or "abstract" elements of subject matter in providing image access. While many studies found that most image descriptions and queries were predominantly at the "general" or "generic of" level, researchers also acknowledge the role that abstract elements play in meeting user needs. In Choi and Rasmussen's analysis of image queries on the topic of American history, the researchers found that only 5.3 percent of search requests belonged to the "Subjective needs" category (as opposed to "General" or "Specific" needs categories). Nonetheless, they also explained that "subject descriptors that represent about-ness of the image content were a key element for user's judgment of image relevance."[39] Hollink et al. similarly concluded that "users prefer general descriptions as opposed to specific or abstract descriptions," while at the same time observing a difference in the use of "Abstract" elements when participants described a scene (11.1 percent) as opposed to when they highlighted key terms in searching for an image (5.2 percent).[40]

Howard Greisdorf and Brian O'Connor propose that "viewers of pictures should be able to explicate their impressions of what they see, not just what is there, by object, by title, or by mechanized content."[41] Classifying user image descriptions according to seven low-level and high-level attributes, they found the descriptions included more affect/emotion-related terms than object-related terms. Interestingly, they also found that participants provided "descriptions of objects and content-based elements that are not evident or not even present in the image."[42] For instance, participants attributed

the terms "fishing" and "boat" to an image that had "a large body of water" in the foreground, and "walking" to two images "even though no such action is apparent in the pictures other than the possibility of some sort of path."[43]

Just as the interpretation of the "aboutness" of an image is susceptible to indexer subjectivity, its "ofness" also poses problems. As the results from Greisdorf and O'Connor suggest, there are inherent limitations in the indexing of even generic content elements since it is impossible to predict just what a user will see in an image. Peter Enser describes a case from the Hulton Deutsch Query Analysis Project in which 18 participants used a total of 101 terms (42 unique terms) to describe a single photograph entitled "Paris in Springtime."[44] These terms covered the entire panoply of Shatford's categories: *Generic Of* (e.g., "Tower"; "River"); *Specific Of* (e.g., "Eiffel Tower"; "Seine"); and *About* (e.g., "France"; "Civil Engineering"). In fact, many of the *About* terms appeared to be polar opposites (e.g., "Serene" versus "Excitement"), illustrating again both the prevalence and the subjective nature of affect-related *About* terms. But this example also demonstrates the sheer range of *Generic Of* and *Specific Of* related terms that can be associated with a single image.

This range of terms reflects both the relevancy of an image to multiple subject areas and the specific information needs of users in each of those domains. Jane Greenberg suggests that most images apply to at least one of three, non-mutually exclusive domains: visual resource, art, and archival.[45] Noting that "an image produced in one domain may function in another domain," she describes how "an archival photograph documenting the construction of the Brooklyn bridge can also function as an aesthetically pleasing *art photograph* and as a *visual resource* portraying state-of-the art bridge engineering using wire cables"(original emphasis).[46] In each of these scenarios, the photograph is specifically "of" the Brooklyn bridge. Depending on the perspective of the viewer, however, the *Generic Of* elements could vary greatly, from, say, wire cable components for an engineer, to skyline and cityscape elements for an historian. Enser points out that the result of such "unpredictability of retrieval utility" is that "there can be no means of determining the appropriate level of indexing exhaustivity."[47] While current applications of the Panofsky/Shatford model can guide the indexer in determining the different kinds, or levels, of meaning in an image, there is still the question of what constitutes a suitable range of subject elements for image access at these levels. The answer to this question will, of course, vary from collection to collection.

The issues of exhaustivity and the "unpredictability of retrieval utility," on the one hand, and indexer subjectivity and the role of affect/emotion terms, on the other, have prompted a re-evaluation of image access approaches in

which indexers alone select terms based on their own subjective judgements and according to frameworks such as the Panofsky/Shatford model. Greisdorf and O'Connor argue "that viewers of images maintain new creative rights and should be allowed to see what matches their own prototypes" of image content.[48] Pauline Brown et al. also "reject the idea ... that we must somehow standardise the 'user' (indexer & retriever) either through a fixed vocabulary or a limited set of indexers."[49] The result has been an investigation into the utility of "democratic" approaches to image indexing in which users contribute indexing terms through feedback mechanisms.

In democratic indexing, users provide their own terminology to describe images without recourse to controlled vocabularies established by indexers or traditional indexing resources, such as thesauri. Brown et al. propose a model with "no 'preferred' terms. The relevance of a term depends on its common usage by a number of users to refer to the same thing/image."[50] This emphasis on user-determined relevance is intended "to ensure that the controlled vocabulary does not become a straight-jacket for interpretation and associative thought."[51] Another incarnation of democratic approaches to image indexing is the "folksonomy," a term originated by Thomas Vander Wal to describe web-based classification systems developed by web-users, rather than web-architects.[52] In folksonomies, users provide "tags" describing the information or material to be classified, such as a web page, bookmark, or a digital photograph. These tags form categories within the folksonomy, thereby collocating all items that have in common a particular tag, such as photographs tagged "tree." In photo-sharing sites that employ folksonomies, such as "Flickr," users have the option of creating their own tags or categorizing their images using existing tags popularized by other users.

The Role of Iconographic Tradition

Panofsky's theories of iconographical analysis represent the inverse of the democratic indexing model. The essential difference between the two approaches can be traced to their respective goals: the identification of the meaning of a work of art in the case of Panofsky, and the identification of what an artwork means to the user in the case of democratic indexing. Shatford's adaptation of Panofsky's theories falls in the middle of this spectrum by reworking the levels of meaning identified by Panofsky into categories of meaning that can be applied to different facets of an image. Many aspects of this faceted classification address emotive or abstract content that can vary from viewer to viewer. Subsequent applications of the Panofsky/Shatford model moved from the realm of image meaning to image attributes, classify-

ing the elements identified by users in image descriptions and queries into the categories of *Generic of, Specific Of,* and *About/Abstract* in order to examine which classes of attributes best address user needs. The focus on user needs (as well as the resulting questions concerning exhaustivity and indexer subjectivity) resurrects the concept of democratic indexing and the rejection of Panofsky's theories as suitable for image access approaches. Lost is Shatford's assertion, "The level of sophistication of the users of a general collection may help determine the vocabulary employed to describe the subjects of a picture, but the choice of subjects should depend on the picture itself."[53]

The limitations of the Panofsky/Shatford model can be traced to two inter-related factors, both of which concern how Panofsky's original theories of iconographical analysis have been adapted by the information studies community. First is the treatment of Panofsky's framework as discrete levels rather than as stages in a process. Second is the range of the images to which these levels are applied. The central question is not so much whether Panofsky's framework is suitable for addressing user needs, but whether certain images are suitable for Panofsky's framework. Furthermore, what are the criteria for determining this suitability?

Noting the difficulty in distinguishing primary subject matter from secondary subject matter, or "ofness" from "aboutness," James Turner questions "whether the levels can be separated in any meaningful way."[54] The findings from his study of image descriptions provide evidence of this difficulty, with 28 percent of the terms classified within the "Either Ofness or Aboutness category."[55] Similarly, Peter Enser found image requests "conforming with pre-iconography, but also encompassing those abstract concepts which inhabit iconology," such as "Children at the seaside: traditional, nostalgic (sandcastles, donkey)."[56] Raya Fidel linked the difficulty of separating "ofness" and "aboutness" to the intended use of the image.[57] Based on her classification of 100 user requests at a commercial image provision agency, she formulated a distinction between the "Data Pole" and the "Objects Pole" in image retrieval. Images at the "Data Pole" are retrieved for the information they provide — for instance, a user needing "a map to see how to get from one place to another," or a chemist requiring "a diagram of a chemical structure to examine the molecular structure of the elements involved."[58] Conversely, images at the "Objects Pole" are treated and used as objects. Requests at this pole might include "a very specific kind of image of a person or event, or for any image that represents a specific idea or object."[59] Fidel points out, "Each Pole generates a certain searching behaviour which has characteristics opposing those of the other Pole."[60] For example, the difference between "ofness" and "aboutness" is much clearer at the "Objects Pole" than at the "Data Pole." She contrasts a map of Seattle ("Data Pole"), which "is of Seattle and about

it as well," with "a drawing of volcanoes spewing with lava and smoke" ("Objects Pole")—an image of a volcano that also "can be about anger."[61]

Arguably, the difficulty in separating "ofness" and "aboutness" has less to do with the intended use of images, or with the categorization of image descriptions and queries, than with what is actually depicted in the images themselves. This distinction is evident in two examples used by Shatford to explain the concepts of "ofness" and "aboutness." The first is Jan van Eyck's *Giovanni Arnolfini and His Bride*, painted in 1434. As expressed by its title, the painting is of (in the specific sense) the silk merchant Giovanni Arnolfini and his wife Jeanne Cenami. The painting is also, as Shatford indicates, "*About* marital faith,"[62] or what Panofsky himself identified as the sacrament of marriage.[63] In fact, this painting is frequently cited in the study of iconography, and, as Linda Seidel mentions, Panofsky's interpretation "has informed virtually all discussion of the work during the last sixty years."[64] A pre-iconographic (*Generic Of*) description of *Giovanni Arnolfini and His Bride* might note the standing figures of a man and woman holding hands. These figures are presented within a domestic interior, as indicated by the presence of a bed, chair, and mirror, as well as by the shoes on the floor and the small dog at the woman's feet.

Now consider art historian Frederick Hartt's analysis of this same scene:

> The little dog in the foreground is a traditional symbol of fidelity; the clogs, cast aside, show that this is holy ground; the peaches, ripening on the chest and on the windowsill, suggest fertility; the beautifully painted brass chandelier holds one lighted candle—the nuptial candle, according to Netherlandish custom the last to be extinguished on the wedding night. The post of a chair near the bed is surmounted by a carved Margaret, patron saint of childbirth. The "mirror without spot" was a symbol of Mary, and its sanctity is reinforced by the garland of ten Gothic paintings of scenes from the Passion of Christ inserted in its frame and by the rosary hanging beside it.[65]

This synopsis demonstrates the transition from a pre-iconographic description to iconographic meaning—in other words, the process of moving from what a painting is "of" to what it is "about." Recognizing the connection between pre-iconographic/primary subject matter elements and what these elements collectively represent requires the viewer to be familiar with the "iconographic language ... of both signs and symbols"[66] utilized by Van Eyck in the Arnolfini portrait. These primary subject matter elements are coded representations that the artist used to communicate a particular event according to the patron's wishes. The presence of these symbols therefore indicates specific artistic intent.

Another image discussed by Shatford is a photograph of architect Louis Sullivan's Guaranty Building (now the Prudential Building) in Buffalo, New

York. She suggests that the *Generic Of* aspect of the photograph could be expressed through a term such as "Skyscraper" or "Office Building," and that the *Specific Of* aspect would be "Sullivan's Guaranty Building."[67] While these interpretations are straightforward, Shatford's proposal that the *About* aspect of the image could be "Modern Architecture" raises a number of questions. Does Sullivan's building itself represent "Modern Architecture," or is the meaning of the photograph of Sullivan's building "Modern Architecture?" What is the basis for either of these interpretations: is it historical documentation, inherent knowledge, or visual clues presented in the photograph? Then there is the question of artistic intent. Are the visual elements presented in the work consciously intended (by either the architect or photographer) to signify "Modern Architecture?" Instead, one could argue that the term "Modern Architecture" represents a higher categorical class under which terms such as "skyscraper" and "office building" could be placed. It does not necessarily represent a distinct level of meaning within the image itself.

Comparing *Giovanni Arnolfini and His Bride* and the photograph of the Guaranty Building reveals a clear difference in how the levels of Panofsky's model are applied and interpreted. In the case of the Van Eyck painting, the enumeration of primary subject matter/*Generic Of* elements is an integral step in identifying the work's meaning. The relationship between primary and secondary subject matter is such that the proper identification of what the image is "of" leads the viewer to understand what it is "about." But this relationship is not as clear in the case of the Guaranty Building photograph. Here, the connection between the "ofness" and "aboutness" of the image is more arbitrary: another viewer might determine that the image is about "The Chicago School" (of architecture), for instance, or "The Rise of the Steel Industry." Indeed, Shatford points out that "the description of Sullivan's skyscraper as Modern Architecture ... could easily be questioned by persons who feel that Modern architecture began with Frank Lloyd Wright."[68] The range of potential subjects for this image exemplifies the problem of indexer subjectivity. A disconnection between primary subject matter elements and secondary subject matter or meaning creates a situation where the determination of what the image is "about" is based entirely on the indexer's interpretation. At the same time, these myriad interpretations do not provide the indexer with a sense of which primary subject matter elements are most relevant at the "of" level, leading to the problem of exhaustivity.

Why is the connection between "of" and "about" more arbitrary in the Guaranty Building photograph than in the Van Eyck painting? Karen Collins's observation that a "distinction between pre-iconographical and iconological levels of analysis ... is perhaps less useful for describing ordinary images than it is for art images" suggests one answer.[69] Rather than focusing on the dis-

tinction between art and ordinary images, however, this question can be examined in terms of the relationship between an image and iconographic tradition. As noted in the Introduction, the phrase "iconographic tradition" signifies: (1) the presence of, and interconnection between, both primary and secondary subject matter; and (2) the substantiation of the relationship between primary and secondary subject matter outside of the context of the artwork itself.

Examining the first of these elements, not all images — whether "ordinary" or "art" — lend themselves to iconographical analysis or to the identification of secondary subject matter. Panofsky identifies "works of art in which the whole sphere of secondary or conventional subject matter is eliminated, and a direct transition from *motifs* to *content* is striven for, as is the case with European landscape painting, still life and genre" (original emphasis).[70] In other words, in an artwork such as a still life, "of" is the same as "about." Because of this equivalency, any indexing terms that attempt to assign an intrinsic meaning to the work would, by definition, fall within the realm of either attributed interpretation or emotive reaction of the viewer or indexer.

Just as the photograph of Sullivan's Guaranty Building could be about any number of different subjects, Shatford observes, "That *Giovanni Arnolfini and His Bride* is *About* marital faith could probably be contested as well."[71] Certainly, all images are subject to varying interpretations. What distinguishes these two examples — and what makes the connection between the Van Eyck painting and the subject of marital faith difficult to dispute — is the ability to verify the connection between the "of" and "about" aspects in this work. Therefore, iconographic tradition concerns not only the presence of both primary and secondary subject matter, but also the ability to confirm the interrelationship between these elements.

Carl Landauer points out that Panofsky's "art historical enterprise had its genesis in the Renaissance."[72] Western art from this period, and throughout the eighteenth century, was predominantly text-based. As Brendan Cassidy explains, "For text-derived images, two sources above all had a long and perennial influence: the Bible and classical mythology with its tales of the Gods and heroes of ancient Greece and Rome. Only slightly less popular were the lives of Christian saints and the events of Greek and Roman history."[73] In addition, the sixteenth century introduced a period of "more local iconographic traditions that drew upon national history and native writers for their inspiration," such as Tasso and Ariosto in Italy, and Shakespeare and Milton in England.[74] Thus, Panofsky indicates that iconographical analysis "presupposes a familiarity with specific *themes* or *concepts* as transmitted through literary sources, whether acquired by purposeful reading or by oral tradition" (original emphasis).[75]

An image need not be text-based, however, for it to be amenable to

iconographical analysis. As Shatford remarks, "Panofsky is obviously using [the term] 'literary sources' in a very broad sense, appearing to equate literary sources with any form of linguistic communication."[76] Rather, literary sources could also be construed as documentation that substantiates a perceived relationship between primary and secondary subject matter. Hartt observes that artists such as Van Eyck "worked with the aid of iconographic handbooks."[77] These handbooks (also known as emblem books or iconographic dictionaries) serve as reference tools in the analytical process. Landauer explains, "Panofsky would deftly reidentify Renaissance paintings by comparing what would seem minor attributes of classical figures with their representational tradition in art and literature. To establish that a vine-enveloped tree trunk might accompany a representation of Bacchus, Panofsky turned to an early seventeenth-century emblem book for its reference to Catallus's *Carmina*."[78]

Iconographic Tradition and the Process Model

The relationship between primary and secondary subject matter and the ability to verify this relationship outside the context of the image itself are what distinguish images that fall within an iconographic tradition from those that do not. Underscoring this relationship is the idea that Panofsky's model of iconographical analysis is a process model, in which recognition of an image's primary subject matter elements gives way to analysis of these elements as indicative of specific meaning. This relationship, as well as the role of "literary sources" or documentation, creates a set of checks and balances that frames the selection of primary and secondary subject matter elements as image access points.

These two interrelated concepts — iconographic tradition and the process model — suggest a new paradigm for determining the applicability of Panofsky's theories to image access. This chapter has illustrated the limitations of Panofsky's theories as a level model. In the level model, primary and secondary subject matter (often interpreted as "of" versus "about," or as "general" versus "specific") are treated as de facto categories for distinguishing the various subject matter elements within an image. This model does not take into account whether there is any documented relationship between what is classified as primary or secondary subject matter — in other words, whether the image falls within an iconographic tradition. Nonetheless, the information studies community has generalized Panofsky's theories as applicable to what Shatford characterizes as "any representational pictorial work."[79] But as images such as the photograph of Louis Sullivan's Guaranty Building demonstrate,

not all representational pictorial works lend themselves to an iconographical analysis. In some cases, it is not possible to differentiate what an image is "of" and what it is "about." In other cases, primary subject matter elements do not reveal a picture's inherent meaning. Therefore, the determination of what an image is "about"—in other words, the selection of image access points according to secondary subject matter—becomes a highly subjective exercise based solely on an image cataloguer's or indexer's interpretation.

Arguably, determining the applicability of Panofsky's theories according to the criteria of the process model and iconographic tradition would alleviate the problems of subjectivity and exhaustivity in image indexing. Images that fall within an iconographic tradition, such as Jan van Eyck's *Giovanni Arnolfini and His Bride*, are composed of a visual language employed by the artist to communicate a specific message. The purpose of iconographical analysis is to translate this message—to identify the visual cues expressed through primary subject matter and pre-iconographical description and to view them in the context of secondary subject matter or meaning in the artwork. Applying Panofsky's theories as a process model for image access therefore involves examining and verifying the relationship between primary and secondary subject matter and determining access points based on this relationship.

On the one hand, applying these criteria would limit the applicability of Panofsky's theories to images that fall within an iconographic tradition—to images in which both the presence and interconnection of primary and secondary subject matter can be verified. On the other hand, these criteria do not limit the applicability of Panofsky's theories to purely representational works. As noted in the Introduction, the goal of providing image access to nonrepresentational/abstract images has been considered unattainable in terms of the Panofsky/Shatford model. Shatford provides the following caveat to her theoretical investigation: "Pictures that cannot be analyzed as *Of* anything beyond abstract forms are not representational, and are beyond the scope of this article, although these pictures (abstract art, for example) may well have *About* qualities."[80] Jörgensen similarly observes that "different types of collections, such as abstract art or medieval manuscript illuminations, also seem to require vastly different approaches."[81] But what if the nonrepresentational/abstract art images in question fall within an iconographic tradition? Could Panofsky's theories of iconographical analysis be used to identify secondary subject matter in this type of image?

The classification system for graffiti art styles presented in this book explores this possibility. As detailed in the following chapters, graffiti art embodies both primary and secondary subject matter, and the interconnections between these elements can be verified. Specifically, primary subject matter in graffiti art is the pure forms of the letters; the secondary subject matter is the

resulting style of the graffiti art. Verification of the relationship between primary and secondary subject matter comes from the "oral tradition" of the history of styles that is shared among graffiti writers.

As with other art forms, the identification of secondary subject matter in graffiti art requires specialized knowledge. Returning to Jan van Eyck's *Giovanni Arnolfini and His Bride*, a non-specialist user would not necessarily know that the dog depicted in the image is a symbol of faith. He or she would, however, be able to recognize that the creature is a dog based on practical experience. Similarly, individuals outside of the graffiti art community would not be able to identify specific graffiti art styles. Therefore, the goal of the classification system is to provide a bridge for image cataloguers and indexers between the visual elements present in a graffiti art image (primary subject matter) and the specific style of graffiti art exhibited in the image (secondary subject matter.) Applying the classification system reflects the process of iconographical analysis, in which the identification of secondary subject matter or meaning in an image is dependent on the identification of primary subject matter.

The classification system is essentially a manifestation of the new paradigm for Panofsky's theories proposed in this chapter. It is constructed according to the twin criteria of iconographic tradition and the process model, and one of its goals is to determine whether Panofsky's theories can be applied to nonrepresentational/abstract images according to this framework. But understanding how the development and application of the classification system reflect this paradigm first requires an exploration of the nature of graffiti art itself.

2

Graffiti Art in an Iconographic Framework

Chapter 1 examined the limitations of Erwin Panofsky's theories as a level-based model for image access and suggested as an alternative a process-based approach. The concept of the process model hinges on iconographic tradition — the idea that there is an interconnection between primary and secondary subject matter in an image, and that this interconnection can be verified outside the context of the image itself. In fact, the process that engenders the name "process model" is iconographical analysis, in which the successful identification of secondary subject matter is dependent upon the correct identification of primary subject matter. The process of moving from primary to secondary subject matter within an image also involves a change in perception. Recognizing, for example, that the painting of an angel with a sword is a depiction of the archangel Michael produces an "aha!" moment in which the viewer reaches a more complete understanding of the artwork's meaning.

The theoretical basis of the classification system presented in this book reflects the relevance of iconographical analysis to the determination of graffiti art styles. When the process model is applied to graffiti art, primary subject matter constitutes the appearance of the individual letters in a graffiti art piece, while secondary subject matter is the overall style in which the piece is executed. Moreover, the interrelationship between primary and secondary subject matter can be verified outside the context of the piece itself. Recognizing that the letters in a piece collectively denote not only a written word but also a particular graffiti art style produces an "aha!" moment for the viewer similar to that of the archangel Michael example: the viewer's comprehension of the piece shifts from a simple enumeration of visual features at the pre-iconographic level to a fuller understanding of the piece's iconographic meaning.

The classification system's use of theories developed in the context of

Renaissance art raises questions concerning the way in which the process model can be applied to graffiti art. How, for example, can style be equated with subject matter? And how can letters convey iconographic meaning? In order to address these questions, this chapter looks at the role of style in graffiti art and its connection to iconographic tradition.

The Development of Graffiti Art Style

To most people, the names "East Coast Piecing," "Los Angeles Cholo-based," and "Philly Wickeds" are as inscrutable as the types of graffiti art they describe. To members of the graffiti art community, these names conjure specific, identifiable styles of graffiti art. These names are not assigned by graffiti writers arbitrarily, but are instead based on tangible components of the styles' composition or history. Consider the example of Philly Wickeds, a name which refers simultaneously to the style's provenance of Philadelphia and to its intended visual effect. GREX4 explains that the style's "letters are elongated and disjointed in surrealistic, distorted fashion. Wickeds are designed to shock, disturb," adding, "They can be quite violent."[1] Noting that they are "a marriage between technique and emotion," the Art Crimes web site describes Philly Wickeds as "electric whipped barbed wire streaks" and "the graffiti your mother warned you about."[2]

A style also can be named for the writer or crew (collaborative group of writers) who developed it. CTK and TFP, for instance, are acronyms of the crew names Crime Time Kings and The Fantastic Partners. Yet even cognominal styles can transcend the identification of a particular crew or writer and come to represent an underlying aesthetic. The Wild style, created in 1974 by the writer Tracy 168 and named for his crew, provides an example of this process. GREX6 characterizes the style as "consistent with the whole movement of graffiti in which text is taken to new limits, into a 'wild frontier.' It's dangerous, unpredictable, and exciting." These qualities are manifested through two components of Wild style pieces: arrows and illegibility. Like GREX6, the writer MARE 139 alludes to the 'dangerous' aspect of the Wild style emanating from the liberal use of arrows: "What distinguishes wild-style letters from anything else is the arrow. Arrows always give direction. The arrow is the movement, it's the definitive mark of wild-style. Arrows have an attitude. An arrow shooting one way is penetrating space, it's bold. The arrows tend to assault people. They are missile like, or like knives. Arrows have this aggressive, dangerous quality."[3] By honing letters into dangerous projectiles, arrows also transform the physical appearance of the letters, rendering them virtually illegible. The name "Wild style" therefore signifies a reconstituting

of the alphabet within the graffiti culture, changing it, in the words of the writer Lee, "into a wild, rambunctious, erratic thing."[4]

While the origins of specific styles can be traced through their names, what is the genesis of graffiti art style as a concept? The question is deceptively simple. Just as the word "graffiti" can describe writings as varied as gang communication and political discourse, possible uses of the term "style" are equally exhaustive. Style, however, assumes a particular meaning in the context of graffiti art. In fact, the development of graffiti art style is intertwined with the development of graffiti as an art form. Understanding the concept of graffiti art style therefore first requires examining this shared history.

Today, graffiti art is practiced world-wide, its popularity attributed to the globalization of the hip-hop movement.[5] Its roots, however, are in Philadelphia and, especially, in New York City. The evolution of graffiti art begins with what is known as a "tag" — a stylized signature of a graffiti writer's pseudonym. The pseudonym usually consists of a single name or the combination of a name plus numbers. While most writers create names, others use their initials or a childhood nickname.[6] One of the earliest examples of a nickname-based tag was that of Cornbread, who blanketed Philadelphia with this moniker as a sign (both literal and figurative) of devotion in what *Philadelphia Weekly* described as "surely one of the more determined wooing projects of the latter 20th century."[7] According to urban legend, the name Cornbread stems from the writer's time in reform school, where, pining for his grandmother's cooking, he peevishly inquired, "How come y'all never fix no cornbread?"[8]

Numbers in tags usually refer to some component of the writer's address, such as a street or house number.[9] One of the most famous tags from the early 1970s combines both nickname and number — that of Taki 183, known as "the grandfather of graffiti artists."[10] Although Philadelphians lay claim to their city as "the birthplace of modern graffiti,"[11] Taki 183 is credited with the popularization of tagging (the process of writing your tag on a wall or other surface) in New York City. As Joe Austin explains, Taki 183, a bicycle courier, "aspired to have his name noticed by a journalist or filmmaker and concentrated his writing efforts where he knew the elite members of these occupations were likely to live and work."[12] After the *New York Times* published an article about him in July, 1971, including a photograph of the ubiquitous Taki 183 tag, the number of taggers in the city grew. As the number of taggers seeking notoriety increased, so too did the competition to get noticed. This led to the deliberate choice of moving vehicles, such as subway trains and buses, for tagging surfaces because, as Austin points out, "the name circulated throughout New York City, increasing its exposure."[13] Jack Stewart

observes that one of the greatest coups of this period was accomplished by three subway writers whose tags were shown in the opening credits of the television show "Welcome Back Kotter," leading him to observe, "For years their names sailed across the T.V. screen every Saturday night at seven P.M."[14]

It was around this time that graffiti writers began to view originality and creativity in tag design as another way of drawing attention to oneself and one's work. Indeed, the primary difference between the graffiti movement instigated by Taki 183 and earlier examples of graffiti is its emphasis on style and the absence of "social, political, or scatological content" and gang affiliation.[15] Austin explains, "Early writers, like Taki 183, were more interested in 'the way the name looked' in the urban landscape rather than in claiming some part of that landscape as exclusive territory."[16] The emphasis on the style of the work led to experimentation with letter forms and colors, as well as the enlargement of the work itself. The result was the development of what are known as throw-ups and pieces. Throw-ups, so called because of the speed with which they are executed, are still dominated by the letters of the tag, but they also exhibit three-dimensional letter forms. While tags are monochromatic, throw-ups are often rendered in more than one color. Like tags, however, throw-ups are designed to get one's name over as many surfaces as possible, and are therefore less concerned with "style or technical proficiency."[17] Pieces, short for masterpieces, are considered the pinnacle of graffiti art. With their range of colors, intricate lettering, backgrounds and visual details, pieces are all about style.

The new focus on style and the subsequent development of pieces represented a marked departure in both the nature and intent of graffiti art. In describing the innovative and freewheeling style of basketball found on inner-city playgrounds, Michael Mandelbaum notes that the playground style "represents a form of self-expression for people who, because of the straitened circumstances of their lives, have few other outlets for it. It is a way of establishing a personal identity, winning respect and admiration, and succeeding in the eyes of the world."[18] A similar dynamic underscores graffiti art. For Taki 183 and his acolytes, tagging was a form of self-expression that both mocked and embraced the emblem of success which defines mainstream consumer-culture: seeing one's name broadcast across the city. Consider the example of Donald Trump, whose eponymous real estate and business ventures (e.g., Trump Palace, Trump Parc, Trump Tower, Trump Vodka, Trump Magazine) demonstrate the transformation of an individual's name into a commodity. Or the example of what Charles Isherwood identifies as "the graffiti of the philanthropic class"—the phenomenon in which the name of "some wealthy, generous, and obviously not publicity-shy donor" appears on "every nook and cranny" of new theaters, auditoriums, museums, and the like.[19] As

Isherwood notes, "These possessory tags subtly convey the message that culture belongs, first and foremost, to the rich."[20]

Early graffiti writers sought to challenge this dynamic, similarly recognizing that their names could be used as both a brand and a marketing tool in their quest for recognition. In a published interview, the writer Iz the Wiz observed, "OK: Mr. Mobil; Mr. Amoco; Mr. Exxon. They're rich. They can put their name on any sign, any place. Build a gas station and there's their *name*."[21] One manifestation of the name-as-brand concept occurred when established writers sold their tags to neophyte writers. These newcomers — known as "toys" — were expected to add Roman numerals to the tag to indicate its lineage.[22] This franchising of names prompted Richard Goldstein to comment in *New York* magazine that "sometimes the process becomes exceedingly elaborate, so that you wonder how it was that Rican XLIV determined his identity."[23]

With the development of pieces, however, came a redefinition of success. Graffiti writers still saw New York City as a place where they could, both figuratively and literally, "make a name" for themselves.[24] This objective, however, could no longer be achieved just by "getting up" — seeing one's name in as many places as possible. It now involved gaining admiration for artistic skill, which was measured in terms of a writer's style. The goal of fame through ubiquity was replaced with that of fame through proficiency. As Ivor Miller remarks, "The evolution of style resulted from aesthetic battles in which writers competed for the title of king."[25] Steve Grody likewise observes that "the development of a distinctive visual style ... is the single determining factor in how a writer is judged among his peers."[26]

This new competition shifted the intended audience of the writers' work from the general public to the graffiti community itself. Pieces were critiqued by fellow-writers using criteria such as "originality of design," "brightness of color," "smoothness of paint application," "sharpness and accuracy of outlines," and "effective use of details."[27] Not surprisingly, this new configuration of graffiti art produced a schism between taggers and the writers who concentrated their efforts on pieces.[28] Writers who produced elaborate masterpieces "believed that few writers possess the artistic ability" to move beyond tags; taggers could not understand "why they should sacrifice their existing fame to the long-range task of developing the technique and style necessary" for creating pieces.[29]

Just as graffiti writers replaced the goal of gaining notoriety from the general public to that of achieving the admiration of their peers, the way in which the tag functions in graffiti art underwent a similar change. While pieces are still based on a writer's tag, in many cases the presentation is abstracted to such a degree that the name is rendered illegible to most view-

ers, a reflection of writers' de-emphasis on simply getting-up. Illegibility in graffiti art would have been counterproductive for writers such as Taki 183, whose ambition was to have his name seen — and understood — by as many people as possible. For the writers who focused on pieces, however, the intricate letter forms which produced this illegibility added another aesthetic dimension to their work. Joe Austin notes that "the more abstract lettering styles are 'narrowcast,' or specialized, languages created primarily for the appreciation of other writers, rather than a 'broadcast' language accessible to a wider audience."[30]

At the same time, tags became associated not only with individual writers, but also with categorical styles of writing — styles of graffiti art which exhibit consistent sets of identifying characteristics. Jack Stewart explains that the "sudden appearance on the scene of an identifiable style to which a name could be given was a milestone in this rapid evolution of graffiti," with the result that "writers were quick to discern the importance of consistency in a style if it was to be coherent enough to carry a name — and if you couldn't name a new style you couldn't claim it — and staking a claim was essential to making the fame."[31] The first named style emerged just one year after the *New York Times* reported on (and contributed to) the Taki 183 phenomenon. Broadway Elegant, also known as Manhattan style, was described in a contemporary publication as a style in which "artists use blatant colors and often outline their bold letters to reinforce the shapes."[32] Other boroughs of New York were also represented in the first generation of graffiti styles, such as the Brooklyn style, associated with "swirls and lots of ornamentation," and the Bronx style, "characterized by 'bubble' letters."[33]

The introduction of named styles in 1972 coincided with graffiti's "metamorphosis from crime to art."[34] The initial stages of this transition occurred in academia, where, as Susan Stewart explains, graffiti was "derailed onto the track of art history, specifically the history of painting as institutionally canonized."[35] The idea of graffiti as "high art" was first promoted by United Graffiti Artists (UGA), an organization founded by City College of New York sociologist Hugo Martinez. Convinced that the writer's goal of gaining fame and affirmation would "be better served by displaying his name in an art gallery than on the streets,"[36] Martinez tried to persuade writers to eschew illegal graffiti and to direct their talents instead toward creating socially-sanctioned, canvas-based artworks. Pointedly suggesting that "if people see graffiti on walls inside buildings instead of on walls outside buildings, they will think it is art,"[37] Martinez sought to cast the organization as an artist-driven, modern art movement in the tradition of twentieth-century "isms" such as Futurism and Abstract Expressionism.[38]

UGA was featured in the first exhibition of graffiti art canvases, organ-

ized by the art department of City College in December, 1972. The success of this exhibit, including favorable reviews in the *New York Times* and *Newsweek*, guaranteed access to other venues. In addition to shows at Soho galleries, UGA played a visible part in the 1973 Joffrey Ballet production of Twyla Tharp's *Deuce Coupe*, literally spray painting scenery "onstage while the performance takes place."[39] Like the art exhibitions, *Deuce Coupe* generated positive press coverage from such diverse sources as the *Wall Street Journal* and *New York* magazine, which described the ballet as "an immense success — the hit of the season, actually."[40]

With their enthusiastic receptions, the Tharp ballet and the UGA exhibitions marked the recognition of graffiti as a distinct type of art. In fact, the *Times* review of the City College exhibit was the first time that a mainstream publication used the term "artist" to describe practitioners of graffiti.[41] This reappraisal of graffiti and of the individuals who create it was undertaken not only by the media, but also by the graffiti writers themselves — a reflection of UGA's mandate for writers to "place their work on canvas and to take it seriously, as worthy and valuable art."[42] According to Jack Stewart, "Though there had been a general increase in the appreciation of the design of graffiti among most of the writers since the summer of 1972, the creation of U.G.A., based as it was on aesthetic considerations, bolstered their appreciation of design factors and led to their having a new perception of themselves as 'artists.'"[43] Referring to gallery-based graffiti writers as "muralists," sociologist Richard Lachmann observed, "The muralists echo their patrons' distinction between subway graffiti and art on canvas, which is 'post' graffiti. Several of the gallery muralists advocate a ban on subway graffiti, arguing that 'we were the first and the best. The writing now is just scribble-scrabble. Our pieces were art.'"[44]

This is not to say that all graffiti art moved "off the streets and into the coffee-table books and the galleries."[45] Despite the efforts of Hugo Martinez to establish graffiti within the "high art" realm, few writers felt at ease in this milieu. Many members of UGA, which disbanded in 1975, did not stop their subway writing;[46] other writers discovered that the transition "from train to canvas was difficult and awkward."[47] The example of Jean-Michel Basquiat (1960–1988) presents another cautionary tale. Originally a New York City–based graffiti writer with the tag "SAMO," Basquiat dedicated himself to studio-based work and gallery sales in the late 1970s. As Leonhard Emmerling explains:

> Unlike most graffiti artists, he stopped tagging buildings and subway cars, preferring the context of galleries or even vernissages, and drawing media attention to himself. The way in which the art market used him and other "kids" shows what he tragically shared in common with other graffiti artists. These kids, like

Basquiat, moved from spraying subway cars to the canvases of the galleries, from being ignored to being shuttled from opening to opening, only to be unceremoniously dropped as soon as interest died.[48]

At the same time, graffiti writers who had once associated with Basquiat distanced themselves from their former peer, having determined "that the future star artist was selling the graffiti movement out to the very establishment he once reviled."[49]

Contemporary practitioners of graffiti art still find themselves negotiating an identity between "artist" and "writer," with both of these terms falling somewhat short of the mark. Jack Stewart contends "that young graffitiists came to eschew the term graffiti writer by 1975 and thought of themselves as what the establishment was calling them: graffiti artists."[50] GREX1 identifies with this group, having adopted the term "artist" because he "view[s] graffiti as an art form." He adds the caveat, "However, I do not consider all graffiti to be artistic." Other writers seem less concerned or less comfortable with identifying themselves as artists. According to GREX2, "Labels are just identifiers. They both refer to the same thing as far as I'm concerned." The comments of GREX9 express a similar ambivalence: "I refer to myself as both [artist and writer.] I find myself adjusting the term based on my audience. If the person(s) seem less familiar with graffiti, I refer to myself as a graffiti artist. If it's someone who's down, in the know, or another writer, I refer to myself as a graffiti writer." At odds with GREX1's view of graffiti as an art form is GREX6's belief that "art is created by artists and graffiti is created by writers." These comments suggest that the shift in identify from writer to artist described by Stewart was neither universal nor permanent.

The Concept of Iconic Style

Despite the often uneasy association between graffiti art and fine art, analogies between the two can, in fact, shed light on the meaning and interpretation of graffiti artworks. Interestingly, the most relevant fine art movements are those which, arguably, bear the least visual resemblance to graffiti art. Rather than the Pop Art and avant-garde movements which draw frequent comparisons, graffiti art shares a common mode of expression with a significantly earlier period in the history of art: the Renaissance.

Underpinning the development of named styles in graffiti art is the fact that in order to carry a name, a style must be consistent.[51] This consistency, in turn, is the product of conventions governing the form and the feel of the style and, consequently, of artworks created in that style. As Ivor Miller remarks, "Writers are conscious of themselves as practitioners of an art form

that has a history."[52] This history is inculcated through interactions within a graffiti crew between novice and skilled writers — a system that scholars have compared to the apprenticeships of Renaissance painters and to medieval trade guilds:

> Depending on one's individual interests and the skill level already attained, an initiate might assist in the execution of works designed by the crew's masters (usually just by filling in the larger areas of color after the initial outlines had been drawn on the outside of the subway car but before the more detailed work began).... As the sophistication and complexity of various writing styles increased over the course of the decade, some crews became organized like a medieval guild or trade union, with self-recognized apprentices working under masters to assist them in the creation of (master)pieces.[53]

This mentor-protégé system not only allows new writers to "remain innovative while maintaining ideals of respect for earlier masters,"[54] but also enables them to learn the customs that define and differentiate extant graffiti art styles. Describing the mentoring role of writers and crews in Los Angeles, Steve Grody explains that apprentices are taught "anything from gathering materials to 'routes' ... to technical and aesthetic pointers."[55] One element of apprentices' technical education involves sketchpads, known as black books, which writers use to hone their skills, master a particular style, and create new designs. The designs and sketches are then evaluated by the writers' peers. As James and Karla Murray point out, "The shapes and colors of one individual drawing may be put together with others to form a new, unique style of graffiti"[56] — a new style that will eventually be "critiqued, reworked, rejected or accepted, and then passed on in a dynamic process of continual cultural reproduction."[57] The writer REVOK summarizes this process, noting that early New York writers had "their own unique styles, and from those camps have come several generations of great writers."[58] Likewise, graffiti from the Los Angeles area has "evolved and improved over several generations of being passed down, each generation adding their own little elements into it."[59]

The mentor-protégé system reveals two distinct aspects of style in graffiti art. The first is a writer's personal style, expressed in the concept of having "a good hand"— that is, of being innovative and creative in the formulation of specific designs and of being skilled in executing them. The second aspect is style as convention, which can be defined as the "development of entire stylized alphabets, as opposed to designs for single letters, signatures, or names."[60] John Frow states that graffiti art "possesses a comprehensive vocabulary of evaluation ... and a distinctive technical vocabulary to describe its tools and activities."[61] In his instructions on "How to Read Graffiti," for example, graffiti writer Jason Dax Woodward enumerates several visual features that

distinguish a piece as exemplary of a particular style. He provides the following guidelines for the Wild style:

> Exaggeration and interconnecting letter play is the key to a good wildstyle piece. This interplay between the letters is often referred to as the flow of the piece. A wildstyle piece generally uses a number of arrows and arrowheads to create an indication of letter flow and to create energy. A well-executed arrow will exaggerate the flow of the lines.... Arrows that are excessive or awkward are considered poor form. So too arrows which appear to be illogically placed. Other design faults are arrows which do not increase dynamic letter flow, or go against letter flow.[62]

While providing a checklist for evaluating individual Wild style pieces, Woodward's analysis also reveals the praxis of the style itself. In fact, his discussion of the "letter flow" and "energy" that emerge from the use of arrows echoes the writer MARE 139's description, cited earlier in the chapter, of arrows as "the definitive mark of wild-style."[63] As indicated by the correspondence between these writers' observations, graffiti art styles exhibit certain features — e.g., exaggerated letters, flow, and logically placed arrows in the case of the Wild style — that both transcend a personal aesthetic and express a set of customs that is accepted and employed by the graffiti art community as a whole.

The idea that style embodies both individual and conventional aspects is not unique to graffiti art, of course. In his examination of style in Western art, Heinrich Wölfflin suggests that artists address the question of style "exclusively from the standpoint of quality" in order to answer the fundamental question: "Is it good?"[64] Woodward's evaluative checklist for the Wild style is one example from the realm of graffiti art. Unlike individual artists, however, the field of art history "conceives style primarily as expression, expression of the temper of an age and a nation as well as expression of the individual temperament."[65] Wölfflin therefore identifies three types of style in art: individual style, national style, and period style. Both national and period style can be analyzed in terms of diametrically paired traits. Works that exhibit a "linear style," with its emphasis on "the solid figure" and "the enduring form, measurable, finite," contrast with works that are characterized by a "painterly style," with its emphasis on "the changing appearance" and "the movement, the form in function."[66] Wölfflin similarly differentiates the "plane type" of painting, with "its relief-like quality," from the "recessional type," in which the "relief-like quality is destroyed" and "which is always combined with an impression of movement."[67] While these pairs of concepts might seem somewhat formulaic, Wölfflin stresses that this approach to national and period style in art in no way detracts from the individualism of the artist's own style: "The objection that, by accepting a development of

imagination determined by law, the significance of the artistic personality is destroyed, is puerile."[68]

The distinction that Wölfflin makes between individual style, on the one hand, and national and period style, on the other, applies to graffiti art as well. Certainly, the work of graffiti writers can be compared and contrasted on the basis of geography and time period. Equally germane to the discussion of style in graffiti art, however, is the distinction between personal style and what can be thought of as "iconic" style. Wölfflin differentiates among style types according to specific traits. These traits are expressions of a visual language that enables the viewer to look past the "different imaginative type" exhibited by two artists and to see "these two types re-unite in a common style."[69] In the same way, there is a visual language of graffiti art. Consider again the example of the Wild style, with its motion and energy, its convergence of letters and arrows. As Joe Austin comments, Wild style "letters were released from their duties as conventional carriers of meanings and became more or less autonomous symbols in a wordlike string."[70] Although the basic unit of graffiti art is the letter, the function of the letter is to communicate more than semantic content. Elaine Svenonius observes that "the language of art might be conceived as having a lexicon, not a lexicon of images but one of forms.... Forms are used to convey content in the sense of being expressive of feeling. There is an understood symbolism in which acute angles suggest pain, vertical lines suggest energy, horizontal lines suggest stability, diagonal ones movement, and so on."[71] There is likewise a lexicon of forms in graffiti art — forms that are "expressive of feeling" and that "convey content" other than the writer's tag alone. The way in which the letters are depicted in a piece — the use of rounded lines as opposed to straight lines, for example, or symmetrical forms versus asymmetrical forms — is indicative of a particular iconic style of graffiti art.

Determining the iconic style of graffiti art pieces is the focus of the classification system presented in this book — a system which is based on Panofsky's model of iconographical analysis. Examining the relevance of this model requires a closer look at how Panofsky's definitions of primary and secondary subject matter apply to graffiti art. Panofsky explains that "primary or natural subject matter ... is apprehended by identifying pure *forms*, that is: certain configurations of line and colour, or certain peculiarly shaped lumps of bronze or stone, as representations of natural *objects* such as human beings, animals, plants, houses, tools and so forth" (original emphasis).[72] In graffiti art, the pure forms of primary subject matter are the letters themselves. In contrast to primary subject matter, Panofsky notes that "when we loosely speak of 'subject matter as opposed to form' we chiefly mean the sphere of *secondary* or *conventional* subject matter, viz. the world of specific *themes* or *concepts*

manifested in *images, stories,* and *allegories*" (original emphasis).[73] The secondary subject matter of graffiti art can be considered from two perspectives. First, the letters form a particular word (i.e., tag). In this sense, the subject of graffiti art is the identity of the writer or of his or her crew. At the same time, the form of the letters and their aesthetic elements express a concept that is distinct from the identity of the writer and from his or her personal writing style. That concept is iconic style.

The application of Panofsky's theories of iconographical analysis to the identification of graffiti art styles seems to equate two seemingly distinct concepts: subject matter and style. Contrasting landscapes by the Dutch artists Meindert Hobbema and Jakob Ruysdael to those painted by the Flemish artist Peter Paul Rubens, Wölfflin observes that Rubens' treatment of the same subject "looks totally different: the earth rolls in vigorous waves, tree-trunks writhe passionately upwards, and their foliage is handled so completely in closed masses that Ruysdael and Hobbema in comparison appear as equally delicate silhouettists."[74] Wölfflin summarizes the differences between the artists' styles as "Dutch subtlety beside Flemish massiveness."[75] This comparison underscores the treatment of style and subject matter as distinct concepts. Style (whether personal, national, or period) addresses the question of *how* subject matter is portrayed, while subject matter addresses the question of *what* is being portrayed. Given this difference, how is it possible to apply Panofsky's model of iconographical analysis, with its emphasis on distinguishing meaning through the interpretation of subject matter, to the concept of style in graffiti art? The answer to this question hinges on the connection between graffiti art and iconographic tradition.

Style and Iconographic Tradition in Graffiti Art

In addition to their use of mentor-protégé systems, there is another similarity between the cultural production of graffiti art and that of Renaissance art. Chapter 1 referred to the language of signs and symbols, collected in emblem books and iconographic dictionaries, which artists use to convey meaning. Graffiti art also has its own visual language employed by writers to convey meaning. In order to execute a piece in a particular iconic style, the writer has to incorporate certain attributes which express that style. Style, of course, is generally thought to be closer to technique than it is to meaning in art. As evidenced in Wölfflin's comparison of Dutch and Flemish painters, the concept of style cannot be equated with meaning as these terms are generally applied in an art historical context. In the context of graffiti art, however, iconic style *is* meaning.

A helpful way of understanding the role of style in graffiti art is through a comparison of a graffiti art piece — any graffiti art piece — to Jan van Eyck's *Giovanni Arnolfini and His Bride*, the wedding portrait painted in 1434 and described in the previous chapter. As Catherine Soussloff explains, portraits by nature contain a "functional dialectic" in which "an indexical exteriority, or resemblance, to the person portrayed simultaneously coexists ... with a claim to the representation of interiority."[76] While exteriority deals with physical resemblance, the concept of interiority "relies on an understanding that ... the portrait is not only about adherence to an exterior reality."[77] Soussloff identifies this interiority aspect as iconic in the sense that, like early Christian icons, the portrait is thought to reify the essence of its subject. The portrait not only presents a visual likeness, but also communicates something of the various social, cultural, political, and spiritual frameworks upon which the life of the subject is constructed at that given point in time.

This dialectic can be applied both to the Arnolfini portrait and to a graffiti art piece. In the example of the Van Eyck painting, the image depicts the figures of Giovanni Arnolfini and Jeanne Cenami. At the same time, art historians, including Panofsky, have examined the various objects depicted in the work, such as the clogs, the mirror, the peaches on the window sill, and have reached the conclusion that these objects in sum signify that the painting is "about" the sacrament of matrimony. Frederick Hartt comments, "All of the objects in the room, represented with van Eyck's customary accuracy, are so arranged as to participate symbolically in the ritual" of the sacrament.[78] This theme — the sacrament of matrimony — represents the interiority, or essential meaning, of the portrait.

While the Van Eyck painting is a portrait, a graffiti art piece is essentially a self-portrait. The exteriority of a graffiti art piece — the notion of physical resemblance to a person — concerns the tag depicted in the work. The tag serves to identify the writer in the same way that more traditional portraiture presents a likeness of its subject. In addition, the interiority of a graffiti art piece — its essence — is revealed through the style of the piece. The choice of style is reflective of the writer as an individual. Just as importantly, the execution of a piece in a particular style reflects the writer's connection to the graffiti art community, his or her knowledge and mastery of, and respect for, its traditions and conventions. By giving visual expression to these traditions, the iconic style of the piece conveys the significance of the work, both within the visual context of the artwork and within the broader societal context of the graffiti art community.

In communicating the interiority of its subject, portraiture relies upon what Panofsky defines as "the world of specific themes or concepts"[79] that constitutes secondary or conventional subject matter. With regard to the graf-

fiti art piece and the Van Eyck painting, the fundamental themes and concepts of these works are purposively transmitted by the artists through a visual language that springs from a particular iconographic tradition. Van Eyck utilized a vocabulary of signs and symbols to communicate a specific theme at the behest of his patron. The significance of these individual signs and symbols transcends the boundaries of any one artwork. Consider the representation of the small dog in the Van Eyck portrait. This "traditional symbol of fidelity"[80] is also utilized in cemetery iconography, where, according to Douglas Keister, "in the Middle Ages dogs were often carved on tombstones to represent feudal loyalty or marital fidelity."[81] Likewise, the depiction of fruit, such as the peaches on the windowsill in the Van Eyck portrait, is a type of visual shorthand, indicating the subject's proven or presumed fertility. Consider the *Portrait of Mrs. Isaac Smith* (1769) by the American portraitist John Singleton Copley, which presents Mrs. Smith seated, her arms folded in her lap, her left hand holding an outsized bunch of green grapes — a "symbol of her fecundity."[82]

These examples are not meant to suggest that the visual language of iconography is invariable. For one thing, different symbols often carry the same meaning. Just as either peaches or grapes can represent fecundity, the depictions of a human foot, an ox, and a fern frond are all synonyms for humility.[83] The context of the artwork also needs to be taken into account. While the grapes in the Copley portrait signify fruitfulness, clusters of grapes in funerary art signify the wine of the Eucharist and are often depicted with sheaves of wheat in a "wine-and-bread combination ... intended to represent Holy Communion."[84] Indeed, while symbols individually convey meaning, their significance in a given artwork depends on other visual cues. Think back to the Van Eyck portrait. Art historians did not reach their conclusions by decoding in isolation the peaches on the windowsill, with their connotations of fertility, or the dog as symbol of fidelity. Rather, it was the juxtaposition of these features, not only with each other, but also with the countless other iconographic elements employed by Van Eyck to convey the theme of matrimony. The iconography of funerary art requires a similarly holistic approach. The combination on a funerary monument of a lamb, daisies, and rosebuds broken at the stem signals that the monument is for a child, with the broken buds symbolizing "the fragile beginnings of life, all too often cut tragically short."[85]

The visual language of iconography is not limited to the Renaissance period of art, or even to the genre of painting. Graffiti art also relies upon a visual language of iconography to communicate its themes. This particular language, however, differs from more traditional iconography in terms of its vocabulary. Whereas the visual language of cemetery iconography or of fif-

teenth- and eighteenth-century portraiture is comprised of iconic *objects* that reflect specific themes or concepts, the graffiti writer's language is comprised of what can be described as iconic *features* that similarly reflect specific themes or concepts — in this case, the style of a graffiti art piece. Examples of these features, which will be discussed in the following chapters, include the types of lines used to form the letters of the tag, the width of the letter strokes, the number of colors selected, and the dimensionality of the letters. Arguably, each of these features alone does not convey meaning in the manner of iconic symbols. While the depiction of a dog signifies fidelity, there is no equivalent translation for the width of a letter stroke. But, as is the case with both portraiture and funerary art, the visual language of graffiti art needs to be read holistically in order to understand the message conveyed by the artist. It is the combination of iconic features within a graffiti art piece that communicates to the viewer the style of the piece — that enables the viewer to grasp the specific themes and concepts that constitute secondary subject matter in this art form.

Although the vocabularies vary among different iconographic traditions, parsing the visual language of iconography entails the same process of understanding the visual elements in an artwork in terms of their thematic significance. This transition from a simple description of raw forms, features, or objects in a composition (i.e., primary subject matter) to an analysis of how these forms, features, and objects are used to express the iconographic meaning of the composition (i.e., secondary subject matter) is the goal of Panofsky's model of iconographical analysis. As Panofsky explains, the dichotomy between primary and secondary subject matter applies not only to the thematic meaning of an artwork, but also to the tools necessary for identifying that meaning. Take two images of a dolphin, one on a funerary monument, the other on an advertisement for an aquarium. On one level, these images depict the same thing. But once the lens of iconographical analysis is trained on the monument, this image assumes an entirely different meaning:

> On funerary monuments, dolphins are often intertwined with an anchor, which was an early disguise for a cross. Dolphins symbolize salvation (in mythology they are often portrayed as rescuing sailors), transformation (Bacchus was said to have turned drunken sailors into dolphins), and love (they are widely thought of as friendly and playful marine mammals). Since early artists rarely saw real whales, their depiction of the biblical fable of Jonah and the Whale usually portrayed a dolphin swallowing Jonah.[86]

Recognizing this transformation from primary to secondary subject matter entails two crucial steps. For Panofsky, "correct iconographical analysis ... presupposes a correct identification of the motifs"[87] of primary subject matter — in other words, the ability to see that the animal depicted is, in fact, a dolphin.

Moreover, the viewer need only "be familiar with the practical world of objects and events"[88] to make this identification. The second step, however, requires more specialized tools. The shift from primary to secondary subject matter "presupposes a familiarity with specific *themes* or *concepts* as transmitted through literary sources, whether acquired through purposeful reading or by oral tradition" (original emphasis).[89]

The concept of literary sources as the "equipment for interpretation"[90] for iconographical analysis needs to be examined in greater detail. As with the dolphin example, the meaning of symbols, and therefore of the artworks in which they appear, can often be traced to literary sources. Seeing a dolphin in terms of its symbolic or iconographic meaning requires familiarity with at least two literary sources: Greek mythology and the Bible. To be sure, one can be familiar with specific themes without having read the relevant texts — a fact that lies at the heart of Panofsky's recognition of both "purposeful reading" and "oral tradition" as the tools of iconographical analysis. Likewise, viewers can consult an iconographic dictionary or emblem book to understand primary subject matter (e.g., the depiction of a dolphin) in terms of its iconographic meaning (e.g., the depiction of a dolphin as a symbol of salvation).

The myriad ways in which a viewer can gain familiarity with the themes and concepts of secondary subject matter — purposeful reading of specific texts, oral tradition, dictionaries, and emblem books — points to a broader, and arguably more significant, function of literary sources. This role has less to do with the source of an artwork's thematic content as with the verification of that content. The interrelationship between primary and secondary subject matter within an artwork points to the meaning of the artwork, and deciphering this meaning requires the viewer to translate the visual language of iconography. But the applicability of iconographical analysis is not limited to artworks that are based on a specific text or that express literary themes. Rather, the purpose of literary sources is to provide the viewer with a means of substantiating the themes depicted in an artwork. As noted in chapter 1, discerning the meaning of an artwork becomes an exercise in subjectivity if secondary subject matter themes and concepts cannot be ascertained outside the context of an individual artwork. Accordingly, Panofsky includes familiarity with literary sources among the conditions for "correct" iconographical analysis. These sources provide the means of establishing the link between primary and secondary subject matter outside the context of the artwork itself.

The use of literary sources in establishing the interconnection between primary and secondary subject matter also applies to graffiti art. Although the secondary subject matter of graffiti art — the range of styles in which graffiti art pieces can be executed — is not based on literary texts, recognition of

style does depend on familiarity with the traditions that are passed down from graffiti writer to graffiti writer. Indeed, the association between pre-iconographic features and iconographic meaning in graffiti art is not arbitrary. In order to create a piece in a particular style, a graffiti writer has to employ a visual language of iconography that communicates that style. Situating graffiti art within Panofsky's model of iconographical analysis, there is an interconnection between primary and secondary subject matter in graffiti art pieces, and this interconnection exists outside the context of the pieces themselves. In other words, graffiti art falls within an iconographic tradition, and style is the expression of that tradition.

The Cultural and Iconographic Contexts of Graffiti Art

In his survey of Western art "isms," Stephen Little identifies four non-mutually exclusive umbrella categories into which major art movements, and their representative artists, can be grouped.[91] The first of these categories is "a trend within the visual arts" [TVA], encompassing isms that "are specific to the visual arts."[92] Among the various isms in this category is Renaissance Naturalism, with Van Eyck's *Arnolfini* portrait cited as an exemplary work of this particular art movement. Twentieth-century art isms are most often classified by Little as a type of "artist-defined movement" [ADM]. He explains: "The 20th century was the high point of isms defined and promoted by artists themselves. These isms can be approached as relatively self-contained groups of artists sharing and defining common goals and values.... These are often the easiest isms to discuss and define accurately."[93] Both Abstract Expressionism and Fauvism are described as ADMs.

Abstract Expressionism and Fauvism are also two art movements frequently associated with graffiti art. As graffiti was reconfigured as art, it became the subject of aesthetic analyses that discuss the visual qualities of the work and the creative process. Many of these investigations are photo-documentaries, where images of graffiti art are interspersed with quotations from graffiti writers themselves. The contemporary British graffiti writer Banksy, for instance, has published a number of volumes of his artwork and commentary, the first of which was entitled *Existencilism*.[94] Other aesthetic examinations attempt to trace a visual lineage between graffiti and other genres of art. Graffiti has been "romanticized as folk art,"[95] and crowned "the romantic heir to abstract expressionism and pop art."[96] In *The Faith of Graffiti*, Norman Mailer suggests that graffiti writers "are unwittingly enriched by all art which

offers the eye a family resemblance to graffiti"—a lineage which includes "Jackson Pollock and the abstract graffiti of his confluences and meanderings" and "Matisse's blue and green Dance. (Matisse's limbs wind onto on another like the ivy-creeper calligraphies of New York graffiti.)"[97] The Janis Gallery catalogue published in conjunction with its 1983 "Post-Graffiti" show also suggests that "urban-bred, the graffiti artist continues the tradition of Pop Art which he admires."[98] As Susan Stewart points out, "Thus this show announces the death of graffiti proper (hence 'post-graffiti') and the rejuvenation of the Pop Art tradition which the Janis Gallery was instrumental in presenting in the first place."[99]

The idea of graffiti art as a descendent of avant-garde movements is problematic on numerous levels. In his treatise "How to Read Graffiti," graffiti writer Jason Dax Woodward situates graffiti within the "narrative of western Highbrow art ... not with the view to elevate graffiti" but rather to explain "the colonialsation (sic) of graffiti and the subsequent misrepresentation of the artform."[100] Commenting on Norman Mailer's analogies between graffiti and art movements such as Fauvism, Ivor Miller writes: "Having made few attempts to talk to writers about what they were doing, Mailer's suggestion that they were influenced by Matisse's painting betrays how little he understood their actual culture."[101] At the core of this misunderstanding is the tendency to construct a graffiti art tradition based on perceived visual similarity while ignoring what Susan Stewart describes as the "distinctive codes of style and behavior ... which are readily recognized by those who practice graffiti."[102] The problem with the misrepresentation of graffiti art is twofold. First, the analogies between graffiti art and avant-garde movements pigeonhole graffiti according to norms and precepts that have little actual relation to the world of graffiti art. Second, the emphasis on visual likeness overlooks not only the role of culture and tradition in the production of graffiti art, but also the source of this tradition.

Certainly, graffiti writers constitute the type of "self-contained groups of artists sharing and defining common goals and values"[103] that Stephen Little associates with ADMs such as Abstract Expressionism and Fauvism. In fact, it is the regenerative process of creating and critiquing, as well as writers' continued focus on the "aesthetic considerations" and "appreciation of design factors" first fostered by organizations such as UGA,[104] which led to the development of style in graffiti art. Despite these shared aesthetic goals and values, writers were not inclined to follow the mandate of UGA to "elevate" graffiti art through an association with the fine art realm. The resistance of graffiti writers to accept the labels or patronage of the art world makes it all the more ironic that, while ADMs are deemed "the easiest isms to discuss and define accurately,"[105] comparisons between graffiti art and twentieth-century

art movements tend to obscure, rather than illuminate, the iconographic traditions that are responsible for the development of graffiti art style.

The relevance of Panofsky's model of iconographical analysis to graffiti art style hinges on the process of moving from the realm of describing visual features of an artwork (primary subject matter) to that of understanding the significance of these features (secondary subject matter). This interpretive process underscores the importance of viewing the visual aspects of an artwork not only within the context of the work itself, but also through the prism of the culture that created it. The connection between iconographical analysis and graffiti art style therefore requires the viewer to reconsider the concepts of iconographic tradition and style. Just as the applicability of these concepts extends beyond the Renaissance period of art, the language of iconography is not limited to object-based signs and symbols. Although the vocabulary differs from other iconographic traditions, the significance of what is presented in a graffiti art piece — the meaning imparted through its iconic style — can nonetheless be understood by translating the visual language employed by the artist.

3

Graffiti Art in a Classificatory Framework

The goal of the classification system presented in this book is to enable image cataloguers who have no background knowledge of graffiti art to identify the style of a graffiti art piece by distinguishing certain visual characteristics. The system thus corresponds to Erwin Panofsky's theories of iconographical analysis as a process: cataloguers move from a description of the basic components of a piece (primary subject matter) to an analysis of the role these components play in the formation of a specific graffiti art style (secondary subject matter). The ability to apply Panofsky's theories as a process model is contingent on graffiti art's iconographic tradition — the concrete, verifiable relationship through which the visual language of graffiti art communicates the underlying meaning of a piece.

While Panofsky's model of iconographical analysis provides the classification system with its theoretical framework, the system also draws on other classificatory frameworks as well. Indeed, its development was informed by theories and models ranging from Henry Evelyn Bliss's "Principles of Classification for Libraries" to B.C. Vickery and S.R. Ranganathan's approaches to facet analysis. By situating graffiti art within these various classificatory models and frameworks, this chapter chronicles the initial steps in the development of both the content and structure of the classification system. These steps sought to address the central questions: (1) what elements of graffiti art constitute primary subject matter; and (2) how can these elements be simultaneously isolated from and viewed within the context of distinct graffiti art styles?

Operational Models

As discussed in chapter 1, the information studies community's adaptation of Panofsky's theories — what is referred to as the Panofsky/Shatford model — centers on the question of which types of image access points would best address user needs: the "generic of" associated with primary subject matter, or the "specific of" and "abstract or about" considered to be secondary subject matter. This level-based interpretation of Panofsky's theories is especially problematic when applied to artworks that are not part of an iconographic tradition. In these situations, there is no means of establishing whether there is a constant relationship between primary and secondary subject matter. Without this relationship, and without recourse to "literary sources" or other means of documentation, there is no system of checks and balances guiding the selection of image access points. These checks and balances prevent the situations described in chapter 1, wherein primary and secondary subject matter are treated as de facto categories approximating an artwork's pre-iconographic "ofness" and iconographic "aboutness" as subjectively interpreted by an image indexer or cataloguer.

While the selection of image access points is never completely objective, iconographic images benefit from the ability to apply Panofsky's theories as a process-based, rather than as a level-based, model. In the process model, the determination of image access points is informed by the process of iconographical analysis — by moving from a description of primary subject matter features to an understanding of how those features illustrate the meaning of the artwork depicted in the image. Rather than disparate attributes characterizing discrete levels, image access points in the process model confirm the relationship between pre-iconographic description and iconographic significance by linking primary and secondary subject matter.

The application of Panofsky's theories as a process model is demonstrated in the classification system for graffiti art styles presented in this book. The system identifies how certain features of graffiti art are applied in the formation of graffiti art styles by illustrating the interrelationship between primary and secondary subject matter. This aspect of the system's functionality follows the model of two classification systems, geared toward more traditional genres of art, which are based on Panofsky's principles: ICONCLASS and Karen Markey's thematic catalog for Northern European artworks.

ICONCLASS (from ICONographic CLASSification system) was developed by the art historian Henri van de Waal. What began in 1947 as a system for organizing a collection of postcard-sized reproductions of Dutch art metamorphosed into an alphanumeric classification system that Van de Waal described as "an elaborate filing cabinet in which there is room for the whole

array of subjects, themes, and motifs in the art of the Western world."[1] This filing cabinet, as Van de Waal originally conceived it, was divided into nine main classes: Religion and Magic; Nature; Human Being, Man in General; Society, Civilization, Culture; Abstract Ideas and Concepts; History; The Bible; Literature; Classical Mythology and Ancient History. Under the direction of Leendert Couprie, a student of Van de Waal's and a subsequent administrator of ICONCLASS, a tenth class ("0") was subsequently added to cover non-figurative (abstract) representations.[2]

Of the original nine classes, the first five express "general subjects," while the remaining four contain "special subjects" whose identification is tied to specific literary or historical sources.[3] The classificatory options presented in these two types of classes mirror Panofsky's distinction between primary and secondary subject matter. The ability to classify the subject matter of an image according to either primary (pre-iconographic) or secondary (iconographic) subject matter displays what J.P.J. Brandhorst refers to as "the system's basic duality."[4] He offers as an example a comparison between the ICONCLASS notation "46C1491 bolting draught-animals" and "95A(HIPPOLYTUS)68 death of Hippolytus: he is killed when the horses that draw his chariot bolt at the sight of a bull-shaped monster."[5] While the first notation could cover any instance where "bolting draught-animals" are depicted, the second notation refers to the portrayal of a specific episode from Greek mythology. The two notations also provide evidence of the shift inherent in iconographical analysis from the identification of objects based on practical knowledge to the recognition of a theme grounded on literary sources.

The interplay of Panofsky's modes of analysis is also evident in the alphabetical index that accompanies the classificatory volumes of ICONCLASS. On the one hand, the index can direct the user to a specified notation or entry in the classification system. Working with an image known to depict the death of Hippolytus, for example, an indexer or cataloguer could utilize the alphabetical index to discover the notation for this theme, rather than maneuvering through the hierarchical levels of the classification system itself. On the other hand, the alphabetical index also collocates primary and secondary subject matter in what Leendert Couprie describes as "iconographic clusters."[6] Consider the example he provides of the keyword "mirror." Looking up this term in the ICONCLASS index, the user is guided not only to every instance of a mirror as primary subject matter in the classification system (e.g., "mirror 31A511"; "hall with distorting mirrors 43A341"; "convex mirror (instrument of draughtsman) 48C5253"), but also to notations of iconographic themes involving mirrors (e.g., "Minerva throws the flute away after having seen her face mirrored in the water 92C2521"; "Socrates using a mirror to teach a youth self-knowledge 98B(SOCRATES)51").[7] An

indexer unsure of the secondary subject matter of an image, but noting the presence of a mirror in the scene, could look up "mirror" in the index and discover a range of iconographic themes with potential applicability to the image in question.

Although both primary and secondary subject matter can be accommodated in ICONCLASS, emphasis is placed on providing image access according to the latter whenever possible, reflecting the system's use in iconographic research collections. Van de Waal considered "one of the rules of the system" to be that "subjects belonging to the special divisions six to nine are never indicated by notations from the general divisions one to five."[8] Iconographers and researchers have supported this approach. As Brendan Cassidy observes:

> No amount of description will reveal the subject of a painting if that subject is not already known from its title, or from a literary or visual source. Pre-icono-graphic description might be resorted to when identification has been unsuccessful. It is required only where the subject is not known, whether because it is not derived from an identified text, or the image is not part of a known iconographic tradition, or where the artist has left no information about what he or she intended to represent.[9]

And just as the assigning of extensive and (most likely) discursive notations based on pre-iconographic description serves little purpose when it does not lead to subject identification, the opposite is also true. Karen Markey points out the redundancy of pre-iconographic description in cases where the subject is obvious or familiar: "When a reproduction is assigned a subject heading such as 'Agony in the Garden' (that is, one that describes the work's secondary subject matter), a collection user who knows the biblical account of the Agony in the Garden has a general idea of the primary subject matter depicted in the work."[10]

Despite a consensus that image access based on secondary subject matter is preferable in iconographic research collections, it is also recognized that primary subject matter description can be crucial in furthering iconographic research. Observing that both the nature and audience of iconographic research collections dictate that image descriptions "include everything that is iconographically and iconologically significant," Brendan Cassidy acknowledges that these elements are "not always apparent": "Often we discover what is iconographically meaningful only after research has demonstrated it. Before it was recognized that sunlight passing through windows and glass vessels found in Netherlandish images of the Virgin Mary were allusions to the Virgin birth, such visual metaphors, if noticed at all, would have been seen as conventional props of little importance and possibly ignored in descriptions."[11] Deciding what to index therefore presents a type of chicken-egg conundrum. On the one hand, it seems counterproductive to exhaustively record aspects

of primary subject matter that are already accounted for in secondary subject matter entries, especially since the users of iconographic research collections are more interested in the iconographic implications, rather than the pre-iconographic descriptions, of works of art. On the other hand, recognition of secondary subject matter is predicated on the accurate recording of primary subject matter details.

In addition to overlooking potentially significant pre-iconographic features, image access based solely on iconographic subjects presupposes that all users have knowledge of or recourse to the relevant literary sources which elucidate secondary subject matter. Both Karen Markey and Sara Shatford have documented the challenges that non-specialists face in accessing materials in research-oriented collections, with Shatford noting that "if a user understands only pre-iconographical meaning, he cannot formulate his needs in iconographic terms."[12] Consider John Eakins and Margaret Graham's search example, described in chapter 1, of a theology student seeking "a picture of a female saint with red hair."[13] While a theology student might be able to match a name to this depiction, the same could not be assumed of the non-specialist user. If image access were provided in iconographic terms only, then there would be a cognitive gap between the type of primary or pre-iconographic search terms at the disposal of the non-specialist and the keywords actually applied to the images in the collection.

Karen Markey proposed bridging this cognitive gap by providing access to iconographic images using not only secondary subject matter, but also pre-iconographic description, specifically through the use of "thematic catalogs" that would "help searchers translate primary subject matter into secondary subject matter."[14] In order to test the feasibility of developing such catalogs, Markey asked non-specialists to describe in pre-iconographic terms objects, expressional qualities, and events depicted within a sample of images of Northern European artworks. Composite descriptions were created using the non-specialists' terms; the descriptions were then tested by iconographers to see if they could, without having access to the actual image, recognize the corresponding iconographic theme. Cases where this identification was successful formed the basis of Markey's catalog, in which components of the composite pre-iconographic descriptions are listed alphabetically according to a keyword-in-context format. These keywords are then linked to the secondary subject matter to which they pertain. For example, the entry for the key word "leaning" appears in the primary subject matter description "Joseph, thoughtful, *leaning* on cane;" this description, in turn, leads the user to the secondary subject matter theme "nativity."[15] The catalogue also provides secondary subject matter entries under which are listed all relevant pre-iconographic descriptions for a given theme. Therefore, the user could look up "nativity"

to find which elements of primary subject matter are associated with this theme.

Like ICONCLASS and Markey's thematic catalog, the classification system for graffiti art styles can be used to link primary subject matter elements to secondary subject matter themes. As will be described in greater depth in chapter 4, indexers working with a graffiti art image could use the system's alphabetical index to access the entry for a given style by looking up any one of the primary subject matter features associated with that style, much like a user looking up the term "mirror" in the ICONCLASS index would be guided to notations of iconographic themes involving mirrors. In this sense, the classification system follows Markey's prescription that access to images — even those within an iconographic tradition — should be provided at both the pre-iconographic and iconographic levels.[16] It also reflects the underlying concept of the process model — namely, that the relationship between primary and secondary subject matter should be elucidated within an image access system that is based on Panofsky's theories.

Although the classification system encompasses both primary and secondary subject matter, its primary emphasis is secondary subject matter — i.e., graffiti art style. From a theoretical perspective, this emphasis reifies the concept of Panofsky's process model. Just as the purpose of iconographical analysis is to ascertain the meaning of an artwork, the classification system is similarly focused on the identification of the style of the piece depicted in a graffiti art image. From a classificatory perspective, an emphasis on secondary subject matter follows Helene Roberts's recommendation that information professionals should move "beyond the indexing of an image to the indexing of concepts about that image."[17] In the context of the classification system, graffiti art style is the organizing concept around which image access is based. It is not intended as a tool for classifying individual images per se but as a tool for identifying the style group or category to which an image belongs.

While Panofsky's process model is illustrated in the classification system's use of pre-iconographic description to decipher iconographic meaning, the inscrutability of most graffiti artworks adds another impetus for linking primary and secondary subject matter. The challenges of accessing iconographic images and the subsequent need to provide pre-iconographic descriptors concerns not only non-specialist users, but also non-specialist image cataloguers. The selection of primary and secondary subject matter as access points depends on the image cataloguer's ability to shift from a pre-iconographic description to an iconographic understanding of an artwork — a challenge magnified in the context of nonrepresentational or abstract artworks such as graffiti. Brendan Cassidy cited the absence of iconographic tradition and unknown artist

intent as conditions in which "pre-iconographic description might be resorted to."[18] Graffiti art is part of an iconographic tradition, and artistic intent is expressed through the style of a piece. Yet the ability to determine which style is exhibited in the piece, as indicated by specific visual hallmarks, is beyond the purview of most image cataloguers.

Consequently, the classification system for graffiti art styles operates as a guide for non-specialist cataloguers. In order to ascertain the secondary subject matter of an image (i.e., the style of the piece), cataloguers first identify primary subject matter elements based on their familiarity "with the practical world of objects and events"[19] and then utilize the classification system to establish the relationship between these elements and specific styles. Recalling the role played by emblem books and iconographic dictionaries, the process of transcribing and organizing the hallmarks which define graffiti art styles results in the classification system serving as a type of iconographic handbook for graffiti art.

The Consensus of Experts

Panofsky's analytic model was intended for artworks that fall within an iconographic tradition — a tradition that presupposes the presence of both primary and secondary subject matter within an artwork and the ability to verify the interconnection between the two. Both of these factors should be the basis of any adaptation of Panofsky's model for use in image access. Consider, for example, Karen Markey's choice of European artworks from 1250–1425 in developing and testing her thematic catalogue because of her "great certainty that the content depicted in these visual images exemplified primary subject matter and secondary meaning."[20] Moreover, she constructed the catalogue using only the pre-iconographic composite descriptions whose related subjects were confirmed by iconographers.

Although wider in scope than Markey's catalogue, ICONCLASS also substantiates the connections between primary subject matter motifs and iconographic themes, in this case by citing precedents. Leendert Couprie notes that "each part of the classification [system] has its counterpart in a bibliographical volume," so that "references to iconographic literature are found under the same notations" as the subject matter itself.[21] Take the example of a researcher who examines a painting and observes that there are numerous paintings in the background of this image, a scenario described as a "picture within picture."[22] Having gone first to the "picture within picture" entry in the classification system, the researcher could then use the corresponding classification number to locate "picture within picture" in the bibliography as well.

Here would be a list of scholarly books, articles, exhibition catalogs, and iconographic dictionaries that discuss the occurrence and significance of this pictorial element.

The classification system for graffiti art styles places similar emphasis not only on demonstrating but also on verifying the interrelationships between primary and secondary subject matter. Because it is intended to enable cataloguers to make a "correct" determination of secondary subject matter, the system relies on the knowledge of experts in recognizing which aspects of primary subject matter are indicative of certain graffiti art styles. Therefore, while the process of moving from primary to secondary subject matter within the classification system is based on Panofsky's process model, the actual content of the classification system is based on information provided by graffiti art experts.

A research project was designed to collect and transcribe graffiti experts' views on how the iconic language of graffiti art is manifested in specific graffiti art styles. "Experts" were defined in this context as individuals who possess knowledge of graffiti art styles and the aesthetic components that define these styles. This would include, on the one hand, actual practitioners of graffiti art, and, on the other hand, non-practitioners, such as artists, historians, and visual resource curators, who are familiar not only with graffiti art styles but also with the vocabulary used to describe these styles within the graffiti art community. Data from graffiti art experts were collected using a two-part, e-mail-based questionnaire. In the first questionnaire, experts were asked to name different styles of graffiti art and to answer multiple-choice and open-ended questions about each of these styles. They were also asked to provide visual examples (in the form of jpeg files or a web page link) of each style they discussed. Their responses and sample images were then analyzed and used to formulate individual follow-up questionnaires. These follow-up questionnaires were customized for each expert and were based on the information that he or she had provided in the first questionnaire.

The experts themselves were initially identified from the Art Crimes web site, an online graffiti resource center. The following three criteria were used to narrow this sampling frame: residence in the United States or Canada; a link to a personal web page; and an e-mail address listed in the Art Crimes directory. While Art Crimes exhibits thousands of images of graffiti art, most of these images are identified only by the writer's tag, and no contact information is provided. Writers who can be commissioned for projects, and are therefore amenable to being contacted, are listed under a separate directory of "Muralists and Designers." Some of the individuals listed in this directory, however, fall into the category of web page or graphic designers, not graffiti writers. For this reason, personal web pages were examined in order to deter-

mine whether the individual qualified as a graffiti art expert as previously defined. In addition to writers in the Art Crimes directory, other experts were recruited through a snowball procedure. For example, one expert, identified through Art Crimes, recommended another expert, who, in turn, provided contact information for two other experts; all four of these individuals agreed to participate in the research project.

A contact letter was e-mailed to experts who met the three criteria. The letter provided background information about the research project, describing its purpose, the format of the two questionnaires, and the use of the data collected in developing and testing the classification system. It also included a project consent form that detailed measures taken to ensure the confidentiality of questionnaire responses. Those who elected to participate in the project were instructed to e-mail back the consent form to the researcher as a means of indicating that he or she had read and agreed to the terms of the study. Experts who returned the project consent form were then e-mailed the first questionnaire. A $50 honorarium (U.S. currency) was offered as an incentive to participate.

A total of 11 graffiti art experts —10 men and one woman — completed the two-part questionnaires. Nine of these individuals were graffiti writers. Two of the writers came of age during the early stages of the graffiti art movement itself, honing their skills in Philadelphia and New York from the mid-to-late 1970s. Others began writing in the 1980s and 1990s. Some of the writers recalled their introduction to graffiti art, usually in junior high or high school. One "started writing graffiti in the 8th grade, in 1985 after seeing a few movies with graffiti, and seeing an occasional example at the local school," while another was inspired by the graffiti he saw on train trips to Washington, D.C. Trains were also significant in a Brooklyn writer's immersion in graffiti culture:

> Brooklyn was a very difficult place to grow up because of the poverty, drugs violence things of that nature. For youths at the time the need for acceptance and being known for something unique was really the driving force behind people writing graffiti. It was also something that I admired — Seeing beautiful pieces of artwork on subway cars. Graffiti was like something that not everyone could do. This is what made it special.... I did graffiti on subway cars [and] handball courts for about 5 to 6 years then I retired from illegal graffiti and focused my efforts on canvas and legal murals.

Two other writers also made the point that they had "retired from illegal graffiti," electing instead to create paintings or murals on commission or to pursue endeavors entirely unrelated to art or graffiti.

The remaining two experts who completed the questionnaires straddled the boundary between practitioner and non-practitioner. One was a self-

described "garden-variety painter" who curates an online archive of graffiti art images. The other expert was also an artist. He explained, "I consider my own work to be at the margins of what is traditionally regarded as graffiti, but I take very seriously the obligation to know the history of the art from which I deviate and operate." Although not writers themselves, both of these experts had strong ties to the graffiti community and were well-versed in graffiti art styles ranging from the earliest manifestations to contemporary examples.

Considering that nine of the 11 experts were writers, the 10:1 ratio of men to women within the group is not surprising. As it is pointed out on the Art Crimes site, "There have been prolific female writers throughout modern graffiti history, but not very many of them."[23] Tracing the role of women writers in the development of graffiti art, Jack Stewart identifies BARBARA 62, EVA 62, and MICHELLE 62, known collectively as "the three graces," as the first women to tag in the early 1970s.[24] The paucity of women writers is attributed to the dangers — both real and perceived — associated with graffiti art. Stewart notes that in the early era of New York subway graffiti, women were dissuaded from writing by their boyfriends out of concern for their personal safety. Painting train cars involved dangers as regular and sequential as hurdles on a track: entering the railway yards or navigating the train tracks and tunnels to get to the lay ups at the end of the line; maintaining balance while tagging or piecing; avoiding arrest; and avoiding the third rail that powers the rail lines. Added to these real dangers was the false assumption that graffiti art culture is inextricably tied to gang violence and turf warfare — a further deterrent for many potential women writers.[25]

Nonetheless, women are becoming increasingly visible participants in this culture. Steve Grody observes that, although "the graffiti underground is still a predominantly male bastion, women continue to make inroads and are no longer a novelty at walls around the city."[26] Nicholas Ganz's *Graffiti Woman*, a history of women graffiti writers from around the world, provides ample evidence.[27] Indeed, Ganz suggests that, "by focusing almost exclusively on men," books and films about graffiti have perpetuated the myth that women writers are a rare phenomenon.[28]

Basing the classification system on data collected from experts provides verification as to what constitutes primary subject matter in graffiti art and how it indicates distinct, iconic styles. While verification is a crucial part of Panofsky's model of iconographical analysis, an equally important component in the development of a classification system is consensus. In his treatise "Principles of Classification for Libraries," Henry Evelyn Bliss stresses that "knowledge should be *organized in consistency* with *the scientific and educational consensus*, which is *relatively stable*" (original emphasis).[29] The phrase "the sci-

entific and educational consensus" refers to "the organization of experience, the organization of knowledge, the organization of thought, the organization of will, purpose, or effort, the consensus of communal minds, and the consensus of educational, moral, and institutional minds."[30] Bliss therefore emphasized that the presence and ordering of subjects in classification systems should synthesize the ideals, beliefs, and approaches of individuals and groups who are connected to and knowledgeable about those subjects. The benefit of basing classification systems on the consensus of experts is that the order proposed by the system is demonstrable and, consequently, stable, exhibiting what Bliss identified as a certain "validity and permanence."[31]

To ensure that the classification system reflects the consensus of experts, the data collection process functioned as a modified Delphi method. Developed during the 1950s by the RAND Corporation for decision-making in the armed forces of the United States, the Delphi technique provides "a method for structuring a group communication process."[32] Unlike many forms of group-decision-making, the Delphi method is implemented through questionnaires, thereby insuring the anonymity of the participants. This method, however, differs from traditional questionnaires because results from the first round of responses are incorporated into subsequent rounds of communications. As Ian Mitroff and Murray Turoff explain, "What distinguishes the Delphi from an ordinary polling procedure is the feedback of the information gathered from the group and the opportunity of the individuals to modify or refine their judgements based upon their reaction to the collective views of the group."[33]

As with the Delphi method, graffiti art experts' questionnaire responses were incorporated into subsequent iterations of the first questionnaire. Likewise, the experts were often asked to comment on the opinions of fellow (anonymous) participants, and they were able to alter their own responses after reading these opinions. But, unlike most applications of Delphi techniques, the questionnaires were not distributed in formal rounds. As a result, the experts did not respond to the questionnaires simultaneously, nor did they receive identical iterations of the first questionnaire or of the follow-up questionnaires. The differences among the follow-up questionnaires stem from the fact that the experts themselves chose which styles to discuss in the first questionnaire, based on their own knowledge and expertise. The variations among the iterations of the first questionnaire, however, reflect the ongoing process of facet analysis which was applied to the experts' questionnaire responses.

Graffiti Art and Facet Analysis

The classification system for graffiti art styles is based on the idea that certain visual characteristics in graffiti art point to specific, iconic styles. This idea can be distilled into a simple formula: A1 + A2 + A3 etc. = B, wherein each instance of "A" is a distinct component of primary subject matter, and "B" is the secondary subject matter or theme that these components collectively express. This is not to suggest that graffiti artworks themselves are formulaic. Indeed, how each instance of A1, A2 and so forth are visually interpreted will vary from artist to artist. Rather, this model is patterned on Panofsky's holistic approach to understanding the meaning of an artwork. In order to perceive this meaning, the features of an artwork need to be considered both individually and integrally. Artworks, such as graffiti art pieces, which are part of an iconographic tradition, are amenable to this model precisely because the relationship between "A" and "B" is fairly constant, as demonstrated through the ability to confirm this relationship outside the context of an individual work.

At the most basic level, the purpose of the questionnaires sent to the graffiti art experts was to find out what constitutes the "A's" and "B's" of graffiti art. This entailed not only identifying which components comprise graffiti art generally (the "A's"), but also compiling a list of established graffiti art styles (the "B's"). The questionnaire was also meant to uncover the interrelationships between the hallmarks of graffiti art and individual styles — to see which combination of "A's" are used in the creation of a particular "B," according to the consensus of the experts. In order to incorporate this data within a classification system, however, the experts' responses had to be examined not only within Panofsky's model of iconographical analysis, but also within a classificatory framework. That classificatory framework is facet analysis.

The concept of facet analysis in classification was first introduced by S.R. Ranganathan in India and was subsequently adapted in Great Britain by the Classification Research Group (CRG). B.C. Vickery, one of the CRG's founding members, defines "the essence" of facet analysis as "the sorting of terms in a given field of knowledge into homogenous, mutually exclusive facets, each derived from the parent universe by a single characteristic of division."[34] That is to say, any given subject can be analyzed in terms of its various features. These features are grouped into facets — identified divisions of the original subject area. The principle of the "single characteristic of division" simply means that these divisions or facets should embody only one aspect of, or approach to, the subject area at a time.

Facet analysis can be applied to any subject area. Consider the example of "Buildings." A building can be considered from many different perspec-

tives — its function, the style in which it was designed, and the material from which it was constructed, to name only a few. Each of these aspects — Function, Style, and Material — constitutes a facet of the subject area "Buildings." While each facet is applicable to buildings in general, any single building will exhibit particular features with regard to these facets. Buildings can be residential, industrial, or civic (Function). They can be Gothic, Rococo, or Neoclassical (Style). They can be constructed of stone, wood, or concrete (Material). The specific characteristics or terms connected to each facet are referred to as foci. Within the subject area "Buildings," stone, wood, and concrete are foci of the Material facet.

Facet analysis can be similarly applied to the topic of graffiti art styles. "Graffiti Art Styles" is, in the terminology of Vickery and the CRG, the "parent universe" or subject area of the classification system.[35] It is also what Ranganathan identified as "a compound subject."[36] According to Ranganathan's theories of facet analysis, each compound subject is comprised of a "Basic Facet" — a primary subject field — that is either explicitly contained in, or can be implicitly deduced from, the name or title of the compound subject itself. He provides as an example of an implicit basic facet the relationship between a book about the "Structure of protein" and the basic facet of "Chemistry."[37] "Graffiti Art Styles," in contrast, exemplifies a compound subject with an explicit basic facet — namely, "Graffiti Art."

Figure 1. Classificatory relationship between style and graffiti art

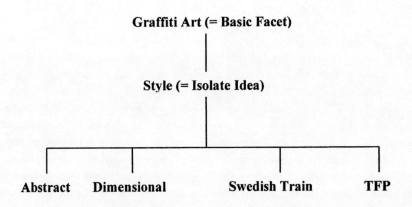

Graffiti Art (= Basic Facet)

Style (= Isolate Idea)

Abstract Dimensional Swedish Train TFP

(Partial array of graffiti art styles)

The concept of "Styles" within the context of "Graffiti Art" presents another classificatory relationship, that of "Isolate Idea" to "Basic Facet." Ranganathan defines an "Isolate Idea" as an "idea or idea-complex fit to form a component of a subject, but not by itself fit to be deemed to be a subject."[38] In practical terms, style is a component or an aspect of the subject of graffiti art. This aspect, in turn, can be examined in relation to its own array of isolate ideas. In this case, the division into isolate ideas of the subject "styles" results in an array of actual graffiti art styles. The relationship between basic facets and different levels of isolate ideas is diagrammed in figure 1.

While style is an isolate idea of graffiti art, it is not the only isolate idea relevant to this subject. Style represents just one component or means of examining graffiti art; another is form. Like style, form can be divided into its own distinct array of isolate ideas — in this case, specific forms of graffiti art. This relationship is illustrated in figure 2.

Figure 2. Classificatory relationship between style and form in graffiti art

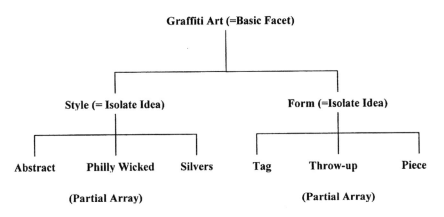

Facet analysis is essentially a mining process, and, as one delves deeper within a subject area, the entities in an array can also function as isolate ideas. Consider the example of how graffiti art is created — its mode of execution. Markers, rollers, sponges, paintsticks, spray cans, and computers are all tools used to create graffiti art, and this list constitutes a partial array for the isolate idea "Mode of Execution." Each of these tools can then be divided into its own distinct array of isolate ideas. Spray cans can be examined in terms of the various types of caps used by graffiti writers: Fanspray; German Outlines; New York Thins; New York Fatcaps; Rusto Fatcaps; and Orangedot Fatcaps, to name a few.

Although it would be possible (at least in theory) to create a classification system that covered multiple isolate ideas of graffiti art, the "parent universe" of the classification system presented in this book is the narrower topic of graffiti art style. The purpose of the questionnaires completed by the graffiti art experts was to define the parameters of this topic from two perspectives. On the one hand, the questionnaires were used to identify an array of named graffiti art styles, such as shown in figures 1 and 2. On the other hand, the questionnaires were also used to elicit the array of characteristics that are associated with these styles — characteristics that were subsequently divided into facets and foci.

In the context of the classification system, facets are distinct, visual components of graffiti art that pertain to all graffiti art styles. Letter Outlines, for example, is a facet of graffiti art. In practical terms, this feature — i.e., how the letter outlines look — provides one means of studying a graffiti art piece, regardless of the style in which the piece was created. Foci are the range of possible characteristics or conditions that exist within a particular facet. In the Letter Outlines example, "Hard," "Implied," "Interrupted," and "No outlines" are all types or conditions of outlines that can be found in a graffiti art piece. Merging the concepts of facets and foci in terms of actual graffiti artworks, the question then becomes: what type of letter outline did the writer employ and what (if anything) does this say about the iconic style of the piece? The classification system seeks to answer this question by examining the relationship between facets and foci in the context of individual styles.

The Development of the First Questionnaire

By applying facet analysis to the experts' questionnaire responses, data concerning various styles of graffiti art were divided into facets and foci. The identification of these facets and foci served two purposes. First, the relationships between facets and foci in the context of the graffiti art styles discussed by the experts were further explored in the individual follow-up questionnaires. At the same time, the facets themselves originate from the same "parent universe"[39] (i.e., the subject area "graffiti art style") and are therefore applicable across the entire spectrum of styles. As different facets and foci were identified, new questions pertaining to these characteristics were incorporated into successive iterations of the first questionnaire. As a result, both the content and format of this questionnaire changed over the course of the data collection process, evolving from a first iteration that consisted of 13 open-ended questions into a fifth and final iteration that contained 27 multiple choice and open-ended questions. (The final iteration is shown in Appendix A.) The

changes to the questionnaire reflect the ongoing process of facet analysis that was applied to the experts' descriptions of graffiti art styles — information they provided in both the first and follow-up questionnaires.

For the first iteration of the questionnaire, the instructions and open-ended questions were contained in a single e-mail message. The first two questions asked for preliminary information about the experts' background in graffiti art and their preference (if any) between the terms "graffiti writer" and "graffiti artist." The remaining 11 questions focused exclusively on graffiti art styles. Experts were asked to name between three and six styles of graffiti art based on their own expertise and to answer the same set of 11 questions for each style. They were also asked to provide at least two sample images for each of the styles discussed, either by indicating a web site URL or by attaching a jpeg file to their responses. The experts completed the questionnaires by replying to the original e-mail and by attaching corresponding image files or providing links to images.

The purpose of the 11 style-based questions was to learn about the characteristics of the graffiti art styles identified by each of the experts. The questions were accordingly designed to be relevant to a multitude of graffiti art styles while also giving participants the opportunity to describe in detail features of the styles they had selected. The first three questions concerned the name and history of a selected style, as well as the cities and surfaces (e.g., trains, walls, canvases) with which the style is most frequently associated. The next seven questions focused on the visual traits found within examples of this style, such as the number and range of colors, highlighting techniques, and types of background. Questions four through six distilled the piece to its most elemental component — the letters. Experts were asked if there is a minimum or maximum number of letters used for pieces of this style, how the letters are shaped, and how they overlap. The final question asked the experts to identify and describe other features of the specified style that were not covered by the preceding questions.

As the experts returned their responses and corresponding images, data about the characteristics of individual styles were divided into facets and foci. Newly-identified facets and foci then formed the basis of questions that were incorporated into new iterations of the questionnaires and sent to subsequent participants. For example, the 11th expert to participate in the research project received a different questionnaire than the eighth expert, who received a different questionnaire than the first expert. Table 4 summarizes the changes to the number and scope of the questions. In some cases, additional facets, such as Legibility and Dimensionality, were identified from the experts' descriptions of particular styles. The ongoing process of facet analysis led to the identification of new facets not only from responses to the first iteration

of the questionnaire, but also from subsequent iterations and from the follow-up questionnaires. For example, the discussion of a style by an expert using the third iteration of the questionnaire resulted in the inclusion of questions related to the Symmetry facet in the fourth and fifth iterations. New facets also emerged from writers' references to other facets. Letter Outlines, for instance, was added to the second iteration of the questionnaire based on experts' explanations of how outlines affect other elements of a piece, such as the dimensionality and overlap of the letters.

Table 4. Facets included in subsequent iterations of the questionnaire

FACETS

Question Numbers	Second Iteration	Third Iteration	Fourth Iteration	Final Iteration
1 & 2	Legibility	Legibility	Legibility	Legibility
3 & 4	Number of Colors	Number of Colors	Number of Colors	Number of Colors
5 & 6	Dimensionality	Dimensionality	Dimensionality	Dimensionality
7 & 8	Letter Outlines	Letter Outlines	Letter Outlines	Letter Outlines
9 & 10	Linearity	Linearity	Linearity	Linearity
11 & 12	Letter Overlap	Word Shape	Letter Strokes	Letter Strokes
13 & 14	Fill Effects	Letter Overlap	Uniformity of Letters	Letter Shape Consistency
15 & 16	Background	Fill Effects	Word Shape	Word Shape
17 & 18	Symbols	Background	Symmetry	Symmetry
19 & 20	NA	Symbols	Letter Overlap	Letter Overlap
21 & 22	NA	NA	Fill Effects	Fill Effects
23 & 24	NA	NA	Background	Background
25 & 26	NA	NA	Symbols	Symbols

As the letter outlines example suggests, questionnaire responses provided both portraits of individual styles and an understanding of how the different components of graffiti art pieces intermesh. Mapping the anatomy of a piece resulted in a reworking of topics from the first iteration and a refining of their definitions. For example, "Number of Colors" originally referred to the total number of colors contained in a piece. The scope of this facet was subsequently narrowed to the number of colors in the letter outlines and fill—a means of quantifying color recommended by some of the experts. Similarly, the topic of letter shape, introduced in the first iteration of the questionnaire, was subsequently divided into three separate facets: Linearity, Word Shape, and Letter Shape Consistency. In other cases, the scope of a topic was broadened as

facet or focus relationships were charted. For example, the topics "highlights" and "shadings" from the first iteration were subsumed into the larger category of Fill Effects as it became clear that highlights were just one of many details that could be added to the fills of letters.

While most of the content-based changes to the questionnaire involved additions or revisions, three topics from the first iteration — range of colors, location/surface, and number of letters — were eliminated. Experts indicated that the choice of colors to be used in a piece, as opposed to the number, was left to the discretion of the individual writer and was not influenced by the style in which he or she is working. As GREX1 explained, "There really are no particular colors — everyone has their own opinion as to what looks great or not. It is a matter of personal preference." GREX6 similarly noted that color selection is a "subjective, personal decision" governed not by "rules" but instead influenced by previous "exposure to memorable, impacting visuals" in other pieces.

This individual's obvious displeasure at the idea that the palette of a graffiti art piece could be subject to guidelines recalls art historian Heinrich Wölfflin's observation that artists tend to associate "a development of imagination determined by law" with a belief that "the significance of the artistic personality is destroyed."[40] Rules, law, and guidelines assume negative connotations when applied to the idea of artistic intent, yet these terms are synonymous with the more benign concept of artistic convention. What the graffiti expert's comments suggest is that color range is not part of any established graffiti art tradition: although it is a characteristic of graffiti art that can be discussed in terms of an individual piece, or in terms of the oeuvre of an individual writer, it is not a facet of graffiti art that reveals a relationship between a piece and the style in which that piece has been executed. It is a facet of personal style, not iconic style.

Just as the issue of color range fell outside the framework of a classification system geared toward the identification of iconic style in graffiti art, similar conclusions led to the elimination of the Location/Surface and Number of Letters facets. With regard to the topics of location and surface, many of the experts' responses presented a sweeping array of possibilities, such as "urban areas" or "high visible/high risk locations that (ideally) surround areas of mass transportation access or passage." These broad definitions make it difficult to differentiate among types of "urban areas" or "high risk locations" and to determine whether any specific types are associated with the styles discussed. A phrase such as "urban areas" also casts a wide net over multiple graffiti art styles, all of which might be found in one or more urban centers. These factors indicate that, while location/surface is indeed a facet of graffiti art styles, it is not especially useful in differentiating among styles. Again, it is not a

facet of iconic style, and it is therefore beyond the scope of the classification system presented in this book.

It also became clear from experts' sample images that location/surface is not necessarily evident from *images* of graffiti art. Viewing a graffiti art piece in person, one could readily conclude that it was painted, say, on a wall on a handball court in New York City. Determining this from an image would depend on the image itself rather than the piece: was the photograph taken from a great distance? Did it zoom in on just the piece and not pick up any of its surroundings? As with range of colors, the decision to eliminate the location/surface topic was made because of the nature and scope of the classification system itself. The goal of the system is to assist cataloguers in ascertaining not simply the iconic style of a graffiti art piece, but, more precisely, the iconic style of a piece as depicted within an image. This is not to say that the system is valid only for images, as opposed to the original artworks reproduced in the images. Nevertheless, the fact that cataloguers would be applying the system within the context of an image collection creates a necessary delimitation. As a result, the facets listed in table 4, as well as the finalized set of facets included in the classification system, encompass only visual components that are relevant to iconic style *and* can be ascertained from graffiti art images.

As with number of colors and location, the "number of letters" topic was removed from the subsequent iterations of the questionnaire because of its irrelevance to the purposes of the classification system. Yet in contrast to these previous examples, the letter quantity is neither a component of iconic style nor of personal style. In fact, it is a facet of a different isolate idea of graffiti art — namely, form. Early questionnaire responses indicated that the number of letters in a graffiti artwork relates to the form of graffiti art; once the form had been ascertained in an artwork, the number of letters would be of no assistance in distinguishing its style.

Understanding the relationship between style and form in graffiti art was central to the development of both the questionnaires and the classification system itself, as will be discussed in chapter 4. Although this relationship can be explicated through classificatory theories, as shown in figure 2, in practice the distinction between these two areas is often blurred. Rather than breaking down styles into mutually exclusive components, much less ascribing these components to parent universes and isolate ideas, writers impart their knowledge through more holistic descriptions of a style's predominant characteristics. As Eleanor Rosch comments, "One influence of how attributes will be defined by humans is clearly the category system already existent in the culture at a given time."[41] For the most part, extant category systems for graffiti art begin by differentiating among the various forms of

graffiti art and then further distinguishing each form according to its salient features. For example, a graffiti "primer" printed in *The Globe and Mail* defined tags, throw-ups, pieces, stencils, and productions, highlighting notable characteristics of each form. Here, pieces were described as "complicated, multi-coloured three-dimensional works" that "can take several hours to do."[42] While this description draws attention to visual elements that distinguish pieces (multiple colours, letters that appear three-dimensional), the category of "piece" itself is not further subdivided.

The focus on form in category systems for graffiti art was reflected in the conflation of form and style in some experts' questionnaire responses. Citing attributes that distinguish form, they described characteristics of forms in general, not of specific styles associated with these forms. For example, three elected to describe the characteristics of tags when asked to select a style of graffiti art, while two talked about throw-ups in general. The individuals who discussed forms, rather than styles, of graffiti art completed the iteration of the questionnaire that consisted only of open-ended questions. Therefore, the instructions for the subsequent, multiple-choice-based iterations of the questionnaire were amended, asking graffiti art experts "to identify specific styles of graffiti art, not forms of graffiti art," with the added explanation, "In other words, please do not use Tags, Throw-ups, and Pieces as the three styles you choose in answering the questionnaire."

These content-based changes to the questionnaire dictated changes to its format as well. The first of these was the introduction of multiple-choice-based questions. The data analysis of the questionnaires resulted in the identification not only of facets, but also of corresponding foci. The Dimensionality facet illustrates this relationship. When discussing the dimensionality of various graffiti art styles, the experts referred to a number of specific types — or foci — of dimensionality: 2-dimensional letters; 2-dimensional letters with 3-d effects; and 3-dimensional letters. Both the facet itself and these corresponding foci were incorporated into subsequent iterations of the questionnaire through the use of multiple-choice questions. Beginning in the second iteration of the questionnaire, the experts were asked in question 5 to select among three statements the one that most accurately described the dimensionality of the letters in the style they were discussing. Each statement corresponded to a definition of one of the three foci just described. Experts also had the option of naming and describing relevant dimensionality foci that were not covered by the questionnaire. This same format, with the question introducing a facet and the multiple-choice options encompassing the corresponding foci, was used for each of the facets identified in table 4.

The use of multiple-choice questions was not intended to limit experts' ability to describe in their own words features of graffiti art. In addition to

identifying foci for each of the facets, experts were given the opportunity in the final question to introduce any topics not already covered by the questionnaire. Rather, the idea behind the multiple-choice format was to introduce the same set of facet and foci definitions. This standardized vocabulary made it possible to differentiate between nuances in how different individuals describe certain foci and nuances in the foci themselves. For example, two experts discussing the same type of letter dimensionality might do so in vastly different ways. The multiple-choice questions eliminated the possibility of mistaking these linguistic dissimilarities for differences in opinion about the relevance and definition of the focus itself.

As shown in table 4, two multiple-choice questions covered each facet in the questionnaires. While the first question asked experts to select a focus, the second question asked them to estimate the applicability of that selection. For instance, if someone had indicated in question 5 that the letters in a particular style were 3-dimensional, question 6 inquired how often that is the case: less than 50 percent of the time; 50–75 percent of the time; or more than 75 percent of the time. These same three options were posed for each of the facets covered by the questionnaire. For facets such as Symbols and Background, where multiple foci might be relevant to any one style, the second question of the two-question set asked experts to specify which focus is most frequently associated with the style. The purpose of quantifying the applicability of the foci was to get a sense of how integral various characteristics are to the style being discussed. The selections of these percentages played a central role in ensuring that the classification system is modeled on the consensus of experts, a point that will be examined in chapter 4.

The shift from open-ended questions to multiple-choice questions led to additional changes in the presentation of the questionnaire. Because of the increased length of the questionnaire, experts were requested to describe 3 styles, rather than 3–6 styles, as was the case in the first iteration. Three separate copies of the multiple-choice questionnaire (one per style) were e-mailed to the experts as file attachments, which were labeled "Style-A," "Style-B," and "Style-C." Each attachment presented the identical set of questions to be answered for each style; the only difference among the three files was in the "Style-A" document, which requested preliminary information about the experts' background in graffiti art. General instructions for completing the questionnaire were provided in the e-mail message sent to each expert. In addition, each file attachment contained an identical set of instructions that explained how they should indicate their selections for the multiple-choice questions.

The Follow-up Questionnaires

The intent of the follow-up questionnaires was to get a better understanding of the styles and issues discussed in the first questionnaire and to provide a forum in which the experts could expand on their own responses and comment about the opinions offered by others. This was achieved through two types of questions. The first type was used to clarify comments made by an expert regarding the characteristics of a style or the vocabulary used to describe the style. In many cases these questions referred to the sample images that he or she had provided:

> On the topic of legibility, you noted that individual letters in the Graphic style usually can be identified, but it is difficult to determine the word that they form. Looking at the two pieces ... it seems that pieces in this style can range from completely illegible to completely legible. Would it be accurate to say, then, that pieces in the Graphic style can range from fully legible to illegible?

The other type of follow-up question solicited opinions on issues raised by other participants. In some cases, questions centered on specific styles discussed by both the follow-up questionnaire recipient and other experts:

> Another respondent mentioned that the East Coast Piecing style is characterized by very thick or wide 3-ds, defined as instances where the thickness of the 3-ds is equal to or greater than the thickness of the letter strokes they highlight. Do you agree?

In other cases, questions addressed the applicability of a facet or focus that had been introduced by an expert discussing a different style:

> I'm considering including a facet in the classification system that I am developing that addresses whether the fills of a given style are consistent or inconsistent. In this context, consistent fills would be defined as fills that exhibit either a color scheme and/or pattern that is identical from letter to letter or a cohesive pattern that runs across the word as a whole (for example, a word consisting of letters with two alternating fill colors). Conversely, in the case of inconsistent fills, there would be no noticeable, cohesive fill pattern or color scheme that runs across the word as a whole. Would you characterize the fills in the Abstract style as being closer to the consistent end of the spectrum or the inconsistent end of the spectrum?

As this last example shows, the process of facet analysis, applied to the questionnaire responses of the 11 experts, shaped not only the subsequent iterations of the first questionnaire, but also many of the questions posed in the follow-up questionnaires. Through this method, experts were able to comment on facets and foci that had not yet been included in the questionnaire that they had completed.

The length of the individual follow-up questionnaires varied widely, depending on the number of styles that the writer had discussed and the number of new facets and foci introduced by other experts. The average length was 13.5 questions, with a range of 6 to 32 questions. Follow-up questions pertaining to new facets and their applicability to different styles took the form of either open-ended or multiple-choice questions.

In order to collect as much information as possible about various graffiti art styles, five of the 11 experts were invited to complete the questionnaire process for additional styles. These five individuals — three writers and two artists/historians — had expressed especial interest in the project and possessed significant background knowledge about a wide range of graffiti art styles. The fact that both writers and non-practitioners were asked to continue their discussion is reflective of the group of experts as a whole. Although some experts were more expressive in their questionnaire responses than others, there was no notable difference collectively between the nine graffiti writers and the two non-writers in terms of their depth of knowledge and expertise.

Four of these five experts (two writers, two artists/historians) agreed to discuss additional styles, using the latest iteration of the questionnaire. These individuals were offered a $25 (U.S. currency) honorarium per style in addition to the initial $50 honorarium for participating in the study and were given the option of selecting a style that had been discussed by another expert or of introducing a different style. With the first option, a list of styles was provided that had been discussed by only one other expert; those who selected from the list would therefore be providing an additional perspective on one or more of these styles. One expert was asked to complete a summary follow-up questionnaire in lieu of discussing an additional style. This questionnaire covered facets that had not yet been identified at the time this individual had completed both the first and follow-up questionnaires.

The willingness of some experts to continue their involvement is an indication of the group's enthusiasm and interest in the project. All 11 experts — not only those invited to complete additional questionnaires — welcomed the opportunity to discuss and explain their work to an individual outside of the graffiti art community (i.e., the researcher) and to hear the viewpoints of their peers, as revealed through the Delphi process. Two of the experts described themselves as "honored" to participate in the project; another wrote, "I would LOVE to be a part of this study." Upon completing the questionnaires, participants echoed the sentiments expressed by GREX4: "Also, if you have any other questions or would like any additional info from me, I'd be more than happy to help you out." Three experts also sent references to articles and web sites they felt might be of interest and assistance to the researcher.

The experts also seemed intrigued by the idea of viewing a graffiti art

piece not only as a finished artwork, but also in terms of its essential components — of describing the interplay of specific visual elements in graffiti art and of naming and defining these elements. Their descriptions led to the identification of, on the one hand, 13 facets and 41 foci of graffiti art and, on the other, 14 different styles of graffiti art pieces. The project's use of a modified Delphi method enabled participants to delve into the topics covered by the questionnaires, ensuring that the facets and foci defined in the classification system are based on the knowledge and consensus of experts. Chapter 4 looks at the process of finalizing these facets, foci, and styles and of expressing their relationship in the classification system.

4

Developing the Faceted Classification System for Graffiti Art Styles

The process of facet analysis described in chapter 3 resulted in changes to the questionnaires for graffiti art experts. New facets and foci were identified; existing facets were determined to be irrelevant and were eliminated. Yet the results of this facet analysis affected not only the range of questions posed to the experts, but also the scope of the resulting classification system. This chapter chronicles the development of the system, beginning with the process of identifying and refining the list of graffiti art styles, facets, and foci on which it is based. The system comprises two main components: (1) definitions of 13 facets and 41 foci identified from the graffiti art experts' questionnaire responses; and (2) descriptions of 14 different styles of graffiti art pieces. The final sections of the chapter tie these components together by explaining how the system operates, using the No-neg style as an example. The entire classification system — a list of the 14 styles and their corresponding style notations; descriptions of these styles; facet/foci definitions; and index — are presented in Appendix B.

As with the questionnaires, the structure and format of the classification system was largely informed by the theoretical approaches to facet analysis advanced by B.C. Vickery and, especially, S.R. Ranganathan. Louise Spiteri notes that "the semantic and syntactic structure of Ranganathan's language may serve to hinder easy comprehension of his principles of facet analysis."[1] This certainly would be the case if Ranganathan's myriad Normative Principles, Laws, Canons, Postulates, and Devices were treated as a literal how-to guide. Nonetheless, Ranganathan's systematic explication of the various stages of facet analysis provides a framework that can be used to map a complex subject such as graffiti art. Indeed, it is less the minutiae of facet analysis than

it is the ability to explore and to structure a subject through this analytic process that is the primary benefit of applying Ranganathan's ideas.

Identifying Graffiti Art Styles

Two aspects of style co-exist in graffiti art, as explained in chapter 2. There is a writer's personal style, and there is iconic style, or style as convention. The classification system is concerned with iconic style — specifically, with the proscribed patterns which dictate how the letters will appear in a graffiti art piece. This is not to suggest that creating a graffiti art piece is merely a matter of following a formula — a street-art version of "paint by numbers." Rather, iconic style refers to the conventions that signal a writer's intent to depict certain core elements; the depiction itself, of course, will also reflect the writer's personal style.

The 11 graffiti art experts who completed the questionnaires identified a total of 30 graffiti art styles. The classification system, however, encompasses 14 graffiti art styles. The reduction from 30 to 14 styles reflects the use of criteria, established through the analysis of the experts' questionnaire responses and the application of classificatory frameworks, for determining which styles could be included in the classification system. The criteria take a number of factors into account, including the range of styles discussed by the experts, the classificatory relationships among these styles, and the function of style in relation to other components of graffiti art. The following discussion looks at each of these factors in turn and examines their impact on the formulation of the criteria and, by definition, on the final list of styles covered by the classification system.

First Factor: The Interaction of Style and Form in Graffiti Art

Determining which styles to include in the classification system was as much a question of form as it was of style. As noted in chapter 3, identifying form and style as distinct isolate ideas within a classificatory framework is not the same as parsing the roles that form and style play in actual graffiti artworks. Indeed, it was the interaction of style and form in graffiti art, rather than the separation of these concepts, that had the greatest impact on the development of the classification system.

To understand the relationship between style and form in graffiti art, it is helpful to draw comparisons to the interaction of style and form in fine art. Figure 3 uses Impressionism, Dada, and Pop Art as examples of fine art styles — distinct modes of expression that emerged from, and that now sig-

nify, different artistic movements. The arrows in figure 3 demonstrate how each of these styles can be manifested in multiple forms of fine art, such as paintings, prints, and sculptures. There are Pop Art paintings, Pop Art prints, and Pop Art sculptures, for instance, just as the Impressionist style also comprises paintings, prints, and sculptures.

Figure 3. Relationship between style and form in graffiti art and fine art

Graffiti Art		Fine Art	
Style	Form	Style	Form
Philly Wicked → Tag		Dada	Painting
Silvers ⇄ Throw-up		Impressionism	Print
Abstract → Piece		Pop Art	Sculpture

A similar dichotomy between physicality and expression exists in graffiti art, which consists of different styles (such as Abstract, Silvers, and Philly Wickeds) and distinct forms (such as tags, throw-ups, and pieces). There is, however, a disparity in the way that style and form interact in graffiti art as opposed to fine art. Most styles are form-specific in graffiti art. For example, figure 3 shows that Philly Wickeds are a style of tag, but there are no such things as Philly Wicked throw-ups or pieces. Conversely, the Abstract style is relevant to pieces only. The one exception is Silvers, which can assume the form of either throw-ups or pieces.

Any classification system designed to assist in the identification of styles would need to take into account the form in which the style is manifested. A classification system intended to differentiate among styles of paintings would need to address facets relevant to painting; one that denotes various styles of sculptures would need to concentrate on facets relevant to sculpture. The same principle applies to graffiti art. In the case of Silvers, a classification system designed to demarcate Silver pieces from other styles of pieces would utilize different facets than would a system for distinguishing between Silver throw-ups and other styles of throw-ups.[2] Therefore, the first step in finalizing the list of styles to be included in the classification system was to map the styles discussed by the experts according to the particular form with which they are associated.

The experts' questionnaire responses yielded data for only two styles of tags (Philly Wickeds and Pichação) and one style of throw-ups (Silvers). As with pieces, both tags and throw-ups can be considered and classified according to distinct styles. GREX4 alludes to "tag styles ... such as prints, scripts, wickeds, rallies, tall boys, etc." The majority of styles discussed by the experts, however, pertain to pieces. Arguably, this focus illustrates the traditional hierarchy of graffiti art forms. This hierarchy is based on the visual complexity of the form, with tags considered to be, according to GREX4, "the meat and potatoes of graffiti" and "the core of the graffiti experience." At the apex are pieces, especially "burners"—pieces that are considered by writers to be exceptional examples of graffiti art. With their often elaborate backgrounds, intricate color schemes, and eye-popping letters, pieces create a very different "graffiti experience" from that of tags and throw-ups. It is conceivable that this elaborateness creates the impression, at least among viewers outside of the graffiti art community, that pieces are somehow more legitimate—that they have a more intrinsic connection to fine art than do tags and throw-ups, which can more readily be stereotyped and dismissed simply as spray-painted scrawls. GREX4 suggests that the graffiti community itself is complicit in the elevation of pieces over other forms of graffiti. He writes, "I also believe that sites like art crimes and movies like style wars minimize the importance of tags and place too much celebration on pieces."[3] Essentially, pieces are attention-grabbers—the equivalent of the gravity-defying slam-dunk in basketball, of baseball's out-of-the-ballpark, grand-slam home run. While all forms of graffiti art require fundamental skills—what GREX4 refers to as having "a good 'hand'"—fundamentals never make the highlight reel.

Experts' emphasis on pieces in their questionnaire responses; the disparities among tags, throw-ups, and pieces; and the specificity of styles to each of these forms all had a direct impact on the classification system. Theoretically, it would be possible to create a classification system that would assist cataloguers in identifying styles of tags and throw-ups. But because the facets needed to demarcate graffiti art styles are form-specific, it would first be necessary to identify the various characteristics of the forms themselves. These characteristics can differ significantly. For example, styles of pieces can vary in terms of the dimensionality of the letters and the number of colors employed by the writer. Conversely, all tags, regardless of style, are two dimensional and monochromatic. These two facets—dimensionality and number of colors—can therefore be used to denote styles of pieces, but they are of no use in distinguishing styles of tags. Experts' questionnaire responses, however, yielded insufficient data concerning the various facets that pertain specifically to tags and throw-ups—facets that would need to be identified in order for these two forms to be included in the classification system.

For these reasons, the extent of the classification system was narrowed to pieces only. This meant eliminating from the list of styles covered by the system the two styles of tags (Philly Wickeds and Pichação) discussed by the experts, as well as Silver throw-ups. It also affected a fourth style of graffiti art known as productions. While the experts collectively described at least one style that is relevant either to tags, throw-ups, or pieces, they did not attribute any specific styles to productions. In fact, only GREX6 mentioned productions in his questionnaire responses. Noting that they "are the largest of graffiti works," he explains that "magnitude, complexity, harmony, and impact are the defining factors of a production." In fact, their physical magnitude affects not only the visual impact of productions, but also the creation process itself. Because of their size, productions are time consuming and require rollers, ladders, and abundant supplies of paint — circumstances that draw attention to the writers as they work. As GREX6 points out, productions are therefore "carried out on legal, or very-safe walls/yards or commissioned murals." At the same time, the scale of productions results in collaborative efforts by a group of writers, each of whom contributes a section. Each section of a production, in turn, is a stand-alone piece.

The connection between pieces and productions relates to the classification system in two ways. First, the fact that productions are essentially conjoined pieces makes it difficult to differentiate these two forms in the context of an image of graffiti art. GREX6 observes that "when a piece which is part of a production is seen alone, it is not easy to determine that it's part of a production. When seen alone, it can be considered a piece in and of itself." In terms of the classification system, ascertaining whether or not a piece is part of a production would require more contextual information than what is usually available within an image. Second, the question of whether or not a piece is part of a production is rendered moot for the purposes of a classification system designed to identify graffiti art styles. In contrast to the relationship between pieces and tags or throw-ups, there is no discrepancy between the range of styles applicable to pieces and productions. Any style that applies to pieces can theoretically also be found in productions, and there are no distinct styles of productions.

Second Factor: Style Versus Facets of Styles

As with the distinction between form and style, the relationship between style and the visual features which contribute to a style's identity influenced the development of the classification system. Just as some experts conflated the concepts of form and style in their questionnaire responses, others discussed "styles" that are facets or components of graffiti art styles. Although

these facets by definition cannot be equated with actual styles of graffiti art, they did play a role in refining the classification system.

One of these facets pertains to what GREX1 identified as the "Block-buster style." Noting that the "style got it's name from the shape of the letters — They are straight and appear to look like blocks," GREX1 mentions that these eponymous block letters are also known as "Straight letters." References to both block letter and straight letter styles appear throughout experts' questionnaire responses, as well as in scholarly works on the history of graffiti art. GREX9, for example, explains that Silver pieces "are often done in block-buster or bubble letter style." Joe Austin, in his study of New York subway graffiti, similarly refers to "'Blockbuster' letters," observing that they "may or may not be three-dimensional."[4] Whereas GREX1 identified Blockbuster as a style of graffiti art, these comments suggest that it is a style of graffiti art typography. Indeed, GREX1 states in response to a follow-up question that there can be both "straight letter" and "rounded letter" wild styles. In a classificatory sense, blockbuster (i.e., straight) letters constitute a focus (along with their visual opposite, rounded or "bubble" letters, as well as hybrid straight and rounded letters) of a facet defined as Linearity in the classification system.

The question of what sets apart graffiti art style from typography is relevant to two other styles discussed by the graffiti art experts: Dimensional (also known as 3D) and Wild style. A given typography or lettering type is applicable to multiple styles of pieces, whereas a style of piece is unique. This uniqueness is a product not only of the linear appearance of the letters (rounded, square, bubble-like, etc.), but also of other factors, such as the number of colors used to create the piece, its symmetry (or lack thereof), and the types of fill effects employed. The graffiti art experts responding to the questionnaires treated the Dimensional and Wild styles as styles of pieces; others have categorized them as letter forms. Nicholas Ganz writes, "Over the years, the original letter style has developed to encompass a whole range of different typographic forms: the legible 'blockbuster,' the distorted and intertwined 'wildstyle,' the familiar 'bubble style' and '3D.'"[5] This interpretation of "typographic forms" applies "wild style" as shorthand for "illegible," just as "blockbuster" becomes synonymous with "legible." Describing the Wild style as "the creative manipulation and abstraction of letterforms," Steve Grody goes so far as to suggest that "the term wildstyle is rarely used now."[6]

But iconic style in graffiti art is not limited to the type of lines used to form letters. The graffiti art experts' questionnaire responses indicate that the Wild style consists of more than just "distorted and intertwined letters," just as Dimensional pieces are defined by elements other than their 3-dimensional letters. Nonetheless, this issue affects the interpretation of one image pro-

vided by GREX9. Identified as an "example of unnamed potential subtypes" of the Dimensional style, the image presents what arguably appears to be a hybrid of the Dimensional and Wild styles: a piece consisting of illegible, intertwined letters that simultaneously exhibit the characteristics of inherently three-dimensional letters. Would this piece be considered a "Wild Dimensional" or a "Dimensional Wild," according to the composite nature of its style? This question will undoubtedly be answered in years to come, as new style innovations splinter existing styles into subgroups. For the purposes of the classification system, however, both Wilds and Dimensionals were treated as distinct and unique styles of pieces, rather than as types of lettering.

As with Blockbusters, the element of graffiti art known as Characters was determined to be a *facet* of graffiti art styles rather than a distinct style. One of the two experts who discussed Characters defined them as "a cartoon character, or an animal etc ... usually accompanying a semi-wildstyle piece." In fact, Characters have been associated with a variety of styles, beginning with the "comic strip period of late 1974 and 1975" in New York subway art.[7] As Ivor Miller explains, "Like the guerrilla artists they are, writers devoured images from the myriad popular culture forms around them. In 1989 AMRL/BAMA told me, 'I think half the guys who were writers learned how to read and draw better through comic books than school books. ... So we could look at a Captain Crunch ad and see something you could steal for your piece.'"[8] Other examples of cartoon figures co-opted for graffiti art characters include Dick Tracy, Beetle Bailey, Felix the Cat, and the Peanuts gang. Writers integrate a character into their design, often positioning it on either the left or right-hand side of the piece, where it gestures to the tag directly following or preceding it.

Characters can be not only renderings from the comics, but also original figures created by writers. As GREX6 observes, "Some writers excel-in, specialize, or only do characters." Many of the experts' images of different graffiti art styles incorporated original characters, and some images provided by GREX2 were of stand-alone characters. That is, the entire piece was comprised of a character without an accompanying tag. Arguably, these stand-alone characters could be considered a distinct graffiti art style. According to Nicholas Ganz, "Characters, which started off as ancillaries to letters, now form their own graffiti group and range from comical figures to those of perfect photorealism."[9] But because stand-alone characters are not letter-based, they are beyond the scope of a classification system designed to identify cognominal graffiti art styles. And since characters themselves are representational, any attempt to provide access to images of stand-alone characters would be susceptible to the same challenges that characterize the provision of subject-based access to (representational) artworks. In the Panofsky/Shat-

ford level-based model, both a drawing of a dog and a spray-painted depiction of a dog would lead to the same inevitable questions concerning the adequacy and specificity of access points.

The third and final design element that should be considered as a facet of styles is Stamps. Unlike Blockbusters and Characters, however, Stamps cannot be easily classified. From the descriptions of the one expert who discussed them, Stamps come across as a form, rather than style, of graffiti art. According to GREX6, "A stamp would usually fall between a throw-up and a piece": They "are usually done relatively quickly (although longer than a tag or throw-up)," but they have fewer letters than pieces. While this characterization implies that Stamps are a hybrid form of graffiti art that merge traits of throw-ups and pieces, another expert provided a different assessment. Pointing out that the term itself "refers to the act of doing throwups or simple outlined letters that are so similar to each other that it looks like they've been stamped out rather than painted by hand," GREX9 believes that Stamps are not so much a form or style of graffiti art but rather "a quality that some throwups possess"— namely, a "uniformity to the point of looking stamped out." According to this perspective, Stamps would most accurately be defined as a facet of graffiti art styles, with the important caveat that they are a facet of throw-ups, not pieces. Whether they are treated as a hybrid form or as a facet of throw-ups, Stamps fall outside of the classification system's concentration on the visual elements that define styles of pieces.

Third Factor: Classes of Styles

The examples of Blockbusters, Characters, and Stamps demonstrate the classificatory distinction between unique, definable graffiti art styles and visual aspects or facets that are applicable to multiple styles. Some of the graffiti art experts considered styles in terms of yet another classificatory framework: classes of graffiti art styles. The concept of classes of styles is illustrated in the examples of "Old School" and "New School." GREX5 utilized these terms to distinguish traditional, name-based styles of graffiti art from more recent, computer-graphics influenced approaches:

> Old school to me, is anything that isnt influenced by "modern" design. it could be a character or bubble letters or a production ... as long as you can look at it and tell pretty much what your looking at, then it is old school.

> [N]ew school to me, is anything that you look at and go ... 'what the hell is that?' it doesnt have to be anything. So if your looking at some graffiti and you can tell that there are letters but you can or cant read them, then it is old school. but if your looking at something and you cant find any letters or it doesnt fit the normal pattern of graffiti that your used to seeing then its more than likely new school.

As these definitions indicate, the contrast between traditional and new approaches to graffiti art is not as simple as the phrases "old school" and "new school" might suggest. Consider the new school criterion of not being able "to find any letters." How would an illegible "old school" piece (i.e., a piece comprised of a tag in which none of the letters can be identified) differ from a "new school" piece with no letters? At the same time, the ability to ascertain what constitutes "the normal pattern of graffiti" assumes that there is a static, universal pattern that all graffiti art follows. In fact, this "pattern" is in flux, characterized by the development of new styles and techniques, many of which evolve from the work of other writers and media. The adaptation of comic book characters just described is one such example.

Another expert suggested that "new school" serves primarily as a "very broad classification" concerned with the time frame in which a given piece was created. Questioning the utility of this era-based categorization, GREX9 observes that a concept like "new school" is essentially "a moving target" that functions in the same way as music categories such as "alternative rock." What is alternative today is destined to be labeled as classic somewhere down the road. Another style introduced by one of the experts—"Retro"—exemplifies the difficulty of applying era-based categories to graffiti art styles. As the name suggests, pieces executed in a Retro style purposely echo the work of "classic" writers. GREX8 explains that Retro styles "indicate a conscious attention on the part of the painter to render their work in a manner consistent with or in homage to the early subway writers." But the early subway writers whose work is replicated in Retro pieces did not employ one, uniform style. Because Retro pieces themselves would differ depending on which earlier writer is being invoked and the style in which that writer worked, there is no single "Retro" style. Like Old School and New School, Retro functions as a broadly defined category that includes multiple, discrete styles.

In contrast to broadly defined categories such as Retro and New School, other styles discussed by the graffiti art experts are subordinate categories. The concept of subordinate categories can be examined in terms of Eleanor Rosch's "Principles of Categorization." Rosch posits that the categories within an object-based taxonomy—a "system by which categories are related to one another by means of class inclusion"—represent one of three levels of inclusiveness: superordinate, basic level, and subordinate.[10] The basic level, she explains, is "the most inclusive level of classification at which objects have numbers of attributes in common."[11] Applying this concept to graffiti art, a style such as No-neg functions as a basic level category. Subordinate categories are populated by more specific subclasses derived from a basic level category. For example, Rosch cites "Kitchen chair" and "Living-room chair" as subordinate categories of the basic level category "Chair."[12]

A similar taxonomy applies to the Semi-wild and FC styles of graffiti art. Like the association made between "chairs" and "kitchen chairs," Semi-wild styles represent a basic level category that can be further divided into subordinate categories, one of which is the FC style. The connection between the styles became apparent not only through visual similarities in the sample images provided by two of the experts, but also by the characteristics these individuals cited in their questionnaire responses. Asked to comment on these similarities, the expert who discussed the FC style replied, "I would say that FC style is a subset of semi-wildstyles." Indeed, based on the facets and foci identified through the analysis of the questionnaire responses, FC and Semi-wild styles are categorically identical. This correspondence brings to mind Rosch's observation: "Each category within a taxonomy is entirely included within one other category (unless it is the highest level category) but is not exhaustive of that more inclusive category."[13] In other words, while the defining characteristics of the FC style mirror those of the Semi-wild style, FC is not the only type of Semi-wild style. Presumably, there are other sub-categories of Semi-wildstyles, although none was identified by the experts. Ascertaining how the FC style differs from other sub-classes of Semi-wild styles, however, would require the collection and analysis of data about a variety of sub-styles. As was the case with the limited number of tag and throw-up styles, the ability to include a sub-style such as FC is dependent on the range of styles discussed by the experts.

It should be noted that, despite their similar nomenclature, Wild and Semi-wild styles do not represent a basic level or subordinate level relationship. The name "Semi-wild" refers to the fact that pieces in this style are generally more legible (i.e., less "wild") than Wilds; yet, the two styles do not share identical sets of characteristics in terms of the facets covered by the classification system. Still, apart from certain visual features, the styles do have in common a sense of permanence — a longevity bolstered by enduring popularity. Successive generations of writers continue to work in and reinterpret these styles. In the case of the Semi-wild style, the result is a subordinate class such as FC. In the case of the Wild style, writers did not identify distinct subordinate classes, but GREX8 characterized another style — Ces FX — as an example of a "purebred" Wild style: "Ces is really one of the most influential writers in terms of letter design and style. He was probably one of the most copied writers of the 1990's. He was mentored by T-Kid, who in turn was mentored by Tracy 168, who was the originator of the term "wild style." To my mind Ces is really as good an example of "wild style"... as there is."

GREX8 describes a creative process in which writers stay true to the core characteristics that define an established style while infusing the style with their own personal style. On the one hand, Ces's work epitomizes the Wild

style; on the other hand, his contributions "in terms of letter design and style" make his work unique — the intersection of iconic and personal style. GREX8's comments suggest that the Wild style represents a basic level category style that, like Semi-wild style, could at some point be divided into individual, subordinate style categories. Nonetheless, the Ces FX style comprises the same range of characteristics as the Wild style, just as the FC style presented the same elemental features as the Semi-wild style. In both cases, only the basic level style — Semi-wild and Wild — were included within the classification system.

Fourth Factor: Emerging Styles

While the Semi-wild and Wild styles are well established within the graffiti art community, two other styles discussed by the experts — Graphic and Blowout — have emerged much more recently. And while countless precedents for both the Semi-wild and Wild styles exist in the work of several graffiti writers, a similar frame of reference for the Graphic and Blowout styles did not exist. In the case of Graphic, two experts presented dissimilar pictures (literally and figuratively) of what epitomizes this style. GREX11 ascribed uniform letter strokes, inconsistently shaped letters, and consistent letter fills to pieces in the Graphic style, while GREX8 cited the opposite: varied letter strokes, consistently shaped letters, and inconsistent letter fills. While there was not always 100 percent agreement among the experts concerning the primary characteristics of some styles, the discussion of the Graphic style was notable for the almost complete lack of consensus. The resulting ambiguity concerning what, exactly, constitutes the Graphic style was reinforced by the sample images. Not only did the pieces provided by GREX8 bear little resemblance to those of GREX11, but the pieces within GREX11's own image set also seemed visually disconnected, as if they were representing a range of styles rather than exemplifying a single style.

To gain further insight on the Graphic style, a third expert familiar with the style (GREX9) was asked to comment on GREX8's and GREX11's responses and on the difficulty of identifying the style's salient features. GREX9's opinion was that Graphic "is an emerging style family but it might be too undefined to use in your system still." This was echoed in GREX8's observation that "the term 'Graphic' is not descriptive by writer, region, crew or anything." The writers developing this style are not building on the work of one specified writer or group of writers. A writer working in an established style, such as No-neg, has a set of characteristics to use as a starting point. To be sure, all writers who work in the No-neg style would not produce identical pieces: each piece would vary according to the writers' personal inter-

pretations. Their pieces would, however, share some fundamental, underlying characteristics that make No-neg pieces sui generis.

The difficulty in determining the underlying features of the Graphic style is exacerbated by the nature of the style itself. Consider the following description by the German crew Viagrafik, whose work GREX8 cited as an example of the Graphic style:

> The street as a neutral venue gave us the chance right from the start to work independent of rules and models. Over time, other influences and spheres of interest have been added from outside the world of graffiti. Through our work in graphic design, for example, we learned various new approaches to areas like composition and the balance of surfaces and forms. Under the influence of the freer language of form that you find in graphic design, we got new ideas about how to form letters, about irony, playing with proportions, abstracting the original form to the point of dissolving the letter.[14]

The fact that Graphic is, according to GREX9, both "undefined" and "an emerging style family" precluded codifying the style in terms of its primary visual characteristics. On the one hand, the fact that Graphic is undefined was readily apparent in the experts' varying conceptions of the style. On the other hand, the challenges posed by their lack of consensus were magnified by what the members of Viagrafik cite as the style's many influences and its freedom from "rules and models." The inability to codify the Graphic style, in turn, led to its exclusion from the classification system.

Like Graphic, Blowout is also a new style — so new, in fact, that the expert who described it was also the only one aware of it. In contrast to Graphic, Blowout lacks any documentation or confirmation by other experts, and the style appears to have not yet entered the consciousness of the graffiti community in general. Two other experts suggested that it is either a regional phenomenon or a style that "was invented on the spot." Another dismissed Blowout with the comment, "Just a hairdo to me." This lack of corroboration resulted in the style not being included in the classification system.

CRITERIA FOR SELECTING STYLES

The issues underlying the four factors just described were distilled into a set of criteria for determining which styles could be included in the classification system. Of the 30 styles introduced by the graffiti art experts, 14 met these criteria, which can be summarized as follows: (1) the styles must actually be styles, as opposed to forms of graffiti art or facets of other styles; (2) the styles must be relevant to pieces; (3) the styles must be distinct, individual styles, as opposed to broadly-defined classes that encompass multiple styles; (4) the styles cannot be subclasses of another style; (5) the styles must be have an established history within the graffiti art community.

With one exception — the CTK style — at least two experts discussed each style in their questionnaire responses, and other experts contributed ideas and information via e-mail about styles that they had not formally described in their own set of responses. The CTK style, however, was formally analyzed by only one expert; others were cognizant of the style but did not feel qualified to characterize it for the purposes of collecting data. Yet the fact that these individuals were familiar with CTK (unlike the Blowout style) provided evidence that this is an established and categorical style.

As evidenced by this discussion, mapping the interrelationships between style and other aspects of graffiti art poses distinct challenges. Completing the questionnaires led GREX9 to conclude, "I didn't realize how slippery all of these classifications can be until you started asking questions. It's not a very orderly world." Graffiti experts and non-experts alike are not accustomed to deconstructing pieces and the slotting the results of this effort into categories or considering them as distinct facets. The tendency to conflate style with form or with design-based elements like typography is a reflection not only of how tightly interwoven these components are, but also of the centrality of style to graffiti art. When a graffiti art piece is treated as an organic whole, its various features and facets are subsumed within the concept of style. Style takes precedence, acting as the prism through which other design elements are viewed. And it is precisely this central role of style — both within a graffiti art piece and within the mindset of the graffiti art community — that makes Panofsky's model of iconographical analysis particularly well suited as the basis for the classification system.

Establishing the Facet/Foci Order and Notation

The next step in the development of the classification system was to finalize the list of facets along with their corresponding foci, and to determine the order in which they would appear. As described in chapter 3, foci are the visual characteristics (i.e., primary subject matter elements) associated with graffiti art styles. Once identified from the experts' questionnaire responses, the foci were then grouped into facets — into mutually exclusive divisions of a subject area, the subject area in this case being styles relevant to graffiti art pieces. These facets are applicable to all graffiti art pieces, regardless of the style in which the piece has been created. For instance, any graffiti art piece can be analyzed in terms of its legibility, its dimensionality, its use of arrows, and its fill effects.

Thirteen unique facets were identified from the analysis of the graffiti art experts' questionnaire responses, and there are between two and six foci

for each of these facets. (The average number of foci per facet is 3.15.) The facets are patterned after the range of topics covered by the final iteration of the questionnaire (Appendix A). There were, however, two cases where facets addressed in this questionnaire were ultimately eliminated from the classification system (Word Shape and Background), and one case where the facet was redefined (Symbols). The rationale for removing Word Shape — the overall shape of a graffiti art piece according to the collective arrangement of the letters — was its limited utility in assisting cataloguers to differentiate styles of pieces. This facet was first introduced in the third iteration of the questionnaire, based on GREX8's observation that "most traditional wildstyles will still fit into a rectangle, somewhat neatly," and that pieces in the Abstract style "might fit the shape of a crescent, a check mark, a wedge, or some other non-quadrilateral." But GREX9 questioned the usefulness of word shape as a means of demarcating graffiti art styles, observing, "Most pieces are rectangular or diamond shaped, so it's not a big differentiator." The analysis of experts' responses corroborated this viewpoint: with the exception of the Abstract style, which GREX11 agreed is "very organic in shape," the data indicated that pieces in the other 13 styles are indeed rectangular.

The other facet eliminated from the classification system was Background, which includes elements of a graffiti art piece that do not directly involve the letters or how the letters themselves are created. Characters are one example of a background element. Experts' responses indicated that background elements are not associated with particular styles but rather are left to the discretion of the individual writer. This same distinction between, on the one hand, design features associated with a particular style, and, on the other hand, design features associated with a particular writer or crew, also led to the refinement of the Symbols facet. This facet was subsequently redefined in the classification system to refer solely to the role of arrows as letter endings. Unlike other symbols such as crowns, faces, and stars, this specific use of arrows is linked to, and indicative of, specific graffiti art styles.

As with the list of facets, the final foci list was based on the analysis of the questionnaire responses. To be sure, the enumeration of foci for facets such as Fill Effects and Letter Outlines are not exhaustive: there could very well be fill effects other than those named in the classification system. Rather, these fill effects comprise design elements that are associated with one or more of the styles covered by the classification system — an association determined by the 11 individuals who completed the questionnaires. Both the range and terminology of the foci for all 13 facets are based on cultural warrant, as identified by graffiti art experts. In the context of the classification system, cultural warrant refers to the justification of the range of facets and foci included in the system. This justification stems from the recognition of certain aes-

thetic elements of graffiti art, and the application of these elements to distinct styles, by the graffiti art community.

The order in which the facets appear in the classification system is based on Ranganathan's Principles for Facet Sequence, beginning with the Whole-Organ Principle. This principle states, "If, in a subject, facet 'B' is an organ of facet 'A,' then A should precede B."[15] In terms of graffiti art, facets that treat the word presented in a piece as a single, complete entity (Legibility, Number of Colors, and Symmetry) were placed before facets that examine the characteristics of individual letters, since the individual letters are "organs" of the word itself. In determining the sequence of these "organ" facets dealing with the formation and shape of the letters, Ranganathan's Wall-Picture Principle was applied. According to this Principle, "If two facets A and B of a subject are such that the concept behind B will not be operative unless the concept behind A is conceded, even as a mural picture is not possible unless the wall exists to draw upon, then the facet A should precede the facet B."[16] The Dimensionality facet was therefore placed directly before the Letter Outlines facet, since the determination of the type of letter outline used in a piece necessitates first examining the dimensionality of the letters. Similarly, facets that pertain to the fill (or interior) of letters were positioned after facets that deal with how the letters were formed in the first place.

Once the facets had been ordered, their corresponding foci were arranged. For each facet, the sequence of foci was intended to convey the interrelationship among the foci themselves. In most cases, this relationship is sequential, ranging from simple to complex. For example, the foci for the Number of Colors facet move from "2 colors" to "At least 3 colors" to "At least 5 colors." Similarly, the foci for the Letter Overlap facet begin with "None"—meaning no overlap whatsoever—and end with the highly complex form of letter overlap known as "Intertwined." Yet, as Vickery points out, the foci within a given facet might not have an intrinsic relationship to each other, resulting in an "unprincipled" array—one in which there is no obvious principle for determining the sequence of foci.[17] This was the case with the Fill Effects facet, where the individual fill effects are not linked in any notable way. Following Vickery's approach for "unprincipled arrays," the fill effects were therefore listed alphabetically.

After the order of the facets and foci had been established, an alphanumeric notation was assigned. First, each facet was specified by a letter that corresponded to its position within the classification system. Legibility, the first facet, was assigned the letter "A"; Number of Colors, the second facet, was assigned the letter "B," and so forth. Next, the foci for each facet were assigned numbers based on the predetermined order of foci within the array. The first Legibility focus ("Illegible") is "1" and the second Legibility focus

("Partially legible") is "2," just as the first Number of Colors focus ("2 colors") is "1" and the second Number of Colors focus ("At least 3 colors") is "2." The combination of letter and number forms a notation unit that indicates the focus and facet being referenced. The notation unit A2, for example, signifies that a given piece is only partially legible.

The Role of Facet-Focus Combinations in Assigning Style Notations

The preceding sections of this chapter have described the processes of refining the list of styles and of ordering the facets and foci that comprise the classification system. These components come together in the style notations that were subsequently assigned to each of the 14 styles covered by the system. A style notation codifies a style, manifesting its fundamental characteristics. An analogy can be drawn to Erwin Panofsky's model of iconographical analysis. The style notation unlocks a graffiti art piece by translating visual clues into stylistic meaning, in much the same way that iconographic texts enable art historians to perceive secondary level meaning as communicated through primary level visual elements. Each of the 14 style notations is unique and, once decoded, serves as a bridge linking an individual piece of graffiti art to the style in which that piece was created.

The style notations also reflect the fact that, while all 13 facets of the classification system are applicable to each graffiti art style, these facets vary in importance from style to style. Experts' questionnaire responses made clear that some facets define a given style while others play a less significant role. More precisely, it is the manifestation of a particular focus for a given facet — a specific notation unit — that becomes inextricably linked to a style. Take the No-neg style. According to the experts who discussed this style, No-neg pieces are defined, in part, by letters that exhibit a form of dimensionality known as "relief effect." As one individual explains, relief effect "is **the** key to a no-neg style, so it's [present] 100 percent" of the time (original emphasis). The name "No-neg" indicates another style marker — the absence of negative space within each letter of the piece. Because these two components are hallmarks of the No-neg style, any No-neg piece will display these characteristics, regardless of which writer created the piece.

In the context of the classification system, a facet-focus pairing that, like the use of the relief effect and the absence of negative space in the No-neg style, serves as an indicator of a style has been termed "definitional." Definitional facet-focus combinations remain constant across multiple examples of a given style. They are the building blocks of iconic style. Separately, each

definitional facet-focus combination represents one essential ingredient that a graffiti art piece needs to exhibit in order for it to be representative of a given style. Taken together, the definitional facet-focus combinations form the notation for that style. For example, seven definitional facet-focus pairings are associated with the No-neg style. This produces in the classification system a style notation composed of seven definitional notation units: D3E3F3H3J2K2M1. This assemblage of style notation units represents a set of guidelines that, on the one hand, the graffiti writer has followed in creating a piece and that, on the other hand, viewers can use to link the piece to its style.

While the style notation codifies the defining characteristics of a style, the classification system as whole accommodates characteristics that are more contingent on a graffiti writer's own interpretation of a graffiti art style. These elements have been termed "predominant" and "non-definitional" in the classification system. Non-definitional facets are not associated with any one focus but instead vary from piece to piece based on an individual writer's predilections. They are strictly in the domain of personal, not iconic, style. Predominant facets fall between their definitional and non-definitional counterparts, exhibiting more variability than the former but more stability than the latter.

Predominant and non-definitional facets recall Panofsky's distinction between factual and expressional primary subject matter. As noted in chapter 1, factual primary subject matter "implies the conscious intention of the artist," while expressional primary subject matter "may well be unintentional."[18] This is not to say that graffiti writers did not intend to include certain features, subsequently categorized as predominant or non-definitional in the classification system, within their work. What is does mean is that the inclusion of these features is separate from the writers' intent to create a piece in a certain style.

Facets that are non-definitional for one style, however, might be predominant or definitional for another style. For example, while one expert observes that "coloring has little to do with" the No-neg style, color is a fundamental aspect of the Silvers style, as indicated by the style name itself. As GREX9 notes, "Fills are completely silver (chrome) 95 percent of the time" in Silver pieces and have "a flat dark color outline, usually black. Outline color variations are usually blue, green, or red." The consistent pairing of silver fills with a single outline color means that B1 (Number of Colors: 2 colors) is a definitional notation unit for this style; it therefore appears within the Silvers style notation. Conversely, because color plays a predominant, rather than definitional, role in the No-neg style, the Number of Colors facet is not part of the notation for this style.

Assigning a notation for a style therefore entailed determining which facet-focus combinations were definitional, which predominant, and which non-definitional in the context of that style. This process involved not only identifying in the graffiti experts' questionnaire responses which characteristics are associated with a style, but also evaluating the strength of this relationship. If one of the experts indicated that the letter overlap in a given style is "Intertwined," the underlying question becomes whether this facet-focus pairing is always (or almost always) associated with that style (definitional), usually associated with that style (predominant), or rarely associated with that style (non-definitional). While it would be unlikely that someone would select a focus that rarely occurs, the non-definitional categorization can also express a range of potential foci. If the Letter Overlap facet is not especially consequential to a style, then "Minimal," "Standard," and "Intertwined" might be equally applicable foci. The identification of the applicable focus (as well as the strength of that association) was made for every facet within the context of each of the 14 graffiti art styles covered by the classification system.

The classifications of the definitional pairings that comprise the style notations, as well as the predominant and non-definitional facet-focus combinations which express the more interpretive aspects of a style, take into account the nuances of the experts' opinions and accommodate differences of opinions. As a result, the classifications are based on the consensus of the graffiti art experts. Consider the following situation in which two experts attributed dissimilar characteristics to the East Coast Piecing style. With regard to the Legibility facet, GREX10 described the style as illegible, while GREX8 characterized it as legible. These individuals offered contrasting opinions not only about the focus itself, but also about the applicability of their individual selections: GREX8 indicated that pieces in this style are legible 50–75 percent of the time; GREX10 felt that pieces in this style are illegible more than 75 percent of the time. These percentages mirror the experts' multiple choice-based selections, described in chapter 3, concerning the applicability of their focus selections.

The strength of the relationship between a focus and facet, as expressed by these percentage selections, played a central role in reconciling experts' divergent views. Continuing with the example of the East Coast Piecing style, the notation unit A1 (Legibility: Illegible) was ultimately assigned to this style in the classification system. This decision was based on the fact that one of the experts had indicated that the illegible focus applied to pieces in this style more than 75 percent of the time. This notation unit, however, was not classified as definitional, and A1 is therefore not part of the style notation for the East Coast Piecing style. Instead, the facet-focus pairing of A1 was classified as "predominant," taking into account the second expert's opinion that "Leg-

ible" was the appropriate focus, albeit only 50–75 percent of the time. In practical terms, the categorization of A1 as predominant signifies that, while the concept of legibility is not all that important in the East Coast Piecing style, examples of this style are most likely to be illegible. But this categorization does not preclude the possibility that pieces created in the East Coast Piecing style might be legible (or partially legible, for that matter.) The unique role of predominant and non-definitional facet-focus pairings in the process of style identification will be examined later in the chapter.

As this example shows, a conservative approach was taken in the categorization of facet-focus pairings in order to best reflect the opinions of the graffiti art experts. Occasionally facet-focus combinations were categorized as predominant even when the same focus was selected. In one such case, two experts both felt that the focus "Varied" best characterized the letter strokes of the Swedish Train style. While one of these individuals indicated that varied letter strokes occur in pieces of this style more than 75 percent of the time, the other made the more conservative estimate of 50–75 percent. In situations such as these, the focus was categorized as predominant. That only one of the two experts felt that the letter strokes are "Varied" more than 75 percent of the time signifies that this facet-focus pairing is not a characteristic that *defines* the Swedish Train style. Without consensus as to the facet-focus combination itself and its rate of occurrence, these combinations cannot be considered definitional.

The categorization of the facet-focus pairings was intended to be not only conservative, but also inclusive. This goal is best illustrated in the context of the non-definitional category. The non-definitional designation was applied to cases where experts agreed on a given focus but indicated that it occurred less than 50 percent of the time, as well as to cases where experts agreed that multiple foci are equally applicable to a particular style. The non-definitional classification also covers situations where individuals disagreed as to the focus but cited the same rate of occurrence. One such example is the relationship between the Letter Overlap facet and the No-neg style. GREX8 felt that "Minimal" best describes how the letters overlap in No-neg pieces, while GREX11 identified "Standard" as the most appropriate focus. But both indicated that their selection was applicable more than 75 percent of the time. This lack of consensus regarding the focus itself, combined with the lack of differentiation as to the likely rate of occurrence, resulted in the categorization of both "Minimal" and "Standard" as non-definitional foci for the Letter Overlap facet.

The examples provided thus far have illustrated cases where two experts discussed a given style. What happened when more than two experts contributed different viewpoints? Compounding this lack of consensus was the

fact that not all experts completed the multiple-choice version of the questionnaire and therefore did not numerically indicate the strength of the relationship between a facet and their foci selections. In order to accurately incorporate all contributed viewpoints, the categorization of facet-focus pairings in these situations took into account both the number of experts who discussed a given style and the format of the questionnaire they had used. If the experts had discussed a style using different formats of the questionnaire, then the categorization of facet-focus pairings was based on majority opinion. Consider the example of the Wild style, which was discussed by four experts. One of these individuals, responding to the multiple-choice-based questionnaire, indicated that 50–75 percent of Wild style pieces have an "Intertwined" letter overlap. If he had been the only one analyzing the Wild style, this facet-focus combination (I5) would have been categorized as predominant. But three other experts discussed the Wild style using the open-ended questionnaire, and two of these individuals also described the letter overlap in Wild style pieces as Intertwined, albeit without the quantification. (The fourth expert who discussed the style did not offer an opinion about letter overlap.) Since intertwined letters were cited by the majority of experts who discussed the letter overlap facet for this style, I5 was categorized as a definitional notation unit for the Wild style.

In other cases, majority opinion dictated that the classification of a facet-focus pairing should reflect a more tenuous relationship between a visual element and a style than that suggested by one of the experts. For instance, the expert who completed a multiple-choice-based questionnaire felt that Wild style pieces are "2-dimensional with 3-d effects" more than 75 percent of the time. Conversely, others working with the open-ended questionnaire, while agreeing with the focus itself, indicated that 3-d effects are optional on Wild style pieces. Since the majority of experts described these effects as non-essential, this feature cannot be said to define the Wild style, and the facet-focus combination was categorized as predominant.

Despite the absence of quantifiers to indicate the strength or frequency of facet-focus relationships, this information could be gleaned from the descriptions that experts had provided of the styles. Both open-ended and multiple-choice questionnaire respondents often used terms such as "hallmark" or "key" in their characterizations of the elements which define a style, whereas features destined to be classified as predominant in the classification system were given qualifiers such as "usually." Experts' sample images also provided visual clues as to the relative importance of certain characteristics. A Wild style image provided by GREX6 (who had completed the open-ended iteration of the questionnaire) prompted this follow-up question: "The first wildstyle example that you provided feels less 3-dimensional than the other

two examples, but instead it has a very intense, fluid motion. Am I correct in thinking that the letters in wildstyle pieces or burners can be either 2-dimensional or 3-dimensional?" In his response, GREX6 confirmed that this piece "doesn't have 3Ds," adding that "Wildstyle frequently starts with interlocking letters, then the 3Ds are added in later steps." This observation echoed the comments provided by GREX1, who described one of his own Wild style pieces as having "a 3d feel to it — It looks as if it were coming out at you" before noting that "*many* [wild style] pieces are done this way to give it more complexity and interest" (emphasis added). Taken together, these comments indicate that 3-dimensional effects are an optional, albeit popular, component of this style.

Distribution of Definitional Notation Units Across Styles

Across the sample of 14 styles covered by the classification system, the average number of definitional facet-focus pairings was seven, with a range of 3–11. That is, the styles had between three and eleven defining characteristics, each of which was encapsulated in a notation unit and expressed collectively through style notations. Table 5 shows the distribution of notation units across the 14 styles, as well as the number of experts who discussed each of these styles.

Table 5. Number of definitional notation units per graffiti art style

No. of Units	Style Name(s)	No. of Experts
11	Los Angeles Cholo-based	2
10	Silvers	2
9	Semi-wild	3
8	CTK	1
8	Pichador	2
7	East Coast Piecing	2
7	Neo Classic American Freight	2
7	No-neg	2
6	Abstract	2
6	Dimensional	3
6	Swedish Train	2
6	TFP	2
4	Wild	4
3	Dortmund	2

As this table indicates, there is little correspondence between the number of definitional notation units for a style and the number of experts who discussed that style. This is especially notable since it would be tempting to posit that as the number of viewpoints increased, the number of definitional facets would decrease. According to this theory, the more people discussing a given style, the less likely that consensus could be reached regarding which characteristics define that style. Based on the styles listed in table 5, this was not the case. For instance, styles that were discussed by two experts range from 11 definitional notation units for the Los Angeles Cholo-based style to three for the Dortmund style. CTK — the only style with one contributor — has the same number or fewer definitional notation units (8) than four other styles. The one exception appears to be the Wild style, which was discussed by four experts and whose style notation is comprised of only four definitional facet-focus combinations. Yet, here the low number of definitional pairings can be as readily explained by the nature of the style itself as by a lack of consensus. As noted earlier in the chapter, the Wild style is an established and popular graffiti art style that is constantly being reinterpreted by writers. Arguably, the fact that writers so often incorporate their own personal style within the Wild style would have reduced the number of core characteristics (i.e., definitional facet-focus pairings) still associated with the style.

The idea that the inherent nature of a style dictates the number of definitional notation units is also applicable to other styles. Consider the Silvers style, which has a style notation comprised of 10 definitional facet-focus pairings: A3B1C2D1E1G1I2J2K1M1. GREX9 noted that Silver pieces "are quickly painted, good for a tight spot or a tight schedule." At first glance, it seems somewhat ironic for a style that is quickly painted to have the second longest style notation in the classification system. But it is precisely the quickness of execution of Silver pieces that informs many of its 10 defining features. Silver pieces are known to be asymmetrical, 2-dimensional, and not have arrows. The inverse of these features (i.e., symmetrical pieces with 3-dimensional effects and decorative elements such as arrows) takes time to create — more time than the Silvers writer is able or willing to spend. Similarly, since Silver pieces are legible, there is little surprise that the letters in these pieces have minimal overlap: the more the letters are intertwined in a graffiti art piece, the more difficult they are to read.

Based on an analysis of the characteristics themselves, the fact that the Silvers style has an unwieldy notation is a reflection not of how many experts examined the style in their questionnaires, but of how certain features engender other features. Eleanor Rosch observes that "the perceived world is not an unstructured total set of equiprobable co-occuring attributes. Rather, the

material objects of the world are perceived to possess ... high correlational structure. That is, given a knower who perceives the complex attributes of feathers, fur, and wings, it is an empirical fact provided by the perceived world that wings co-occur with feathers more than with fur."[19] Patterns can be detected in the relationship between certain attributes of graffiti art pieces — a relationship that is expressed through the style notation.

How the Classification System Operates

Composed of definitional facet-focus combinations, each of which constitutes a building block of a given style, the style notation is a crucial aspect of how the classification system functions. As mentioned earlier in the chapter, it serves as a bridge between an individual graffiti art piece depicted within an image and the identification of the style in which the piece was created. But how does an image cataloguer arrive at the style notation in the first place? Remember, the cataloguer would not know which characteristics define the style depicted in an image; he or she would not know which facet-focus combinations are definitional for that style or image.

The classification process is predicated on the image cataloguer selecting foci for all of the system's 13 facets, beginning with Legibility (A) and working through to Fill Consistency (M). Consider the following scenario in which a cataloguer is working with an image of a piece in the No-neg style. Applying the definitions of the facets and their foci, she produces the following string of notation units: A2B3C1D3E3F3G2H3I3J2K2L6M1. The style notation for the No-neg style is the less unwieldy D3E3F3H3J2K2M1. The question then becomes: how does the cataloguer whittle this string of 13 facet-focus combinations that she selected into the seven-unit style notation for the No-neg style? Furthermore, how is she to interpret the style notation itself?

The answer to these questions lies in the relationship between the style notations and two components of the classification system: (1) descriptions of the graffiti art styles; and (2) an alphabetical index that lists definitional notation units. While the style notations figuratively serve as a bridge between an image of a graffiti art piece and the identification of that piece's style, they literally link the image to a style description provided in the classification system. The style descriptions are arranged according to the order of the notation units in the style notations themselves. Therefore, the Abstract style is the first entry, not because the style name happens to begin with the letter "A," but because Abstract is the only style in the classification system that has A1 in its style notation. (In other words, Abstract is the only style for which

Legibility: Illegible is a definitional facet-focus combination.) The next style description — that of the TFP style — has a style notation that begins with the notation unit A2 (Legibility: Partially legible). If two styles share the same initial notation unit, their placement is determined by the next facet-focus pairing in the notation. For example, the notation for the Dortmund and Wild styles both begin with E1. In this case Dortmund precedes the Wild style because the next unit in its notation — G1— comes before that of the Wild style (I5).

Although they are arranged according to style notation, the individual entries provide descriptions of the styles that move beyond what is codified in the notation. Background information, consisting of the provenance of the style and of the style name, serves as an introduction to the style at the beginning of the entry. These brief introductions are also used to contextualize salient features of styles that, unlike "No-neg," are not revealed in the style name itself. The description for the Pichador style, for instance, explains that

> The Pichador style is derived from Pichação, a tag-based lettering style native to São Paulo, Brazil. Pichação tags are created using buckets of latex paint and 3-inch paint rollers. The use of rollers produces letters of uniform width — a hallmark of Pichador pieces as well.

While the preliminary material occasionally emphasizes characteristics that are highlighted in the actual descriptions, at other times it draws attention to facets not covered by the classification system. It was previously noted, for example, that Word Shape was eliminated from classification system because of this facet's limited utility in denoting styles other than the Abstract style. Nonetheless, information regarding word shape was provided in the introductory material for the Abstract style description because it is germane to pieces created in this style.

Following the brief introduction, each style description is divided into three parts: Defining Characteristics, Predominant Characteristics, and Other Characteristics. As their labels suggest, each of these sections corresponds to one of the three types of categorizations for facet-focus combinations: definitional, predominant, or non-definitional. For the No-neg style, the Defining Characteristics section lists the definitional notation units of this style in the order that they appear in the style notation, beginning with the relief effect (D3) and ending with the consistent letter fill (M1). When applicable, additional information that is not conveyed through the notation units alone is also provided. For example, while the style notation indicates that arrows are "Not integral" to the No-neg style (J2), the entry clarifies this relationship by indicating that arrows are not associated with the style at all. This information provides an additional clue to the style, differentiating it from

styles in which arrows, although present, are not an integral component. (See, for example, the description of the Neo Classic American Freight style.)

Although they are not part of the style notations, predominant and non-definitional facet-foci pairings are indispensable parts of the style descriptions. And while the definitional notation units serve as the primary means of connecting an image to its corresponding style, the features described in these other sections would theoretically enhance a cataloguer's ability to distinguish graffiti art styles by providing details that are not communicated through the notation itself. (This point will be discussed further in chapter 6.) Thus, a cataloguer reading the No-neg entry would learn that the letters in this style most often have either minimal or standard overlap, for instance, and that they can have either no fill effects whatsoever or have some combination of fades, fill shapes, and shines.

The example of the Letter Overlap facet in the context of the No-neg style demonstrates how non-definitional facet-focus combinations were transcribed in the composition of the style descriptions. As noted earlier, the two experts who discussed this style disagreed about the most appropriate focus for the Letter Overlap facet. At the same time, they both stated that their selection was applicable more than 75 percent of the time, resulting in a non-definitional classification for this facet. The No-neg style description lists Letter Overlap under "Other Characteristics," indicating that there is not one type of letter overlap that predominates among No-neg pieces. But the style description does note the two most likely forms of letter overlap, as identified by the experts: Minimal (I2) and Standard (I3).

While facet-focus combinations categorized as "predominant" are referenced in the style descriptions under the "Predominant Characteristics" section, the references themselves are expressed in one of two ways, depending on the underlying reasons for the categorization. For instance, facet-focus pairings were categorized as predominant in cases where it was agreed that a given focus occurs in 50–75 percent of pieces in a particular style, as when both experts stated that No-neg pieces are partially legible 50–75 percent of the time. Here the reference to legibility in the style definition cites the specific focus, noting that No-neg pieces "tend to be Partially legible (A2)." In other cases, the experts who discussed a style did not agree on the corresponding focus; furthermore, they often indicated different degrees of applicability. In these situations, the reference under "Predominant Characteristics" in the style description cites both foci, but emphasizes that one is more likely to occur than the other. With regard to the Number of Colors facet, for instance, the No-neg style description explains that "No-neg pieces generally have at least 3 colors (B2) but can have more than 5 (B3)." As these examples illustrate, the style descriptions employ the complete range of experts'

viewpoints. Theoretically, cataloguers would use the information provided in "Predominant Characteristics" and "Other Characteristics" sections, in conjunction with the features codified in the style notation, to compare what they had determined to be the characteristics present in an image with how these characteristics relate (or do not relate) to individual styles.

Another component of the classification system, the alphabetical index, is intended to aid cataloguers in locating relevant style descriptions. On the one hand, the index provides access to the descriptions through an alphabetical arrangement of the style names, accompanied by their style notations, such as "Los Angeles Cholo-based Style, B3D2E1F3G2H1I2J1K1L2M1." On the other hand, the index also follows Vickery's approach by including "not only each scheduled term, but also those combinations of terms which have been used" in the style descriptions.[20] As per one of Vickery's examples, an alphabetical index should therefore include not only "Flying operations, K," but also "Mountain flying, Kvj," "Night flying, Kvb," and Ocean flying, Kvh."[21] The classification system's alphabetical index provides access to the descriptions of graffiti art styles through the notation unit of every possible facet-focus combination. For example, directly under the listing for the Los Angeles Cholo-based style in the index is an entry for M1, the notation unit representing the facet-focus combination of "Fill Consistency: Consistent." Within this entry is a list of all the styles that have M1 in their notation — that is, all styles covered by the classification system that have "Fill Consistency: Consistent" as a definitional facet-focus pairing. The notation unit entries are listed alphabetically by notation, not by terminology, thereby operating as an inversion of the type of index described by Vickery.

The notation unit entries demonstrate the role of the index in linking images to styles — in enabling cataloguers to move from the string of 13 discrete notation units, which are the result of the initial application of the facet and foci definitions, to a distinct style notation. Consider again the example of the cataloguer working with an image in the No-neg style who has produced the following string of notation units: A2B3C1D3E3F3G2H3I3J 2K2L6M1. While her string of 13 notation units actually contains the No-neg style notation (D3E3F3H3J2K2M1), she cannot simply look up "A2B3C1D3E3F3G2H3I3J2K2L6M1" to discover the style of the image with which she is working. This string of units does not exist within the context of the classification system because it is not a style notation; in fact, no style notation exceeds 11 units. What the cataloguer can do, however, is look up each of the 13 units individually in the alphabetical index to see which styles have these facet-focus combinations as defining characteristics. She can then read the descriptions of each of these styles to see which style matches the image she is classifying.

This process of identifying a style based on individual notation units — exceedingly time-consuming when using a text-based system — is most readily explained in the context of an automated system. Imagine that the cataloguer has typed "A2B3C1D3E3F3G2H3I3J2K2L6M1" into a database that operates in the same manner as the classification system. Matching each notation unit in this string to the definitional facet-focus combinations contained in the alphabetical index would produce a series of hits. A search based on M1 alone would yield 11 hits, since there are 11 styles, ranging from CTK to Wild, that have consistent fills as a defining characteristic. Typing in the entire 13-notation-unit string would yield 14 hits — one for each style contained in the classification system. In other words, each of these 14 styles has at least one definitional facet-focus combination in common with the 13-notation-unit string produced by the cataloguer. To be sure, it would be highly impractical to have to read through all 14 style descriptions in order to discover that the image in question belongs to the No-neg style. Yet, if the 14 hits are ranked according to the number of definitional notation units a style has in common with the cataloguer's query, as shown in table 6, it is clear that the cataloguer would begin the identification process by reading the description for the No-neg style first.

Table 6. Rankings of styles for hypothetical No-neg query

No. of notation units in common	Style Name	Style Notation
7	No-neg	D3E3F3H3J2K2M1
3	East Coast Piecing	D2F3G2H3K1L2M1
3	Los Angeles Cholo-based	B3D2E1F3G2H1I2J1K1L2M1
3	Neo classic American Freight	D2E1H2I3J2L5M1
3	Pichador	A3G1H1I1J2K1L6M1
3	Swedish Train	C2D2H3I2J2K2
3	TFP	A2B3H2I3L3M2
2	Abstract	A1C2F3I5J2K2
2	CTK	A3C2D2E1F3G2H2M1
2	Dimensional	D4E2J2L1L2M1
2	Semi-wild	B2D2E1F3H2I3J1K1M1
2	Silvers	A3B1C2D1E1G1I2J2K1M1
1	Dortmund	E1G1M1
1	Wild	E1I5J1M1

This example is meant only to demonstrate how the classification system functions. It is a best case scenario in which the cataloguer had successfully identified all seven of the definitional facet-focus combinations contained in the notation for the No-neg style. Even if the cataloguer had identified,

say, only four of the seven units, it is nonetheless plausible that the combination of the ranking of the styles by an automated system and the details provided in the style descriptions would provide sufficient information to identify the style presented in an image.

Scope and Limitations of the Classification System

The classification system as it stands is intended as a model for investigating the applicability of Panofsky's theories of iconographical analysis to graffiti art. It is not a definitive system that covers all styles of graffiti art pieces. It is, however, a working model that could be expanded to incorporate additional styles. Because the facets and foci are applicable to all styles of pieces, new styles could be assigned notations and accommodated within the system. While the notations for the 14 styles now included are mutually exclusive, it would be impossible to predict whether they would remain so with the addition of new styles. A new style incorporated into the classification system could theoretically have the exact same range of definitional facet-focus pairings as one of the current 14 styles. The addition of other styles might also lead to the identification of new foci, or even facets. While affecting the notations of new styles, additional facets would alter the current set of style notations.

Despite the inability to guarantee the mutual exclusivity of the style notations, it could also be argued that a situation in which styles share the same defining characteristics is unlikely to occur. If a style is truly an iconic style — if it is a unique, verifiable, and replicable graffiti art style — it would be improbable that its defining characteristics would be entirely indistinguishable from other styles. More likely are scenarios where the range of defining characteristics for older, established styles, such as the Wild style, diminishes over time as new styles are based on the original style's core elements. Yet even a situation where multiple styles shared the same notation would not render the system inoperable. Two styles with the same notation would receive the same ranking in a given search, thereby leading a cataloguer to both style descriptions. The details provided in the descriptions would help the cataloguer to differentiate the two styles and to select which applies to the image being classified. While the style notation encapsulates the essence of a style, it is the style description that paints the full picture of the style and its features.

The scope of the classification system was dictated by the information provided by the eleven graffiti art experts who contributed their expertise. The facet, foci, and style descriptions are therefore based on data provided

by a limited number of experts. And while the style notations and descriptions presented in the classification system mirror the opinions of these experts, they are not meant to be immutable. Just as style notations could change with the identification of new facets, they might also fluctuate with the inclusion of additional viewpoints. The notations and descriptions are based on the consensus reached among the experts who discussed these styles. Incorporating the viewpoints of other experts might result in a definitional facet-focus pairing being re-categorized as predominant, or, conversely, a predominant facet-focus pairing being re-categorized as definitional.

It is therefore impossible to describe the style notations as infallible. While this partly reflects the fact that other experts might not agree with the current categorizations, it is also an acknowledgement that graffiti art is not static. Graffiti writers are continually experimenting, reinterpreting existing styles and developing new styles. The underlying premise of a definitional facet for a style is that the same focus is likely to occur in more than 75 percent of examples of that style: for instance, more than 75 percent of pieces in the No-neg style have no negative space. Although the relationship between characteristics and styles that are named for those very characteristics, as in this example, are apt to stand the test of time, other connections between styles and characteristics might prove to be more tenuous. Style notations should thus be interpreted as exemplifying the majority of pieces in a given style, with the understanding that there could always be exceptions.

As with the range of the facet, foci, and style definitions, the focus of the classification system on styles of pieces only (as opposed to tags and throw-ups) was also dictated by the range of data provided by the graffiti art experts. But the emphasis on pieces in the questionnaire responses, and the resulting focus on pieces in the classification system, does not constitute a limitation for two reasons. First, as a visually complex form of graffiti art, pieces span a far greater number and variety of individual, distinct styles than would be the case with tags and throw-ups. Second, the classification system is based on the consensus of the graffiti experts who contributed their viewpoints and opinions. This consensus applies not only to the range of facets and foci defined in the classification system, but also to the breadth of styles that it covers. By concentrating on pieces, the classification system reflects the graffiti experts' consensus about what is the most relevant form of graffiti art, in the context of their own work as well as that of their peers.

5

What Image Cataloguers Saw

Chapter 4 used the example of a cataloguer trying to identify the style of a No-neg piece to illustrate how the classification system operates, both in its present text-based form and in a hypothetical automated version. As demonstrated by this "search," the system functions by linking the primary subject matter elements identified by the cataloguer (i.e., her foci selections for each of 13 facets) to descriptions of specific graffiti art styles, using the alphabetical index. This identification process mirrors Erwin Panofsky's model of iconographical analysis: the cataloguer moves from an enumeration of primary subject matter elements within the image to an understanding of how these elements contribute collectively to the meaning — the iconic style — of the piece.

It was noted in chapter 3 that Karen Markey's choice of certain European artworks for her thematic catalog reflected her "great certainty that the content depicted in these visual images exemplified primary subject matter and secondary meaning."[1] While graffiti art pieces embody this same dynamic, another related issue needs to be addressed. With regard to her selection of artworks, Markey adds, "Furthermore, the style of art at this time was primarily representational, so indexers with minimal training in observing and interpreting works of art would have little difficulty recognizing the elements of primary subject matter: objects, events, and expressional qualities."[2] Graffiti art, in contrast, is nonrepresentational. Although the tag depicted in a graffiti art piece uses letters to reference a specific writer or crew, the depiction itself is visually abstract — a function of the degree of legibility and interconnectedness of the letter forms. To be sure, styles vary in their degree of abstraction. Yet even the least abstract examples present a vastly different array of primary subject matter than the objects, events, and expressional qualities identified by Panofsky and discussed by Markey. Therefore, the question becomes whether cataloguers can, in fact, identify the primary subject matter of graffiti art images using the classification system's facet and foci definitions.

This chapter reports the findings of a study undertaken to determine whether image cataloguers with no background or expertise in graffiti art were able to understand and apply these definitions to actual images of graffiti art — the essential first step in determining the style of a graffiti art piece. It is important to emphasize that the intent of this study was not to test the functionality of the classification system as a whole, but rather a cornerstone of the system. The implications of the cataloguers' comprehension of the facet and foci definitions in terms of style identification and the applicability of Panofsky's process model are examined in chapter 6.

The Cataloguers

A total of 30 image cataloguers (26 women and 4 men) tested the functionality of the facet and foci definitions. The term "cataloguer" was defined as an individual with work experience in indexing, cataloguing, or organizing images, whether in photographic, slide, or digital formats. This experience could be the result of working with image collections in archives, libraries, academic art departments, or museums. The only other prerequisite for participating in the study was no previous background knowledge of graffiti art. The cataloguers were recruited the following sources: *The Visual Resources Directory*;[3] the web site of the Visual Resources Association; the listserv of the Canadian Art Libraries Society; and referrals from other cataloguers. Each cataloguer was e-mailed a contact letter which provided a description of the study and estimated the time commitment (about two hours) involved in participating. A $50 honorarium (local currency) was offered as an incentive to participate.

The duration of the cataloguers' image-based work experience ranged from 1 to 30 years, with an average of 9.3 years. While these individuals are collectively referred to as "cataloguers" in the context of the study, their job titles — "Online Content Producer," "Photo Archivist," "Image Collections Curator," to cite a few examples — reflect a broad range of roles and responsibilities. This range extends not only to their professional expertise, but also to the type of image collections with which they are affiliated. Table 7 shows the breakdown of cataloguers in relation to the type or location of the collections with which they worked. Nine of the 30 participants were slide or visual resource curators at academic libraries, including both main university libraries and special libraries dedicated to the disciplines of art, design, and/or art history. The eight participants affiliated with university art departments likewise were visual resource curators. The image collections they curate, however, are resources managed within and for a specific academic department and are autonomous from the university library system.

Table 7. Distribution of cataloguers according to type of institution or collection

Type of Institution or Collection	No. of Cataloguers
Academic Libraries 9	
University Art Departments	8
Archives (including Museum Archives)	6
Museums (excluding Museum Archives)	6
Other: Media-based	1
Total	30

As table 7 indicates, six individuals each worked at archives or museums. Two of these six archivists were employed at museums, while the other four worked at public archives. Many other aspects of museum work were represented by the six members of the "Museums (excluding Museum Archives)" category: one was a Visual Resources Cataloguer; another was a Rights and Reproductions Coordinator; three were responsible for creating online image databases; one was the executive director of a museum. The variety of job descriptions also points to the different media that can comprise an image collection. Indeed, considering the group of 30 cataloguers in terms of the types of collections for which they are responsible entails examining not only the type of institution where they are employed, but also the format of the resources within those collections. Of the 30 individuals, 22 (73.3 percent) worked with slides or digital images, while 8 (26.7 percent) worked with original or archival material.

Study Design

Each of the 30 cataloguers was sent by postal mail (or, when feasible, hand-delivered) a package of materials consisting of two booklets, consent forms, a cover letter, and a stamped, self-addressed return envelope. The first booklet provided an overview of the study and general background information about graffiti art. It also contained a "Graffiti Art 101" guide consisting of definitions for four basic terms employed throughout the facet and foci definitions: letter outlines, letter fills, 3-d effects, and letter faces. These materials were followed by 10 images of graffiti art (each representing a unique style) and 10 corresponding classification worksheets. Each classification worksheet presented the 13 facets and their foci in the same order as found in the classification system itself.

The second booklet contained instructions for completing the classification worksheets, as well as the facet and foci definitions. The cataloguers

were asked to examine each image using only these definitions and to mark their foci selections for each of the 13 facets on the classification worksheet. They were not asked to match style notations to style descriptions, and the style descriptions and the classification system's alphabetical index were not part of the project materials. After completing the worksheets, cataloguers responded to six open-ended questions concerning their impressions of the facet and foci definitions, both generally and in relation to the specific images they had viewed.

By dividing the materials into separate booklets, the cataloguers were able to read the facet and foci definitions (located in the second booklet) while studying the images (located in the first booklet). Indeed, the instructions for completing the worksheets asked cataloguers to begin the study by reading the definition of the first facet while looking at the first image presented in the booklet. After reading the facet definition, their next step was to read over each of the focus definitions for that facet, again examining the image as they read. Once they had decided which focus best described what they saw in the image, they were instructed to circle their selection on the corresponding image classification worksheet.

The testing of the facet and foci definitions utilized 28 different images: 2 images of each of the 14 different styles of graffiti art covered by the classification system. The images viewed by the cataloguers were selected from the examples provided by the previously mentioned graffiti art experts as part of their questionnaire responses. Therefore, the identification of an image as representative of a specific style had been made by the graffiti art experts themselves. The use of two images per style was intended to ensure both the validity and reliability of the data collected. On the one hand, more than one image per style was needed to confirm that the cataloguers' ability (or inability) to identify certain characteristics within a given image is based on their comprehension of the characteristics themselves — a comprehension that is not limited to that one particular image. On the other hand, including more than two images per style would result in each image being examined by fewer cataloguers, thereby adversely affecting the reliability of the data.

Because multiple experts discussed the same styles, there was a pool of representative images from which to assemble the 28-image sample. The selection of two exemplary images for each style was based on three criteria, the first of which was the clarity of the piece within the image. This judgment was made solely on the quality of the photograph, not on the piece itself. The definitions of the facets and foci are detail-oriented, and these same details need to be visible within the images. Of course, cataloguers in an actual work environment do not work only with clear, perfectly reproduced images. In the controlled environment of the study, however, images were selected in

which the characteristics that cataloguers would need to identify were not obscured. This meant eliminating images in which the piece was photographed from a great distance, since the smallness of the piece would make it extremely difficult to identify specific features. Moreover, enlarging the image digitally would result in the distortion of these features. In the case of pieces that had been painted on trains, this problem was often exacerbated by the fact that the train had been photographed through fencing surrounding rail yards or tracks. Another problem, more frequently associated with photographs of pieces that had been painted on walls, was glare, which made it difficult to distinguish such details as letter outlines and letter strokes within the piece.

The second selection criterion was the condition of the piece depicted within the image. As forms of both public and illegal art, graffiti pieces are famously transient. They are susceptible to "buffing" (removal from a wall or train), "going over" (the covering of a piece with tags or with portions of another piece), and simple erosion over the course of time. What looked to be a design feature of interrupted outlines in one image, for example, was actually a chunk of paint missing from the piece.

This example of the interrupted outline that was not an outline at all ties into the final criterion for image selection: the clarity of definitional facet-focus pairings within a piece. Since the purpose of the study was to see whether cataloguers could identify characteristics based on the facet and foci definitions, this objective was best served using images that most clearly illustrate these characteristics. The judgment of which images best exemplified the characteristics associated with a particular style (and therefore the style itself) was made by the researcher. Consider the following scenario. Two images need to be selected from a pool of four images of pieces in the East Coast Piecing style. The fact that the pieces are of the East Coast Piecing style has been ascertained by the graffiti art experts who provided the images. This identification was also corroborated by the researcher through the identification within the piece of the characteristics that define the East Coast Piecing style — the varied letter strokes, the limited negative space, the consistent letter shape, and so forth. The role of the researcher, then, was to decide which of the four images presented the most clear-cut depictions of varied letter strokes, limited negative space, and consistent letter shape. While individuals with experience in writing or viewing graffiti art could readily determine that all four examples exhibit these characteristics, the goal was to select the image that would most likely stand out to people who have no previous experience with graffiti art, such as the cataloguers participating in the study. Therefore, while all four images of the East Coast Piecing style would have shown varied letter strokes, the two images in which the letter strokes most obviously or exag-

geratedly moved from thick to thin, or from thin to thick — the definition of the varied letter strokes focus — were selected for the cataloguers' booklets.

While the presence of definitional facet-focus combinations within each of the 28 images in the final sample was confirmed through this selection process, the one area in which the researcher's opinion differed from those of the graffiti art experts was the Legibility facet. Specifically, a piece in the TFP style deemed partially legible by the person who provided it appeared to be completely illegible to the researcher. Nonetheless, the opinion of the expert took precedence, and, for the purposes of testing the facet and foci definitions, the piece was categorized as partially legible. That such a difference of opinion would arise in the context of this particular facet is not surprising. While legibility is a highly subjective concept, non-writers typically would be less adept than writers at parsing graffiti art pieces. Writers (and other experts) are familiar not only with the styles of the pieces, but also with the tags of peers who work in those styles. This second point is especially relevant, since the word presented in a graffiti art piece is the writer's tag.

Once selected, the images were professionally printed to ensure that all copies of the same image were identical, with no variations in tone or color. Each image was printed in portrait format on 8½ by 11 inch paper; prior to printing, each image was sized according to individual specifications. These specifications reflected the maximum size to which a piece could be enlarged without distortion and without exceeding the left-right paper margins. A sampling strategy was then used to create the unique sets of 10 images that were distributed to the cataloguers.[4] The goals of the strategy were: (1) to make certain that no style was repeated within a given image set; (2) to evenly distribute the styles and their representative images across all the image sets; (3) to eliminate order effects; and (4) to ensure that each image set was random. As a result of the sampling strategy, cataloguers examined images representing as many styles as possible within their 10-image sets, and there was proportional representation of each style across the sets. Each of the 28 images was viewed by either 10, 11, or 12 cataloguers.

Data Analysis Methodology

Each of the 30 cataloguers who participated in the study made 13 facet-foci selections for 10 images, resulting in 3,900 discrete classificatory decisions. The analysis of these decisions was divided into two components: success rates, on the one hand, and intercataloguer agreement and intracataloguer reliability, on the other. At their most basic level, success rates are concerned with style notations. As described in chapter 4, style notations are comprised

of definitional facet-focus combinations — visual elements that, according to the graffiti experts consulted, define a style and are stable from example to example. Because style notations form a bridge between a given image and its corresponding style description within the classification system, determining whether cataloguers could successfully identify the definitional facet-focus combinations in an image provides some indication of whether they would be able to successfully identify the style of that image. Using the example of an image in the Abstract style, success rate is defined as the number of times that a cataloguer, in filling out the classification worksheet for an image of the Abstract style, correctly identified the six definitional facet-focus combinations — A1 C2 F3 I5 J2 K2 — that form the notation for the Abstract style.

Success rates provide one framework through which to examine the functionality of the classification system's facet and focus definitions. But the definitional facets-focus combinations that determine success rates are not the only type of primary subject matter present in graffiti art pieces. Addressing the question of whether cataloguers could identify primary subject matter in graffiti art images requires examining all of their foci selections across the entire image sample. This includes foci selections that fall within the categories of predominant and non-definitional facets. Indeed, successful style identification depends on the interplay of all facets within a piece: while definitional facet-focus combinations comprise the style notations in the classification system, the style descriptions to which these notations lead provide information about the roles played by all of the facets, regardless of whether they are definitional, predominant, or non-definitional.

Therefore, intercataloguer agreement and intracataloguer reliability take into account cataloguers' foci selections for all 13 facets per image. The terms intercataloguer agreement and intracataloguer reliability are adaptations of the terms "interobserver agreement" and "intraobserver reliability" cited in Marvin Acklin et al.[5] Discussing different frameworks of reliability measurement — or consistency — in the field of behavioral assessment, Acklin et al. note that "data consistency has been assessed through two primary approaches: between-observer reliability (i.e., interobserver agreement) and within-observer reliability (i.e., intraobserver reliability)."[6] Substituting the word "cataloguer" for "observer," a similar dichotomy is used to analyze cataloguers' foci selections. Intercataloguer agreement examines whether cataloguers viewing the same image selected the same focus for a particular facet and looks at which facets generated the most (and least) consensus in terms of the range of foci selected. As a result, an individual cataloguer's foci selections for a given image are examined in relation to the selections made by other cataloguers and not in relation to the style notation of that image.

While intercataloguer agreement examines cataloguers' collective selec-

tions within the context of a single image ("between-observer reliability"), intracataloguer reliability addresses consonance of use of a particular focus by a single cataloguer across that individual's image set ("within-observer reliability"). Intracataloguer reliability has limited applicability to some facets — specifically, to facets that represent highly subjective decisions. One example is Legibility, where a cataloguer's perception of the degree of legibility may vary from example to example. The same is true of the Number of Colors and Symmetry facets. Intracataloguer reliability does, however, provide a means of examining cataloguers' understanding of certain definitional facets and their corresponding foci. Dimensionality provides one example. Say, for instance, that a cataloguer successfully identifies the dimensionality of an image in the No-neg style as "Relief effect." If this individual has characterized the dimensionality of other images as a "Relief effect," and these images are, in fact, defined by a different form of dimensionality, then these foci selections suggest two possible scenarios. The first is that the cataloguer did not fully grasp the concept of "Relief effect"; the second is that there might be certain features shared by these other images that contributed to the cataloguer's misidentification of "Relief effect."

Taken together, the analysis of success rates, agreement, and reliability, as well as qualitative data from cataloguers' responses to the follow-up questions, forms a multi-dimensional picture of what the cataloguers "saw" in each of the graffiti art images and the ways in which that affected their classificatory decisions. This chapter examines cataloguers' decisions in terms of three different measurements of success rates: the Average Success Rate per Cataloguer; the Average Success Rate per Image and Style; and the Average Success Rate per Facet. In addition to calculating and analyzing the results for each type of success rate, the following discussion seeks to answer the question: which facet-focus combinations proved to be especially challenging for cataloguers, and in which circumstances?

Average Success Rate per Cataloguer

How was it calculated?

The Average Success Rate (ASR) per Cataloguer is the average of a given cataloguer's individual success rates across his or her entire 10-image set. Cataloguer #1, for example, scored 100.0 percent on the first image she viewed, which was a piece in the Dimensional style. In other words, she successfully identified within this image all six definitional facet-focus combinations that constitute the style notation for the Dimensional style. She achieved the fol-

lowing scores on the subsequent nine images (all representing different styles): 100.0 percent; 85.7 percent; 55.6 percent; 54.5 percent; 37.5 percent; 100.0 percent; 71.4 percent; 42.9 percent; and 87.5 percent. The average of these 10 scores resulted in a Cataloguer ASR of 73.5 percent. This calculation was repeated for the other 29 image cataloguers.

What does it indicate?

Across the 30 image cataloguers, the mean ASR per Cataloguer was 69.47 percent, with a standard deviation of 7.62. That is, cataloguers were able to identify, on average, 69.47 percent of the definitional facet-focus combinations in the images they viewed. The range of individual Cataloguer ASRs was 54.6 percent to 88.4 percent, representing a considerable variation in the cataloguers' ability to understand and apply the facet and foci definitions. Moreover, the individual image scores that constitute these Cataloguer ASRs often fluctuated markedly. This fluctuation was evident, for example, in the range of individual image scores just cited for Cataloguer #1. Her 73.5 percent Cataloguer ASR is 4.03 percent above the mean for the entire group of 30 cataloguers. Although she scored 100.0 percent on three of the images in her 10-image set, she also registered scores of 37.5 percent, 42.9 percent, 54.5 percent, and 55.6 percent on other images. This variability in individual image scores also applied to cataloguers who scored below the mean. Even Cataloguer #15, with the lowest ASR (54.6 percent) among the 30 cataloguers, had a range of image scores from 16.7 percent to 71.4 percent.

The ASRs per Cataloguer were analyzed in terms of three external factors — factors that exist outside the context of the classification system and that might impact cataloguers' aptitude for understanding and applying the facet and foci definitions. These factors were: (1) the length of the cataloguers' work experience; (2) the type of institution or collection where they are employed; and (3) the format of the materials in these collections. The Cataloguer ASRs were examined based on these factors (for example, cataloguers who worked with original/archival materials versus those who worked with slides/digital images). The results showed no significant differences among groups with regard to any of the three factors. That external factors such as length of work experience had no statistical impact on cataloguers' scores is not particularly surprising. Graffiti art was an unfamiliar concept for all of the cataloguers, regardless of the type of collection they worked with or the length of their work experience. Furthermore, the facet and focus definitions were designed to erase any classificatory distinction between original graffiti art pieces (as viewed on the side of a train or a canvas, for example) and images of graffiti art pieces.

The broad spectrum of Cataloguer ASRs does, however, indicate that the cataloguers collectively had trouble applying the facet and foci definitions to certain images and, in some cases, to certain styles of pieces. The data analysis presented in the following sections of this chapter considers these scores in terms of the relationship between cataloguers' foci selections and their interpretations both of graffiti art pieces and of the facet and foci definitions themselves. At the same time, it looks at which visual elements contributed to cataloguers' ease or difficulty in identifying definitional facet-focus combinations in the various images and styles that they viewed.

Average Success Rate per Image and Style

How was it calculated?

While the ASR per Cataloguer focuses on individual study participants, the ASR per Image and Style examines the success rates for each image and its corresponding style across the entire group of 30 cataloguers. The ASR per Image was calculated by averaging cataloguers' individual success rates for that image. For example, the first sample image of the Abstract style was viewed by 11 cataloguers. The average of their individual success rates, and therefore the ASR for this image, was 89.4 percent. Since two images represented each style, the ASR per Style is the average of the two corresponding ASR per Image scores.

What does it indicate?

The ASRs per Image and Style are shown in table 8. The styles are listed alphabetically, and both the success rate and the range of individual scores are shown for each style's two sample images. The first row of table 8, for example, shows that the Image ASR for Image One of the Abstract style was 89.4 percent, while the Image ASR for Image Two of this style was 85.0 percent, resulting in a Style ASR of 87.2 percent for the Abstract style. The ASRs for the 28 images range from 37.9 percent (Image Two, TFP style) to 93.9 percent (Image Two, Dortmund style), while the ASRs for the 14 styles range from 55.7 percent (Los Angeles Cholo-based style) to 87.2 percent (Abstract style).

The analysis of the ASRs per Image and Style uses the mean of 69.47 percent as a benchmark. Because the Image and Style ASRs were calculated using the same raw scores (i.e., each cataloguer's individual success rate per image) as the ASRs per Cataloguer, 69.47 percent represents not only the mean of the cataloguers' ASRs, but also, by definition, the mean of the ASRs for the images and styles with which the cataloguers worked. The analysis of the ASRs per Image and Style utilizes this benchmark of 69.47 percent to exam-

ine which images and styles posed the greatest or fewest challenges for the cataloguers and why. The fact that a style has an ASR above the benchmark reflects cataloguers' comparative success identifying definitional facet-focus combinations in images of this style, while a style with an ASR below the benchmark reflects difficulty in identifying definitional facet-focus combinations in images of this style.

Table 8. Average success rates for images and styles

Style Name	Average Success Rate Per Image	Range of Individual Scores	Average Success Rate Per Style
Abstract	1) 89.4%	1) 66.7%—100.0%	87.2%
Abstract	2) 85.0%	2) 50.0%—100.0%	87.2%
CTK	1) 61.4%	1) 37.5%—87.5%	62.0%
CTK	2) 62.5%	2) 50.0%—87.5%	62.0%
Dimensional	1) 69.5%	1) 50.0%—100.0%	75.6%
Dimensional	2) 81.7%	2) 50.0%—100.0%	75.6%
Dortmund	1) 78.8%	1) 33.3%—100.0%	86.4%
Dortmund	2) 93.9%	2) 66.7%—100.0%	86.4%
East Coast Piecing	1) 60.7%	1) 42.9%—85.7%	70.4%
East Coast Piecing	2) 80.0%	2) 57.1%—100.0%	70.4%
Los Angeles Cholo-based	1) 57.8%	1) 45.5%—63.6%	55.7%
Los Angeles Cholo-based	2) 53.6%	2) 36.4%—81.8%	55.7%
Neo Classic American Freight	1) 58.6%	1) 28.6%—71.4%	58.4%
Neo Classic American Freight	2) 58.3%	2) 28.6%—85.7%	58.4%
No-neg	1) 76.6%	1) 57.1%—100.0%	66.8%
No-neg	2) 57.1%	2) 28.6%—85.7%	66.8%
Pichador	1) 78.8%	1) 62.5%—100.0%	75.2%
Pichador	2) 71.6%	2) 62.5%—87.5%	75.2%
Semi-wild	1) 67.7%	1) 44.4%—77.8%	67.2%
Semi-wild	2) 66.7%	2) 44.4%—88.9%	67.2%
Silvers	1) 74.5%	1) 50.0%—90.0%	79.2%
Silvers	2) 84.0%	2) 60.0%—100.0%	79.2%
Swedish Train	1) 54.6%	1) 16.7%—83.3%	60.6%
Swedish Train	2) 66.7%	2) 33.3%—100.0%	60.6%
TFP	1) 86.7%	1) 66.7%—100.0%	62.3%
TFP	2) 37.9%	2) 16.7%—50.0%	62.3%
Wild	1) 75.0%	1) 25.0%—100.0%	68.8%
Wild	2) 62.5%	2) 50.0%—75.0%	68.8%

As table 8 illustrates, cataloguers collectively scored above the benchmark of 69.47 percent for six of the 14 styles covered by the classification sys-

tem and below the benchmark for the remaining eight styles. But the scores for the individual images representing a given style can be both above and below the benchmark. Compare, for example, the Abstract and East Coast Piecing styles, both of which have Style ASRs greater than 69.47 percent. On the one hand, the ASRs for the two Abstract images (89.4 percent and 85.0 percent, respectively) are both above the benchmark. On the other hand, the ASRs for the two East Coast Piecing images (60.7 percent and 80.0 percent, respectively) are not as consistent. Not only do these Image ASRs fall on either side of the mean, but there is also a variation of almost 20 percent between the two scores. This pattern also applies to styles with ASRs below the benchmark. For instance, the Style ASR for the CTK style is 62.0 percent, and the ASRs for both images of this style are likewise below 69.47 percent. Conversely, while the ASR for the No-neg style is below the benchmark, one of the style's Image ASRs is 76.6 percent — a score higher than the 69.47 percent benchmark.

The distribution of styles in relation to the benchmark is presented in table 9. Each of the categories shown in this table is discussed in the following subsections. These discussions address a number of questions. First, what characteristics do styles with ASRs above the benchmark have in common, and how might these characteristics have contributed to cataloguers' success in identifying definitional facet-focus combinations? Second, what characteristics do styles with ASRs below the benchmark have in common, and how might these characteristics have contributed to cataloguers' difficulty in identifying definitional facet-focus combinations? As with the range of individual Cataloguer ASRs, scenarios in which the sample images of a given style fall above and below the benchmark suggest that cataloguers had trouble with specific images, rather than with the corresponding style. The following analysis also examines which factors might have contributed to these discrepancies in ASRs for images of the same style.

Table 9. Distribution of styles in relation to benchmark

Styles with both images above benchmark	Styles with one image above and one below benchmark	Styles with both images below benchmark
Abstract	East Coast Piecing	CTK
Dimensional	No-neg	Los Angeles Cholo-based
Dortmund	TFP	Neo Classic American Freight
Pichador	Wild	Semi-wild
Silvers		Swedish Train
Total number of styles: 5	Total number of styles: 4	Total number of styles: 5

Styles with Both Image ASRs above the Benchmark

As table 9 shows, there are five styles with two Image ASRs above the benchmark. While the fact that both image scores are greater than the overall mean illustrates cataloguers' (comparative) ease in working with these styles, the styles themselves are quite visually distinctive from each other. Even the length of their notations — the number of definitional facet-focus combinations, or notation units — varies considerably among the five styles, as shown in table 10. For example, the notation for the Dortmund style consists of only three notation units, while the notation for the Silvers style contains 10 notation units.

Table 10. Average number of notation units for styles with both images above the benchmark and for styles with both images below the benchmark

Styles with both images above benchmark	No. of notation units	Styles with both images below benchmark	No. of notation units
Abstract	6	CTK	8
Dimensional	6	Los Angeles Cholo-based	11
Dortmund	3	Neo Classic American Freight	7
Pichador	8	Semi-wild	9
Silvers	10	Swedish Train	6
Average:	**6.6**	**Average:**	**8.2**

The data presented in table 10 suggest that, in the case of styles with both images above the benchmark, the number of definitional facet-focus combinations is not germane to a cataloguer's success in identifying those combinations. It was noted in chapter 4 that the average number of definitional facet-focus pairings for the 14 styles in the classification system was seven. As table 10 shows, notations for styles with both images above the benchmark had, on average, fewer than seven notation units, while notations for styles with both images below the benchmark had, on average, more than seven notation units. In practical terms, cataloguers tended to have more success with styles that had fewer than the average number of definitional facet-focus combinations. Yet cataloguers' success with the Silvers and Pichador styles (10 and 8 notation units, respectively) also points to the fact that cataloguers were able to achieve ASRs above the benchmark for styles that had more than the average number of definitional facet-focus combinations. The

list of styles with both Image ASRs above the benchmark is not composed solely of styles with just three, four, or six notation units.

In addition to the number of notation units, the five styles with both images above the benchmark also differ in terms of the specific facet-focus combinations expressed in their style notations. One example is Legibility, which is a definitional facet for three of the five styles. At one end of the spectrum, the Abstract style is defined by its illegibility (notation unit A1), while at the other end of the spectrum both the Silvers and Pichador styles are characterized by their legibility (notation unit A3). The fact that cataloguers were able to score above the benchmark for images representative of both illegible and legible styles would seem to demonstrate that degree of legibility has little bearing on how successfully a cataloguer can identify the defining characteristics of a given style. The Pichador style is a particularly vivid example of this. Although A3 is a definitional notation unit for this style, only one of the 10 cataloguers who viewed Image One of the Pichador style actually selected this facet-focus combination. Similarly, only three of the 11 cataloguers who worked with Image Two of the Pichador style considered this piece to be legible. Despite having difficulty distinguishing the letters that form the tag, the cataloguers nonetheless were able to identify other defining characteristics within the two images. In fact, the two cataloguers who described the Pichador image they viewed as completely illegible achieved a success rate for that image that was equal to or higher than the success rates of 14 cataloguers who had characterized their sample Pichador image as either partially legible or fully legible.

The idea that a cataloguer's perception of a piece's legibility (or illegibility) does not affect his or her identification of other definitional facet-focus combinations also applies to situations where Legibility is not a definitional facet. Unlike the other three styles in which cataloguers scored above the benchmark for both images, Dortmund and Dimensional pieces are not characterized by any one degree of legibility. Rather, Legibility is a non-definitional facet for both styles, meaning that individual pieces run the gamut from legible, to partially legible, to fully illegible. As a result, the focus selections for the Legibility facet are not factored into the success rates for these styles and their representative images. These selections nevertheless provide a means of examining whether a cataloguer's individual determination of the legibility of a piece affects his or her ability to identify characteristics that do, in fact, define the style of that piece. In the case of the two Dortmund images, cataloguers' foci selections for the Legibility facet were either "Partially Legible" or "Legible." As with the Pichador style, however, neither characterization translated into notably higher or lower success rates for the two images. For instance, the eight cataloguers who described Image One of the Dort-

mund style as legible collectively had the same range of individual success rates for this image — 33.3 percent to 100.0 percent — as the three cataloguers who said that the piece was only partially legible. This pattern is even more pronounced in the second Dortmund image. Four cataloguers felt that the piece was only partially legible, but each achieved an image score of 100.0 percent for the piece. In fact, only two of the 11 cataloguers who viewed this piece had image ASRs of less than 100.0 percent; both of these individuals thought that the piece was legible. In other words, cataloguers who were not able to recognize all of the letters nonetheless were more successful at identifying the letter outlines, letter strokes, and fill consistency of the piece than cataloguers who could recognize all of the letters.

Although the Style ASRs for the Abstract, Silvers, Pichador, and Dortmund styles indicate that legibility is not a factor in the successful identification of definitional facet-focus combinations, the data for the two Dimensional images complicate this assessment. As table 8 shows, the ASR for Image Two (81.7 percent) was 12.2 percent higher than that of Image One (69.5 percent). None of the 12 cataloguers who viewed Image One considered this piece to be legible. Rather, opinion was evenly divided between the "Partially legible" (A2) and "Illegible" (A1) foci. The average score for Image One among the cataloguers who selected A2 was 72.2 percent, in comparison to the average score of 66.7 percent for those who chose A1. The connection between the recognition of at least some of the letters in a Dimensional piece and success in identifying definitional characteristics was even more pronounced in the case of Image Two. The four cataloguers who characterized the piece as legible had an average score of 95.8 percent for this image, with three of these four individuals scoring 100.0 percent. The average score for the five cataloguers who deemed the piece to be partially legible, however, was 76.7 percent, with the highest individual success rate being 83.3 percent. Finally, the sole cataloguer who described it as completely illegible scored only 50.0 percent.

While there is a connection between, on the one hand, degree of legibility and, on the other hand, success rate in the case of the Dimensional style, the absence of this connection in the context of the other four styles suggests that legibility alone is not a determining factor in cataloguers' success rates for certain images. Cataloguers' responses to the follow-up questions support this view. Eight cataloguers mentioned that they had difficulty applying facet definitions to what one cataloguer describes as "examples featuring illegible words." Although there was some variation as to the specific facets and images they cited, these cataloguers expressed the same underlying point: that illegible letters lack a basic visual framework that would enable them to identify other features of both the individual letters and the piece as a whole. Cata-

loguer #7 wrote, "When an image is illegible it is difficult to figure out where the letter face ends and effects begin, or whether elements are part of fill or background, or are outlines." Similarly, Cataloguer #12 "had a hard time determining ... the stroke and shape of the letters." These comments suggest that rather than degrees of legibility per se, it is the relationship between legibility and other elements within a piece that results in a cataloguer's ability or inability to identify definitional facet-focus combinations.

The corollary, then, is that the connection between legibility and success rate depends upon *which* facet-focus combinations define a particular style. A cataloguer who has trouble identifying the dimensionality, letter outlines, and letter strokes of illegible pieces could still achieve a high (i.e., above the benchmark) success rate for an illegible image whose style notation does not include these three facets. Success rate scores depend not only on which facets constitute the style notation, but also on the specific foci for those facets — an issue that will be examined in the analysis of ASRs per Facet. Therefore, while the specific features of the five styles discussed in this section are not identical, they do have in common the fact that the identification of these particular definitional facet-focus combinations is not contingent on a cataloguer's recognition of the individual letters within a piece. The one exception is the Dimensional style, where illegible letters did preclude some cataloguers from identifying certain defining elements. The Dimensional style has four distinct definitional foci (encompassing the Dimensionality, Letter Outlines, and Fill Effects facets) not shared by the other styles with both Image ASRs above the benchmark.

Although their specific characteristics differ, the five styles do have in common an absence of certain features. All five are visually stark, without the ornamental elements that often appear in other styles. For example, four of the five styles have J2 (Use of Arrows: Not integral) as a notation unit. In all four cases the J2 notation refers to the fact that arrows are not associated with the styles. The fifth style, Dortmund, has J2 as a predominant facet-focus combination; pieces in this style might have arrows, but the arrows would not play an integral role. Yet neither of the two Dortmund images viewed by the cataloguers actually contains any arrows. As one graffiti art expert who discussed this style pointed out, Dortmund "is a stripped down style and there isn't much focus on parts of the letters that aren't utilitarian." One way in which Dortmund is "stripped down" is through the minimal use of fill effects — a characteristic of the other four styles as well. The Abstract, Silvers, and Dortmund styles all have Fill Effects as a non-definitional facet, with individual pieces either exhibiting certain fill effects or having none whatsoever. In the case of the Pichador style, an absence of fill effects is itself a defining characteristic. The one exception is the Dimensional style, which utilizes

directional highlights and fades — two types of fill effects — to create a sense of three-dimensionality within the letters. Yet even in this instance the fill effects serve a functional, rather than a purely decorative, role.

Styles with One Image ASR Above the Benchmark

The analysis of styles with both Image ASRs above the benchmark pointed out shared characteristics that contributed to cataloguers' success in working with those styles. The analysis of the styles with only one Image ASR above the benchmark focuses on divergences rather than commonalities. On the one hand, the two representative images of any style in the classification system by definition share the same style notation. On the other hand, the fact that cataloguers had considerably more difficulty ascertaining these definitional facet-focus combinations in one of the two images reflects their dissimilar perceptions of these features across the images. The question therefore becomes: why did cataloguers have difficulty identifying features of a given style in only certain manifestations?

As shown in table 9, there were four styles with one Image ASR above the benchmark and one below: TFP, East Coast Piecing, No-neg, and Wild. Of the four styles, the most marked discrepancy in ASRs is between the two TFP images. While the ASR for the first sample image was 86.7 percent, the ASR for the second was just 37.9 percent — the lowest ASR of any image, regardless of style (table 8). The only style in the classification system for which A2 (Legibility: Partially legible) is a definitional facet-focus combination, TFP provides another example of the role of legibility in the identification of definitional facets. Of the 10 cataloguers who viewed the first TFP image, 90.0 percent characterized the piece as partially legible. Conversely, none of the 11 cataloguers who examined the second TFP image judged this piece to be partially legible, describing it instead as illegible. As noted earlier in the chapter, despite the graffiti art experts' characterization, the researcher likewise considered this particular piece to be completely illegible.

Cataloguers' inability to distinguish any letter forms in Image Two of the TFP style adversely affected their perception of other visual elements as well. For instance, while 90.0 percent of the cataloguers who viewed Image One successfully identified the focus for the Negative Space facet, this was the case with only 9.0 percent (i.e., one) of the cataloguers who worked with Image Two. In another example, 40.0 percent of the cataloguers viewing Image One accurately characterized the type of letter overlap associated with the TFP style, as compared to none of the 11 cataloguers working with Image Two. This pattern also applies to facets that are not part of the TFP style

notation. In their responses to the follow-up questions, four of the cataloguers who examined Image Two described the difficulty they had in ascertaining the symmetry, dimensionality, linearity, and letter strokes of this piece. Cataloguer #26 singled out the Letter Strokes facet, explaining that she "answered Letter Strokes Varied due to an overall impression rather than a clear examination of individual letters."

While the discrepancy between the TFP image scores can be attributed to a variety of facets, a different pattern emerges with the other styles with only one Image ASR above the benchmark. Consider the example of the East Coast Piecing style. Over 80.0 percent of the cataloguers viewing each sample image described these pieces as illegible. Therefore, varying perceptions of legibility did not contribute to the discrepancy in Image ASRs. In fact, cataloguers identified a number of defining features of the East Coast Piecing style at roughly the same rate for each representative piece. Compare the following percentages: 91.7 percent and 100.0 percent of cataloguers successfully identified the type of letter strokes in Images One and Two, respectively; 66.7 percent of cataloguers successfully identified the amount of negative space in Image One, as compared to 60.0 percent of cataloguers working with Image Two; and 100.0 percent of cataloguers working with both images successfully identified the linearity of these pieces. While the cataloguers had success with the same range of facets across the two images, they also struggled with the same concepts. For instance, only half or less than half of the cataloguers who examined these images were able to identify the correct foci for the Dimensionality and the Letter Shape Consistency facets.

Cataloguers' consistency in identifying certain definitional facet-focus combinations across the two East Coast Piecing images would seem to belie the 19.3 percent differential in Image ASRs (see table 8). In fact, the difference can be attributed primarily to a single facet: Fill Consistency. Whereas 100.0 percent of the cataloguers who viewed Image Two of the East Coast Piecing style correctly characterized the fills in this piece as consistent, this was the case with only 41.7 percent of the cataloguers who examined Image One. When comparing the two pieces, the fill pattern of Image Two is not only consistent from letter to letter, but also identical. The principal color of the letters fades from medium blue to light blue as the eye moves from the base to the top of the letter forms. Red, beige, and pale green accents form three distinct parallel lines that reach across the word as whole, visually connecting each individual letter. Image One, however, presents a different conceptualization of a consistent fill pattern. Here the fills exhibit a complex pattern in which there is no single background color. Like the letter forms in this piece, the fill pattern itself is abstract, with multiple colors used to create the patterns. Although the pattern is not identical from letter to letter,

there is a fixed color scheme, and the abstract shapes that form the fill patterns carry over from one letter to the next. Both of these aspects provide a visual link among the letters — one that, as stated in the facet definition, results in "a decipherable internal logic to the patterns and colors as you move from letter to letter." Nonetheless, as the data from the East Coast Piecing images indicate, cataloguers did not always perceive these more complex patterns as constituting consistent fills, especially in comparison to fills that are both consistent and absolutely identical.

This example demonstrates that the difference in Image ASRs between two images of the same style is attributable not only to a single facet, but also to a specific concept applicable to that facet — for example, the identification of complex as opposed to identical fill patterns. Moreover, neither the concept nor the facet itself might have seemed particularly problematic or challenging to the cataloguers. Indeed, while the cataloguers expressed uncertainty in their questionnaire responses about various foci selections for the first image of the East Coast Piecing style, no reference was made to the Fill Consistency facet.

The No-neg style presents another case in which Image ASRs hinge on a specific concept. As table 8 shows, the ASR for the first No-neg image was 76.6 percent, while the ASR for the second was 57.1 percent. Specific concepts relevant to two facets — Use of Arrows and Letter Outlines — resulted in the sizable difference between these two Image ASRs. Beginning with the Use of Arrows facet, all 11 cataloguers who were assigned Image One successfully identified the definitional notation unit J2 (Use of Arrows: Not integral), as compared to 5 of the 11 cataloguers who viewed Image Two. As was the case with the Fill Consistency facet and the East Coast Piecing style, cataloguers did not cite the Use of Arrows facet as a difficult feature to distinguish in the context of either image. Nevertheless, the image itself provides a sense of how this facet contributed to the disparity in scores between the two No-neg examples. Image One does not actually contain any arrows — a situation which calls for cataloguers to select the facet-focus combination J2, as explained in the facet definition. Image Two incorporates two arrows, one on either end of the piece. But these arrows are not integral: they do not camouflage and/or add complexity to the basic shape of the letters, nor do they serve as a connector between letters — criteria outlined in the relevant facet and foci definitions. The fact that 54.5 percent of those who viewed Image Two nonetheless perceived the arrows in this piece to be integral means that the cataloguers had difficulty distinguishing between the different uses of arrows described in the definitions.

In addition to the Use of Arrows facet, there also was a notable difference in cataloguers' ability to recognize in the two No-neg pieces the type of

letter outlines that defines this style. While 81.8 percent of cataloguers suc-
cessfully identified the interrupted outlines in Image One, this was the case
with only 21.3 percent of the cataloguers who examined Image Two. As
described in the focus definition, interrupted outlines are hard outlines that
are purposively interrupted in places to create the impression that the fill is
"spilling out" of the letter outlines. This visual effect is often achieved through
shines — a fill effect used to create highlights at the points where the outline
is interrupted. Only one cataloguer, however, perceived any shines in the sec-
ond image. Moreover, this individual was one of the three cataloguers who
correctly identified the piece's interrupted letter outlines. Conversely, all but
one of the cataloguers working with Image One detected shines in this piece,
and all but two also characterized the outlines as interrupted, revealing a con-
nection between the recognition of these two interrelated foci.

The comments of one of the cataloguers who examined the second No-
neg image shed light on how the relationship between the Letter Outlines
and Fill Effects facets affected her assessment of the piece. Explaining that she
was not confident that her selection of "hard only" letter outlines was cor-
rect, Cataloguer #7 writes, "Yes, the very outer edge is hard, but there are
other types of outline going on as well.... And I do feel that what character-
izes the piece is a shine-less interrupted outline to the letters." On the one
hand, her characterization of what she saw as "hard" with "other types of out-
line" is a close approximation of interrupted outlines, which are essentially a
variation of "hard only" outlines. On the other hand, her statement also reveals
two factors that might have precluded cataloguers from selecting the inter-
rupted outline focus. First, Cataloguer #7 felt that the outlines were in fact
interrupted, but her rationale for bypassing this focus was her belief that the
piece did not contain any shines. Second, while she was cognizant of the fact
that there was more than one type of outline (i.e., that there were hard out-
lines that were interrupted in places), her comments suggest that she under-
stood the two types of outlines to be mutually exclusive. This, in turn, signifies
that she did not fully understand the focus definition for interrupted out-
lines. At the same time, it is interesting to note that in reaching her
classificatory decisions, Cataloguer #7 seemed more willing to second-guess
her initial reaction concerning the letter outlines than to revisit her charac-
terization of the piece as "shine-less."

Styles with Both Image ASRs Below the Benchmark

The analysis of cataloguers' facet-foci selections identified factors in com-
mon among the five styles with both image ASRs above the benchmark. These

factors — such as the effect of perceived legibility on other defining charac-
teristics and the lack of ornamental elements — reveal more about what is
absent from, rather than manifested in, the corresponding style notations. In
contrast, common features among the five styles with both Image ASRs below
the benchmark (table 9) are apparent from the style notations themselves. For
example, all five styles have D2 (Dimensionality: 2-Dimensional with 3-D
effects) as a definitional facet-focus combination, and all of the styles except
Swedish Train have E1 (Letter Outlines: Hard only) as a definitional facet-
focus combination. Likewise, Negative Space is a definitional facet for the five
styles, although the specific focus varies.

The data from the cataloguers' worksheets, however, reveal that these
facet-focus combinations posed problems in some but not all of the styles in
which they appear. Consider the example of notation unit D2. None of the
cataloguers viewing Image One of the Los Angeles Cholo-based style char-
acterized the dimensionality of this piece as D2; only half of the cataloguers
working with Image Two of this style did so. Yet, in the context of the Neo
Classic American Freight style, the identification of this same form of dimen-
sionality was comparatively easy: 70.0 percent of cataloguers selected D2 for
the first image of this style, as did 83.3 percent of cataloguers for the second
image.

To be sure, the discrepancy in cataloguers' ability to identify the type of
dimensionality common to both styles could stem from different perceptions
of legibility. Of the 21 cataloguers who examined the Los Angeles Cholo-based
images, 16 described these pieces as illegible. Conversely, of the 22 cataloguers
who examined the Neo Classic American Freight images, only two found
these pieces to be illegible, and 10 characterized them as fully legible. It was
noted earlier, however, that degree of legibility affects the identification only
of some facet-focus combinations. Turning to the example of notation unit
E1 (Letter Outlines: Hard only), only 40.0 percent of the cataloguers work-
ing with Image One of the Neo Classic American Freight style and 16.7 per-
cent of the cataloguers working with Image Two were able to identify E1 in
these (relatively) legible pieces. And cataloguers had less difficulty identify-
ing E1 in images of the CTK style — pieces that all but two cataloguers char-
acterized as either partially legible or illegible. Indeed, 72.7 percent of the
cataloguers who viewed the first CTK image selected E1, as did 63.6 percent
of the cataloguers who examined the second image of this style.

Therefore, just as an Image ASR can hinge on a single facet or concept,
cataloguers' identification of a particular facet-focus combination depends on
the context in which that combination appears. At the same time, context
itself can vary not only from style to style, but also between different pieces
of the same style. The Neo Classic American Freight style provides one exam-

ple. As table 8 shows, the Image ASRs for the two images of this style are nearly identical: 58.6 percent for Image One and 58.3 percent for Image Two. This similarity in scores, however, is not reflected in the range of facets that cataloguers found particularly challenging in each of the images. While cataloguers were able to correctly identify the foci for the Fill Consistency, Letter Overlap, and Dimensionality facets at about the same rate, two different features were primarily responsible for the low ASR for each image. For Image One this feature was shines. Although shines are a defining fill effect for this style, the actual execution of the shines in each representative image differed significantly. The shines in Image Two appear as bright asterisks along the letter outline, but in Image One the shines are manifested as white lines along portions of the letter outlines. While 91.7 percent of cataloguers correctly identified shines in Image Two, only 8.3 percent (i.e., one cataloguer) did so in the case of Image One.

This pattern is similar to that which emerged from the analysis of styles with one Image ASR above the benchmark, when the variation in scores was traced to cataloguers' difficulty in understanding a specific concept, such as consistent yet non-identical fill patterns or the presence of arrows that play a non-integral role. These concepts underscore the different ways in which a particular focus can be manifested in certain pieces or styles of pieces. Just as consistent fills might have repeating patterns or identical patterns, shines might assume the shape of asterisks or simple white lines. While the low Image ASR for the first Neo Classic American Freight piece is attributable to visual interpretations of shines, the low Image ASR for the second piece can be traced to the Use of Arrows facet. Arrows, when they appear in pieces of this style, are not integral. In a situation analogous to that of the two Noneg images, Image One of the Neo Classic American Freight style has no arrows, while Image Two does. But only one of the cataloguers who viewed Image Two recognized that these arrows serve a non-integral role.

That the ability (or inability) to identify the same facet-focus combination varies from style to style, or even from image to image within a single style, suggests that cataloguers for the most part had difficulty with specific manifestations of these features, rather than the features themselves. As a result, the inclusion or exclusion of a particular facet-focus combination in a style notation is not typically related to success rate. Say, for example, that five graffiti art styles had identical style notations and identical Style ASRs. Even though there is no classificatory distinction among the five styles, and even though cataloguers achieved the same score for each style, the factors that contributed to the identical ASRs most likely would vary from style to style. Cataloguers might have been able to identify the notation unit F2 in Style A but not in Style B, for instance, or they might have had trouble rec-

ognizing H2 in Style A but not in Style C. As the examples of the East Coast Piecing, No-Neg, and Neo Classic American Freight styles demonstrate, this same idea applies to the identification of a notation unit across images of the same style. Moreover, as underscored by the analysis of styles with both Image ASRs above the benchmark, the recognition of a particular facet-focus combination depends upon how cataloguers' perception is affected by other elements in the image.

Average Success Rate per Facet

How was it calculated?

The final framework through which success rate was calculated and examined is the ASR per Facet. The analysis of the ASRs per Image and Style looked at which visual elements were shared by certain images and styles of graffiti art and how these elements contributed to cataloguers' success or difficulty in identifying definitional facet-focus combinations. The ASRs per Facet examine cataloguers' ability to identify a facet across the entire image set, rather than in the context of a specific image or style. Since success rates are concerned only with the definitional facet-focus combinations that constitute style notations, the ASR per Facet looks at situations where the facet plays a defining role in a style, regardless of its corresponding focus. Consider the example of the first facet in the classification system, Legibility. Legibility is a definitional facet for five styles, meaning that 10 images in the sample have legibility as a defining characteristic, including the two sample images of the Abstract style. In the case of the first Abstract image, ten of the 11 cataloguers who viewed this piece successfully identified it as illegible. The result is a success rate of 90.9 percent for this facet within the context of this image. This score of 90.9 percent was then averaged with the other legibility success rates from the image sample to arrive at an ASR per Facet of 52.6 percent for the Legibility facet. To be sure, none of the facets in the classification system is definitional for all 14 styles. Therefore, the number of images considered when calculating the ASR per Facet varies widely. Fill consistency, for example, is a definitional facet for 12 styles; therefore, it was definitional for 24 of the images tested.

What does it indicate?

As with the ASRs per Image and Style, the ASRs per Facet address the question of whether cataloguers could successfully identify primary subject

matter in graffiti art pieces using the definitions provided in the classification system, but from a slightly different perspective. Rather than determining which features are shared by images and styles, this third ASR framework examines which characteristics are shared by certain facets and the possible impact of these characteristics on cataloguers' success or difficulty in identifying the defining features of graffiti art styles. The ASRs per Facet are shown in figure 4.

Figure 4. Average success rates for facets

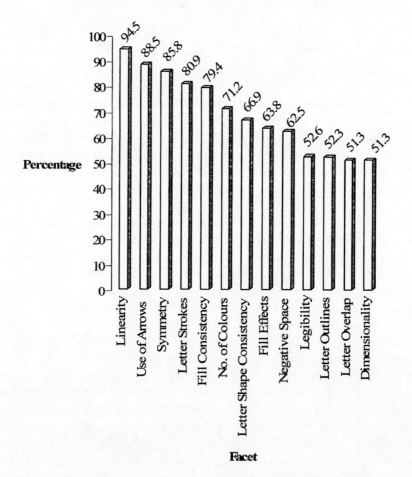

As figure 4 indicates, the 13 facet ASRs vary widely, from 94.5 percent for Linearity to 51.3 percent for Letter Overlap and Dimensionality. Nonetheless, the particular groupings of facets at either end of this spectrum reveal

fairly consistent patterns. Facets with higher ASRs (i.e., above 70.0 percent) embody concepts that are especially familiar outside the realm of graffiti art, such as symmetry and color. Consider the examples of Linearity (94.5 percent) and Letter strokes (80.9 percent). Both of these facets deal with the same fundamental element: lines. Cataloguers are asked to determine whether the lines in a graffiti art piece are curved or straight, and whether the strokes that form these lines alternate between thick and thin or are uniform in width. While the act of examining letter-stroke width might be unfamiliar, the underlying concept of letter strokes and their effect on a line's appearance has relevance outside the context of graffiti art. For example, "Magic Markers" — a mainstay of art, craft, and school supplies — come with either rounded or angled tips. The Crayola Company advertises on boxes of their "Chisel Tip Markers" that the angled tip of the markers can be used to "draw a thick and thin line" — the same effect produced by varied letter strokes in graffiti art lettering. Although some cataloguers cited letter strokes as a difficult facet to identify in cases where the piece is illegible, their actual foci selections often belie this concern, since 100.0 percent of the cataloguers were able to correctly identify the letter strokes for four of the 12 images for which this facet is definitional. Only one of these images, however, was considered fully legible by the majority of cataloguers who viewed it. Moreover, the four images presented examples of both uniform and varied letter strokes, signifying that cataloguers were equally adept at identifying both of these foci.

Familiarity with the basic concept expressed in a facet also explains the high ASR (88.5 percent) for the Use of Arrows facet. Just as linearity and letter strokes center on types and uses of lines, arrows are a well-known and easily recognized symbol. The Use of Arrows facet asks cataloguers not only to recognize arrows, but also to interpret their role within a piece. As noted in the analysis of ASRs per Image and Style, some cataloguers mistakenly attributed an integral role to arrows in certain images. Although they sometimes misconstrued arrows as integral, the opposite was rarely true — cataloguers did not overlook arrows that were integral to a piece.

In addition to embodying familiar concepts, five of the six facets with ASRs above 70.0 percent share another feature. The identification of these facets and their corresponding foci does not depend on cataloguers' perceptions and interpretations of other facets within the image. The capability of seeing that the lines in the piece are curved and that the fill is consistently patterned, for example, would not be adversely affected by, say, the inability to decipher which letters form the tag or to ascertain whether these letters are consistently shaped. This idea also applies to the Symmetry facet, which had the third highest ASR (85.8 percent). While the characterization of a graffiti art piece as symmetrical or asymmetrical is a subjective judgment, this judg-

ment can be made without reference to other aspects of the piece. Like Linearity and Fill Consistency, the Symmetry facet is self-contained. The one exception is the Letter Strokes facet. Some cataloguers mentioned the difficulty they had examining the letter strokes in pieces that they found illegible. Indeed, in cases where the letter stroke is obscured, whether through illegibility or through letter overlap, there is no means of detecting whether the stroke maintains the same width or if it begins to vary in width.

Just as facets with high ASRs have common features, the same is true of the facets with ASRs below 70.0 percent. The Legibility, Letter Overlap, and Dimensionality facets, for example, require cataloguers to make degree-based judgments: how legible is the piece? How much do the letters overlap? How much depth do the letters have? This last question proved to be especially challenging for the cataloguers, as reflected in the 51.3 percent ASR for the Dimensionality facet. In fact, 24 of the 30 cataloguers mentioned in their questionnaire responses the difficulty they had in applying the foci for the Dimensionality facet. Cataloguer #19 observed, "There seemed to be a very fine line in my understanding of 2-Dimensional with 3-D effects, relief effect & 3-Dimensional. I had to constantly read through all 3 of these definitions with every single image." While few other cataloguers cited "2-Dimensional with 3-D effects," many mentioned both the "Relief effect" and "3-Dimensional" foci.

While cataloguers' comments about the challenges of distinguishing the various types of dimensionality are reflected in the low ASR for this facet, there was no such correspondence in the case of the Legibility facet (52.6 percent ASR). One cataloguer who decided to rank the difficulty of each facet on a scale of 1 (easiest) to 5 (hardest) characterized Legibility as a "1." (Only one facet was ranked a "5": Dimensionality.) Although cataloguers discussed the complication of examining facets in illegible pieces, none described the Legibility facet itself as difficult to understand or apply. This is to be expected, since the actual concept of legibility is both familiar and easy to comprehend. Furthermore, because determining legibility is an inherently subjective process, it is unlikely that cataloguers would second-guess their own personal judgment of what is legible, partially legible, or illegible. But their characterizations rarely paralleled those of the graffiti art experts upon whose opinions the facet-focus pairings are based. For example, while all of the cataloguers who viewed Silver pieces described this style as legible, they did not arrive at this same conclusion for other styles, such as Pichador and CTK, which experts define in terms of their legibility. As a result, the low ASR for the Legibility facet can be attributed to the fact that styles defined as partially legible or legible by the graffiti art community proved to be illegible to the cataloguers. While four styles are defined by partial legibility or legibility, only

one style — Abstract — is defined by its illegibility. Cataloguers' tendency to characterize pieces as illegible is reflected in their assessment of the Abstract style: 19 of the 21 individuals who viewed an Abstract piece stated that it was illegible. Their ability to successfully identify this particular definitional facet-focus combination is part of the reason that one of the most abstract and, arguably, visually challenging styles within the image sample nonetheless had the highest ASR per Style (87.2 percent, table 8).

In some cases, the need to identify elements of graffiti art pieces by defining and interpreting degrees of difference resulted in cataloguers conflating closely related foci. This is especially apparent in the case of the Letter Overlap facet (51.3 percent ASR). As with Legibility, Letter Overlap requires cataloguers to make distinctions among gradations. On the one hand, cataloguers had little difficulty identifying the two most exaggerated or pronounced forms of letter overlap: I1 (no overlap whatsoever) and I5 (intertwined letter overlap). The classification system includes two styles for which I5 is a definitional facet-focus combination: the Wild style and the Abstract style. This notation unit was successfully identified by 90.0 percent of the cataloguers who viewed Wild style pieces and by 71.4 percent of the cataloguers who worked with Abstract pieces. Cataloguers had even less trouble with I1, which is a definitional facet-focus combination for the Pichador style. All of the participants who viewed the Pichador images recognized that the letters in these pieces do not overlap. On the other hand, the minimal (I2) and standard (I3) overlaps presented distinct challenges. Cataloguers tended, in the context of particular images, to misinterpret both I2 and I3 as I5. For example, all of the cataloguers who viewed Image Two of the Semi-wild style concluded that the letters in this piece were intertwined, even though Semi-wild pieces are defined by their standard letter overlap. Similarly, only five of the 21 cataloguers (23.8 percent) who worked with images in the Los Angeles Cholo-based style correctly identified the overlap in these pieces as I2; the remaining 16 cataloguers all selected I5.

The fact that both I2 and I3 were misinterpreted as I5 in these examples also points to the difficulty that cataloguers had in differentiating between the minimal and standard letter overlaps themselves. Consider the example of the Neo Classic American Freight style, which is defined by a standard letter overlap. In the case of the second sample image of this style, opinion was evenly split between those who viewed the overlap as standard and those who described it as minimal. For the first image, the ratio was almost the same: 40.0 percent selected I3 and 60.0 percent chose I2. This difference of opinion also occurred when minimal, rather than standard, was the definitional focus. While only one of the cataloguers who examined Image One of the Silvers style chose I2, nine selected I3.

Cataloguers' success or difficulty with a facet depends not only on the cognitive effort required to distinguish among closely related foci, but also on the interrelationships among different facets — a pattern that also emerged in the analysis of Image and Style ASRs. In contrast to Linearity and Symmetry, facets with ASRs below 70.0 percent are not self-contained: they do tend to affect — and be affected by — cataloguers' perceptions of other features in a graffiti art piece. Consider the connection between the Letter Overlap and Letter Shape Consistency facets. Letter Shape Consistency (66.9 percent ASR) is a definitional facet for eight styles in the classification system. Two of these — Silvers and Pichador — are characterized by consistently shaped letters (notation unit K1). In fact, all of the cataloguers viewing Silver pieces and all but one of the cataloguers viewing Pichador pieces selected K1 for these images. The two styles also have in common letters that do not significantly overlap: cataloguers characterized the letter overlap of Silver pieces as either minimal or standard, and recognized that the letters in Pichador pieces do not overlap at all.

The successful identification of the consistently-shaped letters in the Silvers and Pichador styles presents an interesting contrast to the East Coast Piecing style, which is also defined by consistent letter shape. Here, 10 of the 22 cataloguers (45.5 percent) working with images in this style selected K1, and 14 cataloguers concluded that the pieces had an intertwined letter overlap. As the name suggests, these letters are so interconnected as to make it almost impossible to unravel them and to see each letter individually. Arguably, cataloguers who characterized a piece as having an intertwined letter overlap were unable to distinguish individual letter forms, thereby precluding them from seeing any consistency among the letter shapes. This connection is particularly evident in Image Two of the East Coast Piecing style: only three cataloguers did not select the "Intertwined" focus for the Letter Overlap facet. These three individuals were also the only cataloguers who correctly identified the letter shape as consistent.

A somewhat similar pattern emerged when a style is actually defined by inconsistent letter shape (notation unit K2). K2 is a defining feature of the Abstract and Swedish Train styles, and the two represent different degrees of letter overlap — intertwined in the case of Abstract and minimal in the case of Swedish Train. Cataloguers had greater success identifying inconsistently shaped letters when they felt that the letter overlap was intertwined: 81.8 percent and 70.0 percent of cataloguers were able to identify the inconsistently shaped letters in the Abstract style pieces, while only 36.4 percent and 40.0 percent were able to do so in the two Swedish Train images. This seemingly incongruous tendency can perhaps be explained in terms of the same visual connection between the Letter Overlap and Letter Shape Consistency facets

that was evident in the case of K1. If a cataloguer sees an image as having intertwined letters, it is plausible that he or she may be inclined to view the letters as inconsistently shaped. The difficulty in distinguishing individual letter forms when the letters are intertwined may arguably lead to the assumption that the letters themselves are inconsistent. The process is not so much a formal judgment as it is a natural reaction. This same type of reaction also could play a role in cases where the pieces have minimal or standard overlap. Recognizing the shape of individual letters may make cataloguers less inclined to label these familiar shapes as "inconsistent" even though the contours of the letters differ from one another.

Cataloguers' Impressions of the Facet and Foci Definitions

The analysis of success rates indicated cataloguers' ability to understand and apply most of the facet and foci definitions. Their responses to the follow-up questionnaires paint a similar picture. Cataloguers generally characterized the definitions as clear, understandable and, in the words of Cataloguer #2, "extremely easy to use." Cataloguer #1 wrote, "The definitions were very clear in most cases. In the cases where I found them less clear (dimensionality and letter outlines) I doubt they could have been any more clear without the use of diagrams or examples." Some cataloguers singled out specific definitions. Cataloguer #7 "especially liked the description of facet 10: Use of arrows. It made the assessment of the art much easier and actually gave a lot of insight into the works." Likewise, Cataloguer #1 "found the last paragraph on the letter strokes facet [definition] very helpful."

Although Cataloguer #3 "was impressed with the concise explanations," seven cataloguers felt that some of the definitions were "too wordy." Four of these individuals referred specifically to the Dimensionality facet and foci. Cataloguer #19 explained that the problems she had with the Dimensionality foci stemmed from "their length." She continues, "Both the facet and foci are so finely specific that I got confused between letter faces, outlines, what was relief, and what was 3-dimensional." Cataloguer #12 commented on "the sheer scope and length" of these definitions, questioning whether they "could possibly be broken down more" within the classification system.

These comments suggest that the cataloguers took issue with the level of detail rather than with the actual number of words in the definitions. To be sure, the definitions concerning the Dimensionality facet included multiple references to related components of graffiti art pieces, such as 3-d effects, letter outlines, and letter faces — all of which were defined in the "Graffiti Art

101" guide provided in cataloguers' test booklets. While other facets, such as Number of Colors, also incorporated these references in their facet definitions, they were largely absent from the corresponding foci definitions. At the same time, the level of detail in the Dimensionality definitions was compounded by the fact that the foci definitions related to and built upon each other, progressing from the focus that represented the least amount of depth conveyed by letters to the focus that represented the greatest sense of depth. This progression was expressed not only in the order of the foci, but also through references to the other foci in each definition. The amount of information contained in the definitions and the cognitive effort required to process these details may have contributed to the fact that Dimensionality had the lowest Facet ASR.

In some cases, cataloguers questioned the conceptualization, rather than the length, of the definitions. With regard to the Number of Colors facet, Cataloguer #7 "wondered why the ... foci were not given in ranges" such as 1–2 and 3–5, noting that such ranges would "be more specific." Cataloguers also debated the use of only the first and last letter in measuring the symmetry of a piece. Some suggested that symmetry should be examined in terms of the top half versus the bottom half of the piece, as well as the left half versus the right half. Cataloguer #14 commented, "Even if the first and last letter forms are mirror images of one another, the interior letter forms may not be." All these concerns are valid. But the facet and foci definitions were based on the information provided by the graffiti art experts consulted in developing the classification system. The definitions are therefore meant to reflect how the visual components of graffiti art are conceptualized by graffiti writers themselves. While it might seem limiting to some cataloguers, matching the outlines of the first and last letters is how the symmetry of a piece is judged within the graffiti art community. Similarly, the number of colors in a piece is quantified by writers in terms of a minimum but not a maximum, meaning that specific ranges cannot be used for the Number of Colors foci.

As with Cataloguer #1's comment that the definitions for the Dimensionality and Letter Outlines facets could not be made clearer without "the use of diagrams or examples," many other cataloguers broached the issue of visual examples. Citing the helpfulness of the "Graffiti Art 101" guide, thirteen cataloguers suggested that photographs displaying the various facets and foci might have assisted them in identifying these features in the images they viewed. The sample image and definitions provided in "Graffiti Art 101" covered physical elements that are essential to understanding graffiti art in general, but it did not provide visual examples of the specific foci in the classification system.

Visual examples of the foci were not provided for two reasons. The first

concerns the testing of the facet and foci definitions. Providing visual models of the foci in conjunction with the definitions would not provide a clear picture of how well the cataloguers understood the definitions, since classificatory decisions would have been reached using both visual models and definitions. It therefore might be difficult to ascertain whether a correct (or incorrect) focus selection stemmed from the definition or from the visual example. But promising results from the use of verbal descriptions only could provide a basis for future research to determine what role (if any) visual examples of the foci play in style identification.

The second reason for not including visual examples relates to a theme that emerged from the data analysis. Cataloguers had difficulty identifying some but not all manifestations of a particular facet-focus combination. Their ability to identify a feature in some cases and not others reflects the fact that the features themselves will vary from graffiti writer to graffiti writer. Even though a facet-focus combination is based on certain core elements, every incarnation of these elements will not be exactly identical. Providing a visual example of a particular facet-focus combination might therefore lead some cataloguers to reject a focus because the feature in the image with which they are working does not exactly replicate the feature in the visual example.

There is also the question of how much assistance cataloguers would have received from visual examples. It is interesting to note that the 13 cataloguers who introduced this issue in their questionnaire responses had an ASR of 72.0 percent, as compared to the mean ASR of 69.47 percent for the entire group of 30 cataloguers. In other words, those who felt that visual models would be beneficial were not especially in need of this assistance. It is difficult to generalize about the role of visual examples, however, without empirical evidence. Further research is needed to examine whether sample images of the foci would facilitate or hinder cataloguers' accurate application of the facet and foci definitions.

Conclusions

The ASRs for Images, Styles, and Facets are frameworks through which to address the question of whether cataloguers could identify primary subject matter using the facet and foci definitions. More specifically, these frameworks examine cataloguers' ability to identify definitional facet-focus combinations within an image. The results and analysis presented in this chapter suggest that cataloguers collectively were able to identify definitional facet-focus combinations across a variety of styles and images of those styles. As shown in table 8, at least one cataloguer had an individual image score of

100.0 percent for 13 of the 28 images in the sample (46.4 percent), and at least one cataloguer had an individual image score of 70.0 percent or higher for 26 of the 28 images (92.9 percent).

At the same time, the spectrum of scores that comprised each cataloguer's individual ASR suggests that cataloguers' ability to identify definitional facet-focus combinations varied both from style to style and from image to image. The analysis of ASRs revealed that two distinct yet interrelated factors shaped cataloguers' recognition of these definitional primary subject matter elements. The first factor is the interrelationship among certain facets: cataloguers' ability to identify feature A is predicated on their ability to identify feature B. The second factor concerns the role of image context in formulating cataloguers' perceptions: successful identification of a feature can be affected not only by the interrelationship among facets, but also by the particular manifestation of that feature in a given style or image.

Although low ASRs can be attributed in some cases to a specific facet or concept (types of shines, for example, or the integral use of arrows), it does not necessarily follow that cataloguers did not understand the definition or concept in general. The Negative Space facet (62.5 percent Facet ASR) is one example. At least 90.0 percent of cataloguers were able to identify limited, standard, and exaggerated amounts of negative space within the context of one or more pieces defined by this facet. Yet, while cataloguers were generally comfortable applying all three of the Negative Space foci, their recognition of any one of these foci varied from image to image. For instance, 90.0 percent of the cataloguers who viewed Image One of the Pichador style observed that the letters have an exaggerated amount of negative space — a defining characteristic of this style. Yet only 54.5 percent of the cataloguers who examined Image Two of the Pichador style came to the same conclusion. This does not imply that cataloguers did not understand the facet-focus combination. Instead, it indicates that they did not recognize the feature in certain circumstances.

While cataloguers' ability to identify definitional primary subject matter in graffiti art images varied according to image context, it should be emphasized that image context is constructed by both viewer and artist. Cataloguers' recognition of a particular focus in some images and not in others can reflect graffiti writers' own differing interpretations of that focus — variations in how the writers themselves chose to express a particular aspect of a piece. As noted in chapter 4, the fact that a facet-focus combination is definitional does not mean that this feature appears the same in every image. Likewise, cataloguers will react differently to these unique manifestations, recognizing certain characteristics in one graffiti writer's interpretation but perhaps not understanding another writers' rendering of this same characteristic. The ASRs discussed

in this chapter and the factors that contributed to cataloguers' classificatory decisions have implications not only for the functionality of the classification system for graffiti art styles, but also for the applicability of Panofsky's process model to other types of nonrepresentational or abstract art images. These implications are examined in chapter 6.

6

Panofsky's Theories and the Question of Nonrepresentational or Abstract Art

The identification of secondary subject matter in Panofsky's process model is predicated on the correct identification of primary subject matter, a connection that he illustrates using the example of an artist's rendering of St. Bartholomew: "If the knife that enables us to identify a St. Bartholomew is not a knife but a cork-screw, the figure is not a St. Bartholomew."[1] As this example makes clear, the viewer must be able to identify the basic elements that constitute primary subject matter in order for the process model to function. This identification should, at least in theory, rely solely upon the individual's "practical experience (familiarity with objects and events)."[2]

The visual language of graffiti art, however, is not composed of objects and events, but rather of forms and features, such as the uniform letter strokes that define the Pichador style. To paraphrase Panofsky, if the uniform letter strokes that enable us to identify a Pichador piece are varied instead of uniform, then the piece is not in the Pichador style. Given the importance of correct primary subject matter identification in Panofsky's process model, a fundamental question needs to be addressed: are the primary subject matter elements of graffiti art accessible to image cataloguers who lack expertise in this area?

This chapter seeks to answer this question, drawing on the analysis of cataloguers' classificatory decisions and the insights gained from their follow-up questionnaire responses. The first part of the chapter focuses on graffiti art, examining the role that primary subject matter plays in the classification system and evaluating the effectiveness of the process model in identifying secondary subject matter in graffiti art images. The discussion then turns to the ways in which the facet and foci definitions could be modified to better

capture and translate primary subject matter elements for non-experts. The second part of the chapter looks at the broader implications of the development of the classification system and the testing of the facet and foci definitions by investigating the potential applicability of Panofsky's model of iconographical analysis to other types of nonrepresentational or abstract art.

Panofsky's Process Model and the Identification of Graffiti Art Style

By using style notations to link the facet and foci definitions (primary subject matter) to the descriptions of 14 distinct graffiti art styles (secondary subject matter), the classification system presented in this book is based both theoretically and operationally on Panofsky's process model. But using this model entails more than simply transcribing the interrelationships between primary and secondary subject matter within the context of the system. The system also needs to reveal these interrelationships within actual art images. In order to discuss the utility of Panofsky's process model, it is therefore helpful to see how cataloguers' classificatory decisions would affect the identification of graffiti art style in the images they viewed. This final step of the identification process was not tested: the 30 image cataloguers who participated in the study were not asked to link an image to a specific style using the classification system's style descriptions and index. Nonetheless, it is possible to compare a cataloguer's identification of primary subject matter elements in an image to the facet-focus combinations (definitional, predominant, and non-definitional) that define the style of that image. The process of moving from primary to secondary subject matter will be replicated using the example of three image cataloguers' foci selections for Image One of the CTK style.

The success rates presented and analyzed in chapter 5 reflect non-experts' ability to identify and understand *definitional* primary subject matter (i.e., definitional facet-focus combinations) in images of graffiti art pieces. In addition to this data, the following discussion looks at the effect of cataloguers' classificatory decisions for predominant and non-definitional facets on the process of style identification. These decisions cast light on how the classification system operates and on the applicability of Panofsky's process model to graffiti art.

Chapter 4 provided the hypothetical example of a cataloguer who, having applied the facet and foci definitions to an image of graffiti art, produced a string comprised of the 13 facet-focus combinations, or notation units, that she had identified. This 13-notation-unit string was then compared to the clas-

sification system's style notations by entering the string into a (hypothetical) database. This same process was performed using the actual foci selections of three image cataloguers who participated in the study. In other words, the 13-notation-unit strings that resulted from these cataloguers' foci selections for Image One of the CTK style were compared to the style notations of all 14 styles covered by the classification system to determine which styles would rank highest if a search had been conducted using the type of database described in chapter 4. Since this database does not actually exist, the cataloguers' strings were manually compared to each of the 14 style notations to see how many facet-focus combinations the strings and style notations had in common. The results of this comparison — i.e., the rankings of the styles based on the number of notation units in common between a cataloguer's string and a given style notation — are shown in table 11. These rankings show the best match between a cataloguer's string and a style notation. This, in turn, would indicate to the cataloguer which style definition(s) should be consulted first in determining the style represented by the image.

Table 11. Rankings of styles for hypothetical query based on cataloguers' facet-focus selections for Image One, CTK style

No. of notation units in common	Cataloguer #11 87.5% image success rate for Image One, CTK style	Cataloguer #18 75.0% image success rate for Image One, CTK style	Cataloguer #12 50.0% image success rate for Image One, CTK style
8	Los Angeles Cholo-based Semi-wild	N/A	N/A
7	CTK	N/A	N/A
6	N/A	CTK	Los Angeles Cholo-based Semi-wild TFP
5	East Coast Piecing Silvers	Semi-wild TFP	N/A
4	Neo Classic American Freight	Los Angeles Cholo-based	CTK East Coast Piecing
3	Swedish Train Wild	Abstract East Coast Piecing Neo Classic American Freight Swedish Train	Neo Classic American Freight Silvers
2	Abstract Dortmund No-neg Pichador TFP	No-neg Silvers Wild	Abstract Dimensional Pichador Swedish Train
1	Dimensional	Dortmund	Dortmund No-neg Wild
0	N/A	Dimensional Pichador	N/A

As table 11 indicates, success in identifying the definitional facet-focus combinations in an image is not always reflected in the style rankings. Cataloguer #11 had the highest individual success rate — 87.5 percent — for this image, meaning that she correctly identified seven of the eight definitional facet-focus combinations that comprised the CTK style notation. Although she had the highest success rate for Image One among the three cataloguers, CTK was the third-ranked style. In fact, Cataloguer #11's 13-notation-unit string, representing her foci selections for the 13 facets in the classification system, had more in common with the style notations for the Los Angeles Cholo-based and the Semi-wild styles than with the CTK style. Conversely, while Cataloguer #18 correctly identified 75.0 percent of the definitional facet-focus combinations that link the image to the CTK style, a search based on this individual's focus selections produced the highest ranking for the CTK style. The practical implication of these rankings is that CTK would be the first style definition consulted by Cataloguer #18 and the third style definition consulted by Cataloguer #11.

The discrepancy between success rate and style ranking points to the influence of predominant and non-definitional facets. The CTK style has eight definitional facet-focus combinations; the remaining five facets that cataloguers examined are either predominant or non-definitional. These five facets, however, are definitional for other styles in the classification system. Notation unit J1 (Use of Arrows: Integral), for example, is predominant for the CTK style, and Cataloguers 11, 18, and 12 all selected J1 for this particular CTK piece. But J1 is definitional for three other styles, including the Los Angeles Cholo-based and Semi-wild styles — two styles that are ranked higher than CTK for Cataloguer #11 and Cataloguer #12 (table 11). Similarly, the Letter Shape Consistency facet is non-definitional for the CTK style but is definitional for both the Los Angeles Cholo-based and Semi-wild styles: consistently-shaped letters (notation unit K1) are a defining characteristic of pieces in these two styles. While Cataloguer #18 selected K2 for this CTK image, the other two cataloguers selected K1. As with J1, this classificatory decision contributed to the high ranking for the Los Angeles Cholo-based and Semi-wild styles in the hypothetical query.

Although table 11 shows that high success rates do not always correlate with style rankings, it also illustrates the impact that low success rates can have. Cataloguer #12 correctly identified only half of the definitional facet-focus combinations in Image One, and she had four notation units in common not only with the CTK style, but also with the East Coast Piecing style. Furthermore, three other styles — Los Angeles Cholo-based, Semi-wild, and TFP — are ranked higher than CTK. From a practical standpoint, the style definition for CTK would be either the fourth or fifth style definition con-

sulted by Cataloguer #12. This result can be traced to two factors. As was the case with Cataloguers #11 and #18, facet-focus combinations selected by Cataloguer #12 are predominant or non-definitional for the CTK style but are definitional for other styles. At the same time, Cataloguer #12 had fewer correct focus selections than the other two cataloguers. In some cases, these incorrect selections were also definitional facet-focus combinations for other styles. Taken together, these two factors increase the pool of notation units that might be definitional for another style, and consequently elevate the rankings of these styles in searches based on Cataloguer #12's foci selections.

It is also important to note the effect on the style rankings of *which* foci were selected for predominant and non-definitional facets. The significance of these selections is most evident in the case of Cataloguer #18, whose notation-unit string produced a number-one ranking for the CTK style. In the example of the Letter Shape Consistency facet, K2 — the selection made by cataloguer #18 — is a definitional facet-focus combination for three styles, whereas K1 — the selection made by the other two cataloguers — is a definitional facet-focus combination for five styles. Similarly, only Cataloguer #18 chose the notation unit I4 for the Letter Overlap facet. This facet-focus pairing is not definitional for any of the styles covered by the classification system. In contrast, the other two cataloguers selected notation units I2 and I3, respectively. Both I2 and I3 are definitional for three different styles. The fact that K1, I2, and I3 all are associated with a greater number of styles than the choices made by Cataloguer #18 contributed to a larger number of false positives — i.e., styles ranked higher than CTK — for Cataloguers #11 and #12.

The style rankings shown in table 11 do not mean that Cataloguers #11 and #12 would be unable to identify Image One as an example of the CTK style. In the scenario of the database search described in chapter 4, the rankings indicate which style descriptions are most likely to be applicable based on the cataloguers' foci selections. Cataloguers would then use the information presented in these descriptions to classify the image according to its style. Let us say that Cataloguer #11 first consulted the definition of the Los Angeles Cholo-based style. This definition would inform her that pieces in this style are defined by the presence of at least five colors, exaggerated negative space, and the fill effect known as fades. According to her foci selections for the CTK piece, Cataloguer #11 detected none of these features. Theoretically, the inconsistencies between the classification system's description of Los Angeles Cholo-based pieces and this individual's foci selections would prompt her to consult the descriptions of the other styles with high search-result rankings.

In cases where there is no contradiction between a cataloguer's foci selections and the style description, the descriptions themselves might reinforce

or bolster the identification of a particular style. Cataloguer #18 would consult the definition for the CTK style first, based on the search-result rankings shown in table 11. As previously noted, this individual characterized the piece as displaying an integral use of arrows (notation unit J1), and J1 is a predominant facet-focus combination for the CTK style. The CTK style description explains that "CTK pieces often feature multiple arrows of various sizes, ranging from minute to quite large." In fact, Image One incorporates numerous small and large arrows — a design element that might confirm a cataloguer's judgment that the piece is in the CTK style.

These theoretical cases demonstrate how the definitional, predominant, and non-definitional facets within the classification system together contribute to the process of style identification. They also recall the distinction Panofsky makes between factual and expressional primary subject matter, described in chapters 1 and 4. Unlike its factual counterpart, expressional primary subject matter — defined by Panofsky as characteristics that do not coincide with an artist's intent to render a specific figure or theme — does not affect the identification of secondary subject matter. The same idea applies to the identification of style in a graffiti art piece. Predominant and non-definitional facets do not affect secondary subject matter in the sense that they are not the core characteristics that define a graffiti art style. Although they are not codified in a given style notation, they do play a significant role in the *process* of style identification. Both predominant and non-definitional facets are addressed in the style descriptions which, in turn, are instrumental in how the classification system functions. While definitional facet-focus combinations link an image and its corresponding style, the style descriptions provide a complete picture of the style. By incorporating details and by stating the relative importance of these details to a style, the descriptions can either confirm or contradict the foci selections made by individual cataloguers.

The data collected from the cataloguers' worksheets showed that the range of cataloguers' foci selections for predominant and non-definitional facets often mirrored the range of possible foci options cited in the corresponding style descriptions for each image. Consider the following example, in which cataloguers were divided in their opinions concerning the linearity of a piece in the Swedish Train style. While half of them determined that the piece exhibited only curved lines, the other half described the piece as having both curved and straight lines. Linearity is a predominant facet in the context of the Swedish Train style, and the style description states: "Letters are often created with Curved lines only." On the one hand, cataloguers who selected "Curved only" as the focus would find confirmation in the style description. On the other hand, cataloguers who selected "Curved and straight" as the focus would see that "Curved only" is a predominant, rather

than a defining, characteristic. Therefore, both options are feasible, and nothing in the style description contradicts cataloguers' characterization of the piece as having both curved and straight lines.

In their capacity as expressional primary subject matter, non-definitional facets can act as "neutral" characteristics. Since many of these facets encompass their entire range of foci, any focus selection would correspond to the information provided in the style descriptions. For instance, cataloguers selected either the "Straight only" or the "Curved and straight" foci options for Image Two of the Silvers style — foci that represent gradual and subtle gradations of linearity. In terms of style identification, however, the discrepancy has little bearing on whether cataloguers would recognize or reject the categorization of the image as a Silver piece. Linearity is not germane to the Silvers style, being analogous to expressional rather than to factual primary subject matter. The same scenario occurred with the TFP style: the Linearity facet is non-definitional for the TFP style, and all three foci — "Curved only," "Straight only," and "Curved and straight" — are plausible choices.

Of course, the range of foci selected by cataloguers for predominant and non-definitional facets did not always mesh with an image's corresponding style description. And the influence of predominant and non-definitional facets in confirming a style depends on the number of definitional facets a cataloguer had successfully identified. Arguably, cataloguers who had recognized in an image all the definitional characteristics listed in the style description are less likely to be swayed by contradictory information in the "Predominant Characteristics" and "Other Characteristics" sections of the description than cataloguers who did not recognize all of the definitional characteristics.

Nevertheless, the distinct roles played by definitional, predominant, and non-definitional facets in the process of style identification reflect and support the use of Panofsky's theories of iconographic analysis as a process model, rather than a level model, for image access. This model differs from most adaptations of Panofsky's theories to the field of image access, which tend to treat the pre-iconographic and iconographic levels of interpretation as discrete units, rather than as stages in a process. The result of this "level" approach or model is that primary and secondary subject matter become separate de facto categories for classifying the visual elements of an image. In contrast, using Panofsky's framework as a process model emphasizes the interconnections between primary and secondary subject matter. All three categories of facets in the classification system represent primary subject matter. While the specific foci of definitional facets encapsulate the style (i.e., secondary subject matter) of a piece, it is the interaction of all facet-focus combinations that leads to the identification of a style.

Proposed Modifications to the Facet and Foci Definitions

The facet and foci definitions provided in the classification system were intended to assist cataloguers in the identification of key elements of graffiti art — elements that represent visual hallmarks of specific styles. Chapter 5 conveyed image cataloguers' impressions of these definitions. Their comments, together with the data collected from the study, suggest that changes should be made to two areas: the Letter Overlap and Symmetry facets. Although further testing would be needed, it is anticipated that the proposed changes would make the concepts more readily understood and would therefore facilitate the identification of primary subject matter in graffiti art pieces.

The first modification would be to eliminate the distinction between the "Minimal" and "Standard" letter overlaps. Data from the image cataloguer study pointed to the fact that cataloguers had difficulty distinguishing between these two types of overlap. The foci definitions asked cataloguers to differentiate between cases where no more than one-eighth of a given letter overlaps an adjacent letter ("Minimal" letter overlap) and cases where no more than one-quarter of a given letter overlaps an adjacent letter ("Standard" letter overlap). While the principle behind these definitions is not hard to understand, applying the foci required cataloguers to quantify overlap in terms of very precise benchmarks. It is not surprising that cataloguers' opinions regarding a piece were often divided between these foci, since the difference between the two essentially boils down to one-eighth of a letter.

It is also debatable whether the distinction is crucial to the process of identifying graffiti art styles. There is scant difference between the two foci not only in terms of the actual appearance of the letter overlaps, but also in terms of their influence on the relevant style notations. "Minimal" (notation unit I2) is a definitional focus for three styles, as is "Standard" (notation unit I3). Combining the two foci — by changing each instance of I2 to I3, for example — does not affect the mutual exclusivity of the style notations. In other words, removing the distinction between minimal and standard letter overlaps does not result in two or more styles having identical notations. At the same time, eliminating the need for cataloguers to quantify the two letter overlaps might also assist them in differentiating "Standard" from "Intertwining" letter overlaps — another area of difficulty for the cataloguers, as described in chapter 5.

That the amalgamation of I2 and I3 would not affect the classification system as it currently stands calls into question the relevance of distinguishing between the two types of letter overlap in the first place. Adjusting the style notation for the Swedish Train style from C2D2H3*I2*J2K2 to

C2D2H3*I3*J2K2, for example, does nothing to diminish the integrity or uniqueness of the style itself. It also indicates that the other facet-focus combinations in the notation, such as the use of limited negative space (H3) and inconsistently shaped letters (K2), play a greater part in defining the style. This line of reasoning might be challenged by graffiti art experts who can readily discern, say, the minimal overlap of a Silver piece and understand the role it plays in this style. While there are nuances between I2 and I3, these nuances have little bearing on style identification within the context of the classification system.

While the proposed changes to the Letter Overlap facet concern the specificity of the foci definitions, modifications to the Symmetry facet would involve recasting the emphasis of the facet itself. Cataloguers took issue not only with how the facet was presented, as described in chapter 5, but also with its utility. Symmetry is a definitional facet for four styles covered by the classification system, and in each of these cases "Asymmetrical" is the focus. Therefore, although some of the styles included in the classification system are defined by their asymmetry, none is defined by symmetry. Cataloguers observed this imbalance in the image sets they viewed, with one individual questioning whether there are "graffiti works that are actually symmetrical, *exactly* mirror-like?" Another noted that "all of the images appeared to be asymmetrical to me." Similarly, the dearth of symmetrical pieces prompted Cataloguer #14 to comment, "I found it difficult to understand why this [facet] was included."

Differences in opinion concerning the relevance of the Symmetry facet to the classification system also arose in the graffiti art experts' discussions. GREX9 wrote: "I agree that symmetry is an important characteristic in general, although ... it's not really indicative of a particular style." Her point was that symmetry has as much to do with the number and range of letters in a tag — factors which tend to produce asymmetrical pieces — as with the style of the piece. On the one hand, this observation is borne out by the preponderance of asymmetrical pieces in the image sample. On the other hand, data collected from the graffiti art experts indicated the prominent role that asymmetry as a concept can play in a style. Perhaps the clearest example is Silvers. As noted in chapter 4, Silver pieces "are quickly painted, good for a tight spot or a tight schedule."[3] The fact that Silver pieces are, by definition, painted rapidly precludes these works from being symmetrical, since creating a symmetrical piece is a time-consuming process. In this sense, asymmetry is a defining feature of the Silvers style — one that differentiates it from, say, the intricate and elaborate Los Angeles Cholo-based style, whose pieces can be either symmetrical or asymmetrical according to the writer's own predilection. Similarly, asymmetry is a defining feature of the Abstract style, not

because Abstract pieces are painted in haste, but because these pieces tend to be, as explained in the style description, "very organic in shape" and distinctly "non-quadrilateral." A piece whose shape resembles, say, a check mark or an amoeba cannot, by definition, be symmetrical.

While the relevance of symmetry to the identification of graffiti art styles was strong enough to merit inclusion of the facet in the classification system, the facet definition itself, as well as those of the corresponding foci, could be reworded. One option would be to employ Josephine Noah's distinction between pieces that are "precisely symmetrical" and pieces that are "generally symmetrical, meaning the height, width, and outline will be approximately equivalent around a vertical line of symmetry."[4] Asking cataloguers to distinguish between what is precise and general symmetry, however, could produce the same challenges that characterized the distinction between minimal and standard letter overlaps.

A more feasible solution might be to move away from the notion of symmetry, with its emphasis on mirror-imagery, and toward the concept of "balance." Noah points out that balance is a term more frequently found in the graffiti lexicon than symmetry,[5] an observation shared by GREX9. In questioning the inclusion of the Symmetry facet, GREX9 explained that "'balance' is a term I hear a lot when graffiti style is discussed by writers. Balance has to do with letter size uniformity and word shape symmetry. People understand the concept of balance better than they do 'symmetry' which is a more intellectual term." In fact, one cataloguer characterized pieces as symmetrical when she "sensed that the artist's intent was to create a balanced word-object." Replacing the concept of symmetry with that of balance, the new facet definition would emphasize the uniformity of letter size, as suggested by GREX9, and the visual harmony and proportionality of the piece as a whole. In applying a "Balance" facet, cataloguers would be determining, in the words of the cataloguer just cited, whether "the artist's intent was to create a balanced word-object," as opposed to matching the contours of letters, as is presently the case.

The Applicability of the Process Model to Other Types of Nonrepresentational or Abstract Art

The usability of the facet and foci definitions ties into a much broader issue than simply the functionality of the classification system — namely, whether primary subject matter elements in nonrepresentational or abstract artworks are accessible to non-expert image cataloguers. The image cataloguer study examined this issue in terms of the visual elements that comprise pri-

mary subject matter in graffiti art images. The results of the study are promising, but inconclusive. As revealed in the analysis of success rates, cataloguers as a group were able to identify definitional facet-focus combinations across a variety of styles and images of those styles. It was noted in chapter 5 that at least one cataloguer had an individual image success rate of 100.0 percent for 13 of the 28 images in the sample (46.4 percent), and at least one cataloguer had an individual image success rate of 70.0 percent or higher for 26 of the 28 images (92.9 percent).

Yet despite such overall proficiency, the individual image scores that comprised each cataloguer's average success rate (ASR) often varied widely. Cataloguer #7, for example, had a Cataloguer ASR of 69.8 percent — close to the mean ASR of 69.47 percent for the entire group of cataloguers. But the individual success rates that made up her score ranged from 50.0 percent to 87.5 percent. This pattern is just as pronounced in cases where the cataloguer's ASR is above or below the mean. Cataloguer #1 had a Cataloguer ASR of 73.5 percent and individual scores ranging from 37.5 percent to 100.0 percent, while Cataloguer #15, whose Cataloguer ASR of 54.6 percent was the lowest of the group, had individual image scores from 16.7 percent to 71.4 percent.

The analysis of cataloguers' classificatory decisions revealed that the variability in ASRs is often a reflection of the different image contexts in which facet-focus combinations appeared. This pattern applied to intercataloguer agreement as well — the measure of how often cataloguers selected the same foci for the same image (see chapter 5). Image context has two distinct aspects. The first is the issue of artistic interpretation — the idea that various graffiti writers' renderings of the same feature will not be identical. The other aspect of image context is the interaction of various foci, in which cataloguers' identification of one element in a graffiti art piece hinged upon their successful identification of another, seemingly unrelated yet actually interdependent, feature of the piece. For both of these reasons, cataloguers might have difficulty identifying a certain feature in image A, but not in image B.

The variability in cataloguers' identification of the same facet-focus combination across graffiti art pieces points to a major challenge for the identification of primary subject matter in nonrepresentational or abstract images. In representational images, the depiction of an object, such as a tree, is comparatively constant across different examples. Although all trees in photographs or representational paintings are not identical, there is still some degree of "treeness" about these objects that would enable a cataloguer to identify them as such. Similarly, a graffiti writer would be able to identify the use of the relief effect in different styles and in different examples of the same style

based on his or her everyday experience. But non-experts (i.e., individuals outside of the graffiti art community) do not have the same degree of familiarity with a concept such as relief effect and its relevance to graffiti art.

The disparity between what is familiar to graffiti art experts and to non-experts leads to the question of whether the primary subject matter elements in graffiti art are within the scope of primary subject matter according to Panofsky's model. The answer to this question has implications not only for graffiti art, but also for other types of nonrepresentational or abstract art images. As discussed in chapter 5, ASRs were higher for facets that embodied especially familiar concepts, such as linearity and use of arrows, and lower for facets that covered less familiar ideas, such as letter outlines and dimensionality. From a theoretical standpoint, these less familiar elements of graffiti art nonetheless constitute primary subject matter. Panofsky explains:

> In the case of a *pre-iconographical description* ... the matter seems simple enough. The objects and events whose representation by lines, colours and volumes constitutes the world of *motifs* can be identified ... on the basis of our practical experience. Everybody can recognize the shape and behaviour of human beings, animals, and plants, and everybody can tell an angry face from a jovial one. It is, of course, possible that in a given case the range of our personal experience is not wide enough, for instance when we find ourselves confronted with the representation of an obsolete or unfamiliar tool, or with the representation of a plant or animal unknown to us. In such cases we have to widen the range of our practical experience by consulting a book or expert, but we do not leave the sphere of practical experience as such (original emphasis).[6]

Arguably, cataloguers did "not leave the sphere of practical experience as such" in their attempts to identify different manifestations of dimensionality in graffiti art pieces. They did, however, have to "widen the range of [their] practical experience by consulting a book"—or, more specifically, the facet and foci definitions in the classification system.

As noted in chapter 3, the classification system functions as a type of iconographic handbook for graffiti art by elucidating and verifying the relationship between primary and secondary subject matter. To determine the secondary subject matter of an image (i.e., the style of the piece), cataloguers first identify primary subject matter elements based on their familiarity "with the practical world of objects and events" in conjunction with the facet and foci definitions. The definitions are therefore an integral part of the process of moving from pre-iconographical description — or "the sphere of practical experience" — to that of iconographical analysis and secondary subject matter. Chapter 5 relayed cataloguers' comments regarding the length and level of detail of the Dimensionality foci. Their objections raise the question of whether cataloguers' difficulty with the foci stems from how these features were presented in the definitions, or from an inability to grasp the underly-

ing concepts of the features themselves. Is it possible to widen cataloguers' practical experience to include these concepts?

The challenges of identifying some facet-focus combinations, or primary subject matter, in graffiti art have less to do with the suitability of Panofsky's model than with the difficulty discussed by Elaine Svenonious of expressing visual meaning verbally — of "using words to express the aboutness of a work in a wordless medium, like art."[7] Graffiti writers inherently recognize the elements that define a particular graffiti art style but do not necessarily break down these elements into categories, much less assign them definitions. Creating the facet and foci definitions for the classification system required capturing graffiti art experts' descriptions of these elements. The more complex the facet or focus being explained, the more complex or "wordy" the definitions tend to be. The definition for the Linearity facet contains 54 words, for example, while that of the Dimensionality facet is 285 words. It is therefore not surprising that the facets with the lowest success (and agreement) rates were those that required the most explanation.

Yet the difficulty in applying facet and focus definitions that express complex concepts does not necessarily mean that these concepts are beyond cataloguers' comprehension. Some cataloguers questioned what turned out to be "incorrect" foci selections for definitional facets in their follow-up questionnaire responses. One cataloguer who was not confident of her assessment of the letter outlines in a No-neg piece accurately captured the essence of the various focus definitions in the description of her decision-making process. Further evidence that cataloguers' comprehension of the facet and foci definitions are not exclusively conveyed through their foci selections comes from their classification worksheets. The worksheets presented instances where cataloguers had first circled one focus for a given facet, but then crossed out (or erased) this selection and chose another. Although these changes sometimes resulted in cataloguers' second-guessing correct selections, the opposite situation occurred too: cataloguers erased incorrect selections and ultimately chose the correct focus for definitional facets. For example, Cataloguer #5 first determined that the letter overlap of a Semi-wild style image was "Interlocking." This focus selection was then crossed out in favor of the "Standard" focus. The cataloguer's final focus selection illustrates her ability to recognize this defining characteristic of the Semi-wild style.

The question of whether primary subject matter in graffiti art (and in nonrepresentational or abstract art generally) is within the realm of cataloguers' practical experience should also be examined in terms of cataloguer subjectivity. Because nonrepresentational or abstract images do not contain readily identifiable objects, events, or people, the information studies community has generally accepted the idea that identifying the subject matter in

such artworks is therefore a completely subjective exercise. The results of the study indicate that subjectivity did play a role in cataloguers' foci selections. This role became especially apparent in the analysis of intercataloguer agreement rates. Agreement rates are based on the number of images for which cataloguers selected the same focus for a facet, regardless of whether that facet was definitional, predominant, or non-definitional for the style in which the image was created. Consider the example of the Use of Arrows facet, which has two foci. Cataloguers selected the same focus for 17 of the 28 images, or 60.7 percent of the time. This means that cataloguers were in complete agreement as to how arrows were used in 17 of the images and disagreed as to their use in the other 11 images.

Unlike the Use of Arrows facet, the agreement rate for the Fill Consistency facet was comparatively low (39.3 percent), representing a sizeable decrease in the number of images for which cataloguers selected the same focus. Yet the data reveal a number of interesting patterns. On the one hand, cataloguers were in complete agreement for only 11 of the 28 images. On the other hand, of the 17 images where there was disagreement, seven were cases where only one or two cataloguers described the fills as being inconsistently, rather than consistently, patterned. Moreover, it was often the same individual who represented this minority opinion. For example, Cataloguer #27 was the only one to select the "Inconsistent" focus for Image Two of the Dimensional style and was one of two cataloguers who selected this focus for Image One of the Semi-wild style. Furthermore, the other cataloguer who described this Semi-wild style piece as having inconsistent letters fills made the same determination for two other images where only one or two cataloguers had selected the "Inconsistent" focus. In total, the decisions of only six individuals accounted for all instances in which only one or two cataloguers had determined that the letter fills of a given piece were inconsistent. Looking at the focus selections made by these six cataloguers across their individual image sets, these participants described an average of 50.0 percent of their images as having inconsistent fills, led by Cataloguer #27, who selected the inconsistent focus for 70.0 percent of her images. In contrast, the group of 30 cataloguers as a whole identified inconsistent letter fills in an average of 23.7 percent of their images. This indicates that many of the "Inconsistent" focus selections were made by relatively few cataloguers — individuals who, it could be argued, simply had a different (or perhaps more stringent) standard of what qualifies as "Consistent."

As with the Fill Consistency facet, cataloguers often made subjective judgments in determining the symmetry of the pieces they viewed. Cataloguers were of unanimous opinion regarding the symmetry of only one image, resulting in an agreement rate of 3.6 percent for this facet — a far cry from its

85.8 percent Facet ASR. This lack of consensus is interesting in light of cat-
aloguers' comments about what they considered to be a preponderance of
asymmetrical pieces. Some cataloguers described in their questionnaire
responses how they judged the symmetry of a piece, including Cataloguer #20,
who explained that "although many images were not 'mirror images' when
folded in half, I decided to be subjective in my assessment and call them sym-
metrical if they were close enough in appearance."

Although the results of the study show some influence of subjectivity,
this does not mean that the identification of primary subject matter in graffiti
art is merely an exercise in personal interpretation. In fact, data point to
important discrepancies regarding agreement rates for definitional, predom-
inant, and non-definitional facet-focus notation units. With respect to the
Symmetry facet, the instances where cataloguers felt most compelled "to be
subjective" were occasions when this subjectivity would have the least effect
on their ability to identify the style in which the piece was created. Opinion
as to the symmetry of a piece was less divided when the facet was definitional,
as opposed to instances where it was predominant or non-definitional. For
example, pieces in the No-neg style and in the Pichador style can be either
symmetrical or asymmetrical — options that were similarly reflected in the
range of cataloguers' foci selections.

This pattern applied to other facets as well — cases where the ASR for a
facet was substantially higher than the agreement rate. The Letter Strokes
facet (21.4 percent agreement rate and 80.9 percent ASR) is an especially strik-
ing case. This facet is definitional for 12 of the 28 images viewed by the cat-
aloguers, predominant for 10 images, and non-definitional for the remaining
6 images. When the facet was definitional, cataloguers selected the same focus
at a rate of 33.3 percent. This rate drops to 20.0 percent when the facet was
predominant and to zero when the facet was non-definitional. Therefore,
agreement rate increases as the Letter Strokes facet itself assumes a greater role
in defining a particular style.

This tendency to select the same focus at higher rates when it is defini-
tional indicates both shared interpretations and consistent applications of the
foci by cataloguers. It also mirrors Panofsky's distinction between factual and
expressional primary subject matter in the identification of secondary subject
matter. In the context of the classification system, definitional facet-focus
combinations encompass what Panofsky termed factual primary subject mat-
ter. These elements define the style of a graffiti art piece and, like the knife
in the depiction of St. Bartholomew, demonstrate the "conscious intention"
of the graffiti writer to represent that specific style.[8] Non-definitional facet-
focus combinations (and, to some extent, predominant facet-focus combina-
tions) are within the realm of what Panofsky considered to be expressional

primary subject matter — "qualities of the figure [that] may well be unintentional."[9] While it cannot be said that graffiti writers did not intend to incorporate these elements into their work, these aspects are modeled on their own individual interpretation of that style. At the same time, these elements, like the expressional elements of representational art, are subject to more personal interpretations on the part of the viewer. This distinction is evident in the fact that cataloguers agreed to a greater extent about factual primary subject matter than they did about expressional primary subject matter.

Other Applications for Panofsky's Model

That cataloguer agreement was higher for factual primary subject matter highlights the role of iconographic tradition in Panofsky's process model. Iconographic tradition in the context of graffiti art refers to the visual language that expresses the relationship between letter formation and style of graffiti art — a relationship that has been passed down from graffiti writer to graffiti writer and that was documented in the classification system. The relationship between letter formation and style is most strongly conveyed through what were identified in the classification system as definitional facet-focus combinations. These combinations represent factual primary subject matter, which, in turn, communicates the writer's intent to create a piece in a certain style.

Cataloguers' agreement concerning factual primary subject matter suggests that Panofsky's process model could be applied to other types of nonrepresentational or abstract art that fall within an iconographic tradition, such as Optical Art, more commonly known as Op Art. As its name indicates, the impetus behind Op Art is to engage and manipulate the visual perception of the viewer. According to Frederick Hartt, it "has sought to produce by a variety of means strong optical illusions of depth, mass, and motion. Often the materials used are synthetic, and regularity of production is always emphasized."[10] The roots of Op Art can be traced to the pointillist paintings of Georges Seurat.[11] For *Sunday Afternoon on the Island of La Grande Jatte* (1884–86), Seurat conducted nearly 40 color studies in order to create an effect in which every single brush stroke represents a discrete point of color on the canvas.[12] Together these brush strokes merge in the eye of the viewer to form the artist's famous scene of men in top hats and women with parasols enjoying a leisurely stroll by the water's edge. Fifty years later, Op artists took a similarly scientific approach to their work, employing "certain optical phenomena that deceive and continually overtax the eye."[13]

The "regularity of production" referred to by Hartt has as much to do with the time frame in which Op Art emerged as with how it is created. Mag-

dalena Holzhey points out that when Op Art reached its height of popularity in the 1960s and 70s, artists "were infused by a faith not only in technological progress but in societal change."[14] On the one hand, the creative process of Op Art, grounded as it is on scientific principles, results in artworks that can be reproduced. On the other hand, this capability changes the existential nature of the artworks themselves. Holzhey continues, "The notion of a 'democratized,' endlessly reproducible art capable of destroying the aura of one-of-a-kind work and the elitist idea of ownership it entailed, inspired much of the period's art production."[15]

These twin concepts of art that is reproducible and democratized intersect in the work of Victor Vasarely, recognized as the "chief motive personality"[16] in Op Art. Vasarely's goal of democratizing art entailed not only eliminating the traditional model of sole ownership of a masterwork, but also emphasizing both the literal and intellectual accessibility of artworks. To achieve these ends, he employed "a depersonalized visual language based on universally comprehensible, variable modules,"[17] which he explicated in his "Yellow Manifesto" of 1955. Each module, called a "plastic unit," consisted of two contrasting forms and colors, such as a royal blue circle inside a pale orange square, or a pink diamond set in a dark orange square.[18] By manipulating various shape and color combinations of the plastic units, Vasarely was able to achieve the optical effects that define his work.

What is the relevance of Victor Vasarely and Op Art to Panofsky's process model? As with graffiti art, the answer to this question is iconographic tradition. Op Art is centered on a stable, democratized, visual language whose specific vocabulary points to the underlying meaning of Op artworks. Moreover, texts such as Vasarely's "Yellow Manifesto" provide verification of the relationship between this language and secondary meaning outside the context of the artworks themselves. Although epitomized by Vasarely's "alphabet of colors and forms,"[19] this notion of a visual language applies to Op Art generally. Describing the features from which Op Art derives its name, Holzhey identifies "redundant patterns, distortion of lines, contrast effects, afterimages, [and] inversion figures"[20]— the last element referring to forms that appear to alternately recede into and emerge from the picture plane, a characteristic shared by graffiti art letters created with what is termed "Relief effect" in the classification system.

When Op Art is examined through the framework of Panofsky's process model, these optical features represent factual primary subject matter (factual, since, as Hartt points out, Op Art lacks the "individual emotional expression"[21] that is the realm of expressional primary subject matter). The fact that artists like Vasarely "developed a pictorial language whose understandability rested solely on the physiological conditions of vision, independent of the

viewer's background and education"[22] echoes Panofsky's view that primary subject matter requires only "practical experience (familiarity with objects and events)"[23] to be identifiable and understandable. As with graffiti art, the primary subject matter elements of Op Art can also be treated as distinct facets. Investigating what type of contrast effects are used, for example, and the means by which lines are distorted would reveal the corresponding foci.

If, however, Op Art is not subject-oriented and "denies representation altogether,"[24] then how can these elements be considered primary subject matter, and what is the secondary subject matter that they construct? In the context of graffiti art, secondary subject matter is style — what is defined and conceived by the graffiti art community as the underlying "meaning" or import of a graffiti art piece. Just as the iconic language of graffiti art, comprised of the visual elements that constitute the realm of primary subject matter, reveals the style of a piece, it might well be the case that the primary subject matter elements of Op Art, expressed in its own iconographic language, point to the meaning of these artworks, where "the process of vision per se ... becomes the true subject of the picture."[25]

It could be argued that Op Art is in some ways too close to graffiti art to constitute another example of the relevance of Panofsky's process model to nonrepresentational or abstract artworks. Although visually dissimilar, Op Art and graffiti art have much in common, including a period of intense focus and creativity in the 1960s and 1970s and an anti-elitist or anti-establishment tenor. Perhaps most significantly, both Op artworks and graffiti art pieces are representational in the sense that they depict specific, identifiable forms. While the letters in most graffiti art pieces are highly abstracted (either intentionally, or, as the data from the image cataloguer study indicated, in the eyes of viewers outside of the graffiti art community), the forms that constitute Op Art are more readily discernible as actual shapes, such as circles and hexagons. Therefore they naturally fall within the "practical experience" criterion that Panofsky uses to demarcate primary subject matter. Yet it is the way in which these shapes are manipulated — their relationship to each other and to various color spectrums — that contributes to the essence or secondary subject matter of Op artworks. The terms "square," "circle," and "rhombus" would be fairly meaningless as stand-alone image access points without understanding how these elements work together in a larger visual framework that is premised on the application of Panofsky's theories as a process model.

Nonetheless, it is possible to find other areas for investigation — art movements that take an entirely dissimilar approach to the meaning and expression of visual forms. One example is Rayonnism, established and promoted by Natalia Goncharova and Mikhail Larionov between 1911 and 1914. Although Rayonnism was "a short-lived movement," Camilla Gray notes that its lead-

ers and their ideas are "of fundamental importance in the history of the modern movement in Russia."[26] Just as Vasarely believed that his alphabet of forms "bore visual analogies to modern physics,"[27] the Rayonnists based their theories "on a somewhat romanticized interpretation of the discoveries of twentieth-century physicists, especially Einstein."[28] In the Rayonnist Manifesto of 1913, Larionov wrote:

> The style of Rayonnist painting promoted by us is concerned with spatial forms which are obtained through the crossing of reflected rays from various objects, and forms which are singled out by the artist.
> The ray is conventionally represented on the surface by a line of colour. The essence of painting is indicated in this — combination of colour, its saturation, the relationships of coloured masses, the intensity of surface working. The painting is revealed as a skimmed impression, it is perceived out of time and in space — it gives rise to a sensation of what one may call the 'fourth dimension,' that is the length, width and thickness of the colour layers....
> From here begins the creation of new forms, whose meaning and expression depend entirely on the degree of saturation of a colour-tone and the position in which it is placed in relation to other tones.[29]

As reflected in the titles of Rayonnist works such as *Cats* (1911–1912) and *The Green and Yellow Forest* (1912), the color forms reference specific objects (e.g., animals, trees). Yet the execution of these forms — the way in which they are filtered by the artists' eyes through the prisms of light rays — produces artworks that are both nonrepresentational and distinct from the abstractions of both Op Art and graffiti art.

Despite these visual dissimilarities, it is possible to see how Panofsky's process model could also be applied to Rayonnist artworks. Again, this would entail identifying facets which point to the underlying "meaning and expression" of these artworks, which according to Rayonnist theory rests on the forms created through the manipulation of colors and tones. Color combinations, saturation points, and the interrelationships of forms identified by Larionov constitute yet another iconic, visual language that points to the meaning of these abstract artworks. As with Op Art, this connection can be verified outside the context of the artworks themselves, through manifestos of the artists who create them and the scholarly writings of those who study them.

This chapter has examined some of the broader issues concerning the applicability of Panofsky's process model to graffiti art specifically and to nonrepresentational or abstract art generally. Just as the data from the image cataloguer study indicate that primary subject matter in nonrepresentational or abstract art is not beyond the purview of non-specialists, the examples of Op Art and Rayonnism suggest a potential utility of Panofsky's process model beyond graffiti art. To be sure, these two types of nonrepresentational or

abstract art have been introduced only as possible areas for further investigation. But together with graffiti art, they demonstrate not only the possible applicability of Panofsky's process model, but also the need to reconfigure what is meant by iconographic tradition and subject matter in the context of nonrepresentational or abstract artworks. Indeed, these examples call attention to a new paradigm for applying Panofsky's process model to the field of image access. The implications of this paradigm are examined in chapter 7.

7

Graffiti Art Lessons

Graffiti art occupies an increasingly prominent niche in contemporary consciousness — one whose contours are difficult to map. Part of the challenge stems from the contradictory nature of graffiti art itself, described by *USA Today* as "that long-controversial hybrid of art and vandalism."[1] These contradictions are on display in an Atari video game entitled "Getting Up: Contents Under Pressure." Players assume the persona of "Trane, a 'toy' graffiti artist with the street smarts, athletic prowess and vision to become an 'All City King'— the most reputable of all graffiti artists."[2] With its references to toys, tags, and getting up, the game uses the vernacular of graffiti culture to recreate the aesthetic principles and historical context of graffiti art. Not surprisingly, a product that features "tags from more than 50 real-life graffiti artists" and encourages people to create their own tags "using multiple skills and styles" also carries multiple disclaimers.[3] According to the Atari web site, the game "is intended only to provide a fictional environment in which players can view a depiction of the graffiti culture and can act virtually without breaking any laws or affecting the rights of others in any adverse manner," and Atari "does not encourage or condone defacing, destroying, or vandalizing public or private property."[4]

But the contradictions of graffiti art stem not only from the need to reconcile artistic expression with criminal behavior, but also from the fact that graffiti art is not static. Its means of production, how it is defined, and therefore the role it plays in society today are constantly in flux. Consider that the Atari game helps you to "sharpen your skills as you tag with Aerosol, Rollers, Markers, Wheat Paste, Stickers and Stencils."[5] Wheat paste and stickers are most often associated with "adhesive art," defined by Claudia Walde as "hand-painted or crafted stickers and posters" and as "a subset of the booming street art scene."[6] Generally non-letter-based and akin to characters in graffiti art, adhesive art has gained popularity both within and beyond the graffiti art community for a variety of reasons: the ability to create the stickers or posters at

158

home; the reproducibility of the work and ease with which they can be displayed; and, the fact that "the penalties for getting caught with a spraycan in your hand have become increasingly severe."[7] Walde explains, "Many of adhesive art's foremost representatives were (or still are) active in the field of graffiti. With the responsibilities of adulthood, particularly for aerosol artists with families of their own, adhesive materials offered a fresh artistic outlet: they allowed writers to continue to indulge their creative flair, but with far fewer risks."[8] Indeed, cities such as New York and London, Ontario, have enacted bylaws to prevent the sale of "graffiti implements to minors"; Chicago bans their sale to any citizen, with exceptions for "commercial use."[9]

Such restrictions have led to the development of entirely new forms of graffiti, many of which are driven by technology. The impetus behind the Graffiti Research Lab [G.R.L.] in New York City, for example, is "to develop and test a range of experimental technologies for the state-of-the-art graffiti writer."[10] Created by James Powderly and Evan Roth, neither of whom are graffiti writers, the lab's projects include the Electro-Graf, "a graffiti piece or throw-up that uses conductive spray-paint and magnet paint to embed LED display electronics"[11] and LED Throwies, "an inexpensive way to add color to any ferromagnetic surface in your neighborhood."[12] That the Electro-Graf and Throwies are (re)moveable reflects the G.R.L.'s focus on projects that "are intentionally designed to be cheap, user-friendly and not illegal."[13] And, as David Fusaro points out, the fact that the G.R.L.'s funding comes from sources such as the MacArthur Foundation and the New York State Council for the Arts provides "more evidence that graffiti, a once-underground art form, has gone mainstream."[14]

Of course not all graffiti writers consider Throwies, or even posters and stickers, to be graffiti art. Fusaro cites Daze, an "old school" writer from New York who declares: "Graffiti to me is letter-based and spray-paint-based. [The work of the G.R.L. is] more street art, and that distinction should be made. It's definitely not graffiti."[15] Walde similarly alludes to a chasm between spray-painted graffiti and more recent approaches, noting that adhesive art "has mushroomed so much that stickers and posters have become even more widespread than classic graffiti in some areas."[16]

Innovations such as LED-based images and adhesive art, and the resulting "classic" label assigned to spray-can writing, have once again transformed the role of graffiti art. How else to explain the co-existence of Chanel's "Graffiti" hobo bag — a satchel whose design incorporates tag-like Chanel logos amidst printed words like "mademoiselle" — and the "Pop Art" pumps also offered at its boutiques? This unusual pairing suggests that graffiti has entered the pantheon of established art movements, simultaneously edgy and bland enough to sell merchandise to which it has no inherent connection.

But there is more to the canonization of graffiti art than merely its redefinition as a marketing concept. This process is also suffused with a sense of nostalgia. In the Atari game, the development of Trane's style mirrors the evolutionary course of graffiti art, including "the 1980s' train culture scene, where subways were prime targets for gaining fame" and "the silver-train era."[17] Distinct time periods in the history of graffiti art are also being commemorated by New York galleries. In 2004, the Marcoart gallery displayed "100 subway maps tagged by various graffiti writers"; Showroom NYC invited writers to paint model train cars.[18] More recently, the Brooklyn Museum staged "Graffiti," an "exhibition of twenty large-scale graffiti paintings ... [that] explores how a genre that began as a form of subversive public communication has become legitimate — moving away from the street and into private collections and galleries."[19] These treatments of graffiti art are like flipping through a scrapbook, allowing the gallery visitor or game player to witness and relive the various developmental phases that have produced this newly "classic" art.

Yet the "classic" label now applied to graffiti art hardly signifies the end of an era. The shift from "graffiti as crime" to "graffiti as legitimate art" chronicled by the Brooklyn Museum has already played itself out, first during the emergence of the United Graffiti Artists, then during the overheated 1980s gallery scene, when former graffiti writers like Jean-Michel Basquiat were discovered and discarded, and once again during the first decade of the twenty-first century, when graffiti artworks were sold by major auction houses. The constant through each of these periods is that graffiti is a crime, and is still a major concern to cities trying to eradicate the vandalism of public and private property.

Perhaps it is graffiti art's ability to be so many different things to different people — to be provocative and canonical, reviled and memorialized — that has created and sustained an enduring interest in this art form. Indeed, the term "classic" connotes a sense of permanence. As video games and galleries pay homage to "old school" graffiti art, new manifestations of graffiti build on its traditions. For example, Evan Roth, one of the founders of the G.R.L., documents New York City tags, creating "detailed typographic charts of various letters of the alphabet."[20] This typography is then incorporated into other G.R.L.-based projects.[21]

The classification system presented in this book also builds on the traditions of graffiti art by examining the iconic styles of graffiti art pieces. Describing the reasons why a number of artists have turned from graffiti to stickers and posters, Walde remarks:

> Walls are the ideal canvas for many forms of art. But although pieces are there for all to see, they are not always accessible or comprehensible. The graffiti world has been aware of this for decades. An artist may employ the same meth-

ods as an advertiser to spread his name, but only rarely are the general public able to decipher the letters; and even if they are successful, the meaning often escapes them. Frequently only those involved in the scene itself can read a piece or understand its significance.[22]

One of the goals of the classification system is to make graffiti art pieces more comprehensible to individuals outside of the graffiti art community. As Walde points out, there are two components to being able to "read a piece": identifying the word depicted and comprehending its underlying meaning. The classification system concentrates on the second of these readings — the significance of the piece, as manifested through the iconic style in which it was created.

The classification system operates by distilling an image of graffiti art into its essential visual elements and organizing these elements into facets and foci. It also reflects the knowledge and consensus of graffiti art experts about the various roles played by these facets and foci in the context of specific graffiti art styles. According to Henry Evelyn Bliss, the benefit of basing classification systems on consensus is that the order they propose is verifiable and therefore stable. While the synthesis of the ideals, beliefs, and approaches of individuals connected to graffiti art leads to stability in classification systems, the consensus of graffiti art experts about styles and the hallmarks that define them also provides the verification crucial to Erwin Panofsky's model of iconographical analysis.

The classification system is intended as a model only. If it were applied as a functional system within a collection, then its scope (i.e., the number of styles included) would need to be expanded, which would require additional input from graffiti experts and would likely result in changes to the existing style descriptions and facet and foci definitions. As described in chapter 4, the system is flexible, enabling it to accommodate additional styles, facets, and foci. It should also be noted that the classification system is not foolproof. Theoretically, a situation could arise in which a cataloguer's incorrect foci selections for definitional facets and the range of his or her selections for predominant and non-definitional facets could result in the misidentification of the style of a graffiti art piece. Yet even in its current form, the classification system can increase the visual literacy of information professionals with regard to specific graffiti art styles and the visual components that comprise all graffiti art pieces. Furthermore, a classification system that allows image cataloguers to distinguish examples of graffiti art beyond the form-based categories of "tag," "throw-up," and "piece" addresses a growing information need.

While one of the goals of the system was to elucidate style in graffiti art, another was to demonstrate a new paradigm for Panofsky's theories. The classification system applies Panofsky's theories of iconographical analysis as

a process model, in which the correct identification of secondary subject matter — the significance of the piece — is predicated upon the correct identification of primary subject matter. The significance of a graffiti art piece is the style in which it was created. Just as the visual elements of graffiti art (presented in the facet and foci definitions) represent primary subject matter, graffiti art styles (encapsulated in the style descriptions) represent secondary subject matter.

The development of the classification system showed that Panofsky's process model can be applied to graffiti art; the results of the image cataloguer study demonstrated that individuals outside of the graffiti art community can identify primary subject matter in this art form in many, although not all, situations. It is possible that cataloguers' ability to understand and apply the facet and foci definitions could increase as cataloguers use the classification system in an actual cataloguing (as opposed to research) environment, and as they become more familiar with the definitions and with graffiti art in general. To be sure, the image cataloguer study employed a relatively small image sample (two images each of 14 different styles), a limited number of cataloguers (30), and tested only the facet and foci definitions. Further research is needed to examine the functionality of the entire classification system to see whether cataloguers could identify secondary subject matter in graffiti art images using all of the components of the classification system — facet and foci definitions, index, and style descriptions.

The classification system differs from most applications of Panofsky's theories to image access not only in its use of his framework as a process (rather than as a level) model, but also in its application to a specific type of nonrepresentational or abstract art. The information studies community has assigned a high degree of generalizability to Panofsky's model, deeming it adaptable to any image of representational art (i.e., to any artwork in which elements such as objects, people, scenes, and events are readily identifiable). At the same time, works of nonrepresentational or abstract art have been considered beyond the scope of Panofsky's theories and of subject-access systems generally. These assumptions do not take into account the role of iconographic tradition in Panofsky's theories. Iconographic tradition refers to the presence of, and interconnection between, primary and secondary subject matter within an artwork, as well as the ability to verify the relationship between primary and secondary subject matter outside of the context of the artwork itself. Using Panofsky's framework as a level model produces the arbitrary assignment of subject matter elements to categories that are intended to reflect the concepts of primary and secondary subject matter. But primary and secondary subject matter cannot be distinguished with any certainty in images that fall outside of an iconographic tradition.

The development of the faceted classification system for graffiti art styles demonstrates that it is possible to utilize Panofsky's theories as a process model for providing access to nonrepresentational or abstract images that fall within an iconographic tradition. While the development of the system and the results of the image cataloguer study cannot be generalized to other forms of nonrepresentational or abstract art, they indicate that nonrepresentational or abstract art images are not necessarily beyond the scope of Panofsky's model of iconographic analysis. This suggests that the relevance of an image to iconographic tradition is a more accurate criterion in determining the applicability of Panofsky's model than the distinction between representational and nonrepresentational images.

This criterion forms the basis of the new paradigm for the use of Panofsky's model in the field of image access. Because graffiti art falls within an iconographic tradition, there is an intrinsic connection between primary and secondary subject matter in graffiti art images. This interrelationship between primary and secondary subject matter was represented in chapter 3 in terms of the formula A1 + A2 + A3, etc. = B, wherein each instance of 'A' is a distinct component of primary subject matter, and 'B' is the secondary subject matter or theme that these components collectively express. Essentially, this formula presents the idea that, in artworks that are part of an iconographic tradition, primary subject matter elements are interpretive clues which convey the underlying meaning of an artwork. When applying this idea to image access, access points should be selected based on their role in communicating the meaning of an artwork. This approach would alleviate the dual problems of indexer subjectivity and indexing exhaustivity, which have so often thwarted attempts to apply Panofsky's model to the field of image access.

By focusing on the role of iconographic tradition, the new paradigm has ramifications for representational as well as nonrepresentational or abstract art. The Introduction quoted Panofsky's definition of iconography as "that branch of the history of art which concerns itself with the subject matter or meaning of works of art, as opposed to their form."[23] When these forms — patterns consisting of colors, shapes, and lines — can be identified and named as distinct objects or events within an artwork, form evolves into subject matter. But just as not all nameable subject matter conveys meaning, abstract un-nameable forms can contribute to the secondary subject matter or meaning of an artwork. In order to successfully apply the new paradigm, we need a broader understanding of the concepts of "meaning" and "subject matter." While secondary subject matter is represented through style in graffiti art, in other genres secondary subject matter might be expressed through other seemingly incongruous modes, such as contrast effects (Op Art) or color-tones (Rayonnism). What should be of the utmost concern to image cataloguers is

not the kind of primary and secondary subject matter in a given artwork, but the way in which the interrelationship between these elements is indicative of themes and concepts that will increase understanding and access — both literal and figurative — to that artwork.

The new paradigm for Panofsky's model is centered on an interpretive process that is driven by the artwork itself. It calls for the assigning of image access points according to verifiable meaning, rather than anticipated user needs, and for the elevation of the process of iconographical analysis over the arbitrary categorization of subject matter according to rigidly defined levels. The ability to elucidate meaning within the visual context of the artwork and within a broader social context is the strength of Panofsky's process model. This model can be successfully employed as a tool for access to representational *and* nonrepresentational or abstract images, provided that they fall within an iconographic tradition and provided that the information studies community heeds Panofsky's advice to "bear in mind that ... the methods of approach which here appear as three unrelated operations of research merge with each other into one organic and indivisible process."[24]

Appendix A:
Questionnaire for
Graffiti Art Experts

As described in chapter 3, information about styles of graffiti art pieces and the visual elements that define these styles were collected from graffiti art experts using a series of questionnaires. The development of the questionnaires reflected the process of facet analysis. As new facets and foci were identified from the experts' responses, these facets and foci were incorporated into subsequent iterations of the questionnaire. This appendix presents the final iteration, which consists of 27 multiple-choice and open-ended questions, as well as the instructions for completing the questionnaires.

General Instructions:
The purpose of this study is to gather information about the characteristics that define various styles of graffiti art. I realize that the term "style" can have many different definitions when applied to the subject of graffiti art. For instance, writers strive to have great style in their pieces and burners, and the concept of style is often used to determine how well a piece or burner has been executed. In this study, however, the concept of "style" has a somewhat different meaning. I use it to refer to a category of graffiti art rather than to a writer's personal style. Applying this definition, Blockbusters, Semi-wildstyles, and Wildstyles are all styles of graffiti art. While an individual writer would infuse these types of graffiti art with his or her own personal style, categories such as Blockbusters, Semi-wildstyles, and Wildstyles are nonetheless styles of graffiti art that share and can be identified through a set of consistent characteristics. Identifying these specific characteristics is the purpose of the following questionnaire.

To complete the questionnaire, you are asked to identify from your own knowledge and expertise **3 different styles** of graffiti art and to answer a set of 27 questions **for each of the styles** that you discuss. These sets of 27 questions are contained in each of the Microsoft word documents attached to this e-mail. There are also two preliminary questions about your background and interest in graffiti. I know this sounds like a lot, but almost all of the questions are multiple-choice and therefore not too time consuming. Based on the definition of style that I just provided, I ask that you identify **specific styles** of graffiti art, not forms of graffiti art. In other words, please do not use Tags, Throw-ups, and Pieces as the three styles you choose in answering the questionnaire. Instead, please select 3 specific styles of Pieces (for example, the Dimensional style, the Los Angeles Cholo-based style, or the No-neg style). Also, select only **name-based styles**— no Characters please!

I also ask that you provide at least two images that exemplify each of the styles that you describe. You can simply supply me with a link for each image or you can attach the images as separate files when you send me your responses — whichever is easier for you. To be sure that I can match the correct images with each style, I ask that you provide the URL or file name at the beginning of the questions for that particular style, as well as the name or title of the particular work. In other words, if you direct me to a web site with multiple examples of different styles of your work, I need some way of identifying which of these images go with which of the styles you discuss!

I think that the easiest way to approach the questionnaire would be first to decide which graffiti art styles you would like to talk about and the images you would like to include for those styles. Once you have these styles and images in mind, you can then answer the specific questions contained in the three attached files. The contents of the three files — named "Style A," "Style B," and "Style C" — are identical. The idea is for you to use one of these documents to answer questions about each of the styles you have in mind. In other words, begin the questionnaire by opening the "Style A" document and then answer the questions according to **one** of the three styles you intend to discuss. Once you have answered the questions in this document, then open the document called "Style B" to answer the same set of questions for the second style you are identifying. Finally, the "Style C" document should be used to answer questions about the third and final style that you are going to discuss. Once you have finished answering the questions on all three documents, simply e-mail the documents back to me (as well as any image files you might be including) as attachment files. There are further instructions on returning the questionnaire to me within the three documents.

That pretty much covers everything. Once I receive and read over your responses, there will be a short follow-up questionnaire. At that point I will

also ask for your (snail) mailing address so that you can receive your $50 honorarium.

Now that you have read these general instructions, please proceed with the questionnaire by opening the file named "Style A."

Questions for Style A

Instructions for completing the questionnaire:

The following document is one of three components of the questionnaire. You will be answering the questions directly on this document and then returning the document to me as an e-mail attachment. Many of the questions that you will be asked to answer are multiple choice. In order to indicate your answer, you will be asked to delete all the choices EXCEPT the one that is your answer.

To demonstrate how this works, here's an example using the always-engrossing topic of ice cream:

> **Example Question 1:** Please select one statement from below that best describes how you feel about ice cream. Delete all the choices EXCEPT the one that is your answer.
>
> (a) Ice cream is crucial to my existence.
> (b) Ice cream is not crucial to my existence.
> (c) Other
>
> If you selected (c), please describe in your own words how you feel about ice cream.

Okay, if ice cream is in fact crucial to your existence, then your answer to example question 1 would look like this:

> **Example Question 1:** Please select one statement from below that best describes how you feel about ice cream. Delete all the choices EXCEPT the one that is your answer.
>
> (a) Ice cream is crucial to my existence.

Let's say that your answer to this example question is (c). Here's what your answer would look like in this case:

> **Example Question 1:** Please select one statement from below that best describes how you feel about ice cream. Delete all the choices EXCEPT the one that is your answer.
>
> (c) Other
>
> If you selected (c), please describe in your own words how you feel about ice cream.
>
> *I have nothing against ice cream, but I'm really more of a frozen yogurt person.*

So, all you need to do to answer the multiple choice questions is to delete the answers that do not apply. However, please do not delete the question itself or the statement that corresponds to the answer that you have selected. In other words, when answering a question please provide not only the letter (a, b, c, etc.) of the statement you are selecting, but also the statement itself, as shown in the two examples above.

In instances where you want to provide your own description, or in situations where the question is not multiple choice, please use as much space as needed to write your response to the question. Once you have answered all the questions, simply save the document and return it to me as an e-mail attachment.

Here are the actual questions...

Preliminary Information:

(1) In a few sentences, please describe your interest and background in graffiti art.

(2) Do you prefer the term "graffiti artist" or "graffiti writer"?

Questions about graffiti style:

Name of this graffiti style:

File names or URLs and titles of the sample images of this style:

(1) This first question is about legibility. Please select one statement from below that best describes the ease (or difficulty) with which non-graffiti writers would be able to read a name depicted in the style of graffiti art that you are describing. Delete all the choices EXCEPT the one that is your answer.

 (a) The text is easily readable.
 (b) Individual letters can be identified, but it is difficult to determine the word/name that they form.
 (c) The letters cannot be identified.
 (d) None of the above

If you selected (d), please describe in your own words the legibility of this particular graffiti style.

(2) In your estimation, how often is the statement you selected (or the description you provided) in question one applicable? In other words, if you selected statement c — that individual letters cannot be identified — is this the case about 50 percent of the time? 75 percent of the time? Please use the scale provided below. Delete all the choices EXCEPT the one that is your answer.

 (a) less than 50 percent of the time
 (b) 50 percent–75 percent of the time
 (c) more than 75 percent of the time

(3) How many colors are generally used in creating the letter outlines and/or fills of this style? (Please do not include in your estimate the number

of colors that might appear in background elements.) Delete all the choices EXCEPT the one that is your answer.

 (a) one color

 (b) two colors

 (c) 3–5 colors

 (d) more than five colors

 (4) In your estimation, how often is the color range you selected in question three applicable? In other words, if you selected statement c — that there are generally 3–5 colors — is this true about 50 percent of the time? 75 percent of the time? Please use the scale provided below. Delete all the choices EXCEPT the one that is your answer.

 (a) less than 50 percent of the time

 (b) 50 percent–75 percent of the time

 (c) more than 75 percent of the time

 (5) This question focuses on the dimensionality of the letters. Please select one statement from below that best describes the appearance of the letters of this particular graffiti style. Delete all the choices EXCEPT the one that is your answer.

 (a) The letters are 2-dimensional — they are completely flat and have no sense of volume.

 (b) The face or front surfaces of the letters are flat, but the letters nonetheless convey a sense of volume. This sense of volume is achieved after the letter was formed (i.e., by adding 3-Ds or by creating a block letter through shading).

 (c) The letters have an inherent volume. In other words, the creation of the letter-forms and their sense of volume are achieved simultaneously.

 (d) None of the above

If you selected (d), please describe in your own words the dimensionality of the letters in this particular graffiti style.

 (6) In your estimation, how often is the statement you selected (or the description you provided) in question five applicable? In other words, if you selected statement c — that the letters have an inherent volume — is this true in about 50 percent of the examples of this style you have seen? 75 percent of the time? Please use the scale provided below. Delete all the choices EXCEPT the one that is your answer.

 (a) less than 50 percent of the time

 (b) 50 percent–75 percent of the time

 (c) more than 75 percent of the time

 (7) This question looks at how the outlines of the letters are formed. Please select one statement from below that most accurately describes the let-

ter outlines of the style of graffiti art that you are describing. Delete all the choices EXCEPT the one that is your answer.

(a) The letters are outlined.
(b) The letters are outlined, but the outlines are purposively interrupted in places, giving the appearance of the letter fill spilling out beyond the confines of the outlines.
(c) The letters are not outlined.
(d) None of the above

If you selected (d), please describe in your own words how the letters are outlined in this particular graffiti style.

(8) In your estimation, how often is the statement you selected (or the description you provided) in question seven applicable? In other words, if you selected statement c — that the letters are not outlined — is this the case about 50 percent of the time? 75 percent of the time? Please use the scale provided below. Delete all the choices EXCEPT the one that is your answer.

(a) less than 50 percent of the time
(b) 50 percent–75 percent of the time
(c) more than 75 percent of the time

(9) This question concerns the linearity of the individual letter-forms. Please select one statement from below that most accurately describes the appearance of individual letters in this style of graffiti art. Delete all the choices EXCEPT the one that is your answer.

(a) All of the letters in a given piece have rounded lines.
(b) All of the letters in a given piece have squared lines.
(c) The letters in a given piece can have **either** all rounded lines **or** all squared lines.
(d) There are **both** letters with rounded lines **and** letters with squared lines within the same piece.
(e) None of the above

If you selected (e), please describe in your own words the linearity of the letters in this style of graffiti art.

(10) In your estimation, how often is the selection you made (or the description you provided) in question nine applicable? Please use the scale provided below. Delete all the choices EXCEPT the one that is your answer.

(a) less than 50 percent of the time
(b) 50–75 percent of the time
(c) more than 75 percent of the time

(11) This question concerns the thickness of the individual letter-forms. Please select one statement from below that most accurately describes the width of the strokes (in other words, the spaces that create and define the

letters) in this style of graffiti art. Delete all the choices EXCEPT the one that is your answer.

 (a) The letter strokes, and therefore the letter-forms themselves, are of a uniform width.

 (b) The letter strokes, and therefore the letter-forms themselves, vary in width (i.e., the strokes move from thick to thin or thin to thick), with the resulting letters having a jagged or sharp appearance.

 (c) The letter strokes, and therefore the letter-forms themselves, vary in width (i.e., the strokes move from thick to thin or thin to thick), with the resulting letters having a chiseled appearance, much like calligraphy.

 (d) None of the above

If you selected (d), please describe in your own words the thickness/width of the individual letter-forms in this style of graffiti art.

(12) In your estimation, how often is the selection you made (or the description you provided) in question eleven applicable? Please use the scale provided below. Delete all the choices EXCEPT the one that is your answer.

 (a) less than 50 percent of the time

 (b) 50–75 percent of the time

 (c) more than 75 percent of the time

(13) This question looks at whether the individual letter-forms in this style of graffiti art are of a consistent shape. In other words, would each representation of a particular letter be identical within a given piece? For example, if the letter "E" appeared twice within a particular piece in this style, would the shape of the first "E" be the same as the shape of the second "E"? Likewise, do different letters within a particular piece have similar contours, stemming from letter endings or extensions or the angles at which the letters are positioned? (Please note that this question refers only to the consistency of the shape of the letters, not the consistency of their fill patterns.) Please select one statement from below that most accurately describes the shape of the letters in relation to each other. Delete all the choices EXCEPT the one that is your answer.

 (a) The shape of the letters is consistent.

 (b) The shape of the letters is *not* consistent.

 (c) None of the above.

If you selected (c), please describe in your own words the shape of the letter-forms in relation to each other.

(14) In your estimation, how often is the selection you made (or the description you provided) in question thirteen applicable? Please use the scale provided below. Delete all the choices EXCEPT the one that is your answer.

 (a) less than 50 percent of the time

(b) 50–75 percent of the time

(c) more than 75 percent of the time

(15) Please select one statement from below that best describes the shape that the letters collectively create. In other words, do the letters in this style together give the impression of creating a shape that is:

(a) Rectangular

(b) Curvilinear (for example, crescent shaped, elliptical)

(c) None of the above

If you selected (c), please describe in your own words the shape that the letters collectively create.

(16) In your estimation, how often is the selection you made (or the description you provided) in question fifteen applicable? Please use the scale provided below. Delete all the choices EXCEPT the one that is your answer.

(a) less than 50 percent of the time

(b) 50–75 percent of the time

(c) more than 75 percent of the time

(17) This question addresses the symmetry of pieces created in this style of graffiti art. In this context, a symmetrical piece is defined as one where the contour of the left side of the piece is a mirror image of the contour of the right side of the piece. In terms of this definition, would you say that pieces in this style are:

(a) Always symmetrical

(b) Always asymmetrical

(c) Can be either symmetrical or asymmetrical

(18) In your estimation, how often is the selection you made in question seventeen applicable? Please use the scale provided below. Delete all the choices EXCEPT the one that is your answer.

(a) less than 50 percent of the time

(b) 50–75 percent of the time

(c) more than 75 percent of the time

(19) Please select one statement from below that best describes how the letters overlap in the style of graffiti art that you are describing. Delete all the choices EXCEPT the one that is your answer.

(a) The letters do not overlap each other.

(b) A standard overlap is the most frequently occurring overlap.

(c) A reverse overlap is the most frequently occurring overlap.

(d) A blended overlap is the most frequently occurring overlap.

(e) Statements b, c, and d are equally applicable.

(f) The letters appear layered and interconnected.

(g) None of the above

If you selected (g), please describe in your own words how the letters overlap and the effect it produces.

(**20**) In your estimation, how often is the statement you selected (or the description you provided) in question nineteen applicable? In other words, if you selected statement c — that a reverse overlap is the most frequently occurring overlap — is this true about 50 percent of the time? 75 percent of the time? Please use the scale below. Delete all the choices EXCEPT the one that is your answer.

(a) less than 50 percent of the time

(b) 50 percent–75 percent of the time

(c) more than 75 percent of the time

(**21**) What fill effects (if any) are used in the graffiti style that you are describing? Please select as many of the following as are applicable. Delete all the choices EXCEPT your selections.

(a) Fades/Blends

(b) Highlights

(c) Scrub fills/Venetian blind effects

(d) Fill shapes

(e) Other

(f) There are no fill effects associated with this style.

If you selected (e), please name and describe the other fill effects commonly associated with this graffiti style.

(**22**) If you identified more than one fill effect in question twenty-one, which of these fill effects would you say is *most* frequently associated with this style?

(**23**) What background elements are used in this style? Please select as many of the following as are applicable. Delete all the choices EXCEPT your selections.

(a) Characters

(b) Clouds

(c) One-shots

(d) Other

(e) This style does not involve any background elements.

If you selected (d), please name and describe the other background elements used in this style.

(**24**) If you identified more than one background element in question twenty-three, which of these elements would you say is *most* frequently associated with this style?

(**25**) This question examines the *role* of letter endings and extensions. In this graffiti style, are letter endings or extensions — for example, direc-

tional indicators such as arrows, or ornamentation — used to hide or distort the basic letter-forms?

(26) Please name and describe any symbols that are associated with this graffiti style.

(27) (Final Question!) Are there elements not covered by this questionnaire that are important components of this graffiti style? If yes, please explain.

Appendix B:
Faceted Classification System for Graffiti Art Styles

I. List of Graffiti Art Styles

Style Notation	*Style Name*
A1C2F3I5J2K2	Abstract
A2B3H2I3L3M2	TFP
A3B1C2D1E1G1I2J2K1M1	Silvers
A3C2D2E1F3G2H2M1	CTK
A3G1H1I1J2K1L6M1	Pichador
B2D2E1F3H2I3J1K1M1	Semi-wild
B3D2E1F3G2H1I2J1K1L2M1	Los Angeles Cholo-based
C2D2H3I2J2K2	Swedish Train
D2E1H2I3J2L5M1	Neo Classic American Freight
D2F3G2H3K1L2M1	East Coast Piecing Style
D3E3F3H3J2K2M1	No-neg
D4E2J2L1L2M1	Dimensional
E1G1M1	Dortmund
E1I5J1M1	Wild

II. Style Descriptions

Abstract, A1C2F3I5J2K2

In addition to the characteristics listed below, Abstract pieces are described by graffiti art experts as "very organic in shape." One expert notes that pieces "might fit the shape of a crescent, a check mark, a wedge, or some

other non-quadrilateral." The Abstract style is also known as "Transcend," the name of the crew chiefly associated with this style.

DEFINING CHARACTERISTICS

Legibility: Illegible (A1)
Symmetry: Asymmetrical (C2)
Linearity: Letters are created with a combination of Curved and straight lines (F3)
Letter Overlap: Intertwined (I5)
Use of Arrows: Not integral (J2) [Arrows are not associated with this style.]
Letter Shape Consistency: Inconsistent (K2)

PREDOMINANT CHARACTERISTICS

Number of Colors: Pieces generally have at least 3 colors (B2) but can have more than 5 (B3)
Dimensionality: Abstract pieces are often 2-dimensional (D1)
Letter Outlines: Are usually Hard only (E1) or, less often, Interrupted (E3)
Letter Strokes: Are usually Varied (G2)

OTHER CHARACTERISTICS

Negative Space: Can be either Exaggerated (H1) or Standard (H2)
Fill Effects: Abstract pieces can have any (or any combination) of the following: Fades (L2), Fill shapes (L3), and Shines (L5); conversely, pieces can have no fill effects whatsoever (L6)
Fill Consistency: Can be either Consistent (M1) or Inconsistent (M2)

TFP, A2B3H2I3L3M2

The name TFP refers to The Fantastic Partners crew, which was formed in New York City during the 1970s and still exists today. During the 1980s TFP was associated mainly with train pieces; the 1990s were marked by experimentation in wall pieces. One graffiti art expert notes that "this style is very colorful and eyecatching and many people feel this has historically been the high point of graffiti."

DEFINING CHARACTERISTICS

Legibility: Partially legible (A2)
Number of Colors: At least 5 (B3)
Negative Space: Standard (H2)
Letter Overlap: Standard (I3)

Fill Effects: Fill shapes (L3)
Fill Consistency: Inconsistent (M2)

PREDOMINANT CHARACTERISTICS

Symmetry: Pieces can be Symmetrical (C1) but are more often Asymmetrical (C2) [TFP train pieces tend to be symmetrical, whereas wall pieces tend to be asymmetrical.]

Dimensionality: Pieces are usually 2-dimensional with 3-d effects (D2)

Letter Outlines: For the most part, the outlines in the TFP style are Hard only (E1)

Use of Arrows: Arrows, when present, are Integral (J1)

Letter Shape Consistency: Letters can be consistently shaped (K1) but are more often Inconsistently shaped (K2) [TFP train pieces tend to have consistently shaped letters, whereas wall pieces tend to have inconsistently shaped letters.]

Fill Effects: While the use of Fill shapes (L3) is a defining characteristic of TFP, pieces in this style might also have Fades (L2), Scrub fills (L4), and/or Shines (L5)

OTHER CHARACTERISTICS

Linearity: Letters can be created with lines that are Curved only (F1), Straight only (F2), or Curved and straight (F3)

Letter Strokes: Can be Uniform (G1) or Varied (G2)

Silvers, A3B1C2D1E1G1I2J2K1M1

Found throughout the graffiti art world, Silver pieces are named for their silver-colored letter fill. This style is also characterized by speed. According to one graffiti art expert, Silvers "are quickly painted, good for a tight spot or a tight schedule." In fact, the quick execution of Silver pieces informs many of their features. For example, Silver pieces often have Scrub fills (L4), the result of a technique used to fill-in letters very quickly. By the same token, Silvers are devoid of other fill effects, such as Fades and Shines, which are time-consuming to create.

DEFINING CHARACTERISTICS

Legibility: Legible (A3)
Number of Colors: 2 Colors (B1)
Symmetry: Asymmetrical (C2)
Dimensionality: 2-dimensional (D1)
Letter Outlines: Hard only (E1)

Letter Strokes: Uniform (G1)
Letter Overlap: Minimal (I2)
Use of Arrows: Not integral (J2) [Arrows are not associated with this style.]
Letter Shape Consistency: Consistent (K1)
Fill Consistency: Consistent (M1)

PREDOMINANT CHARACTERISTICS

Negative Space: Is usually Limited (H3)

OTHER CHARACTERISTICS

Linearity: The shape of the letters can be composed of lines that are Curved only (F1), Straight only (F2), or a combination of Curved and straight (F3)
Fill Effects: Silver pieces can have Scrub fills (L4) or no fill effects whatsoever (L6)

CTK, A3C2D2E1F3G2H2M1

The Name CTK refers to the Crime Time Kings, a prolific European crew. One graffiti art expert suggests, "What is so important about CTK is that their influence across Europe's incipient graffiti scene in the middle 1980's was almost total."

DEFINING CHARACTERISTICS

Legibility: Legible (A3)
Symmetry: Asymmetrical (C2)
Dimensionality: 2-dimensional with 3-d effects (D2)
Letter Outlines: Hard only (E1)
Linearity: Letters are created with a combination of Curved and straight lines (F3)
Letter Strokes: Varied (G2)
Negative Space: Standard (H2)
Fill Consistency: Consistent (M1)

PREDOMINANT CHARACTERISTICS

Number of Colors: Usually at least 3 (B2)
Letter Overlap: Letters generally have a Standard overlap (I3)
Use of Arrows: Arrows, when present, are Integral (J1) [CTK pieces often feature multiple arrows of various sizes, ranging from minute to quite large.]
Fill Effects: Letters often have Fill shapes (L3)

Other Characteristics

Letter Shape Consistency: Can be either Consistent (K1) or Inconsistent (K2)

Pichador, A3G1H1I1J2K1L6M1

The Pichador style is derived from Pichação, a tag-based lettering style native to São Paulo, Brazil. Pichação tags are created using buckets of latex paint and 3-inch paint rollers. The use of rollers produces letters of uniform width — a hallmark of Pichador pieces as well.

Defining Characteristics

Legibility: Legible (A3)
Letter Strokes: Uniform (G1)
Negative Space: Exaggerated (H1)
Letter Overlap: None (I1)
Use of Arrows: Not integral (J2) [Arrows are not associated with this style.]
Letter Shape Consistency: Consistent (K1)
Fill Effects: None (L6)
Fill Consistency: Consistent (M1)

Predominant Characteristics

Number of Colors: Pieces generally have at least 3 colors (B2)
Dimensionality: Usually 2-dimensional with 3-d effects (D2)
Letter Outlines: The letters in Pichador pieces usually have only Hard outlines (E1)
Linearity: The letters generally are created with a combination of Curved and straight lines (F3)

Other Characteristics

Symmetry: Pieces in this style can be either Symmetrical (C1) or Asymmetrical (C2)

Semi-wild, B2D2E1F3H2I3J1K1M1

The name "Semi-wild" refers to the fact that this style is, in the words of one graffiti art expert, "less severe" than the Wild style. Specifically, Semi-wild pieces tend to be legible, a result of the letters having a standard, rather than intertwined overlap. Semi-wild is not simply "Wild-lite," however; it is a distinct style with its own set of characteristics.

Defining Characteristics

Number of Colors: At least 3 (B2)
Dimensionality: 2-dimensional with 3-d effects (D2)
Letter Outlines: Hard only (E1)
Linearity: Letters are created with a combination of Curved and straight lines
 (F3)
Negative Space: Standard (H2)
Letter Overlap: Standard (I3)
Use of Arrows: Integral (J1)
Letter Shape Consistency: Consistent (K1)
Fill Consistency: Consistent (M1)

Predominant Characteristics

Legibility: Semi-wild pieces are usually Partially legible (A2) but can even be
 Legible (A3)
Letter Strokes: Are usually Uniform in width (G1)
Fill Effects: Semi-wild pieces might have any (or some combination) of the
 following Fill Effects: Fades (L2); Fill shapes (L3); Shines (L5)

Other Characteristics

Symmetry: Pieces can be either Symmetrical (C1) or Asymmetrical (C2)

Los Angeles Cholo-based, B3D2E1F3G2H1I2J1K1L2M1

The phrase "Cholo-based" refers to the fact that the lettering in this
style is based on graffiti created by Los Angeles Cholo gangs in the 1930s.

Defining Characteristics

Number of Colors: At least 5 (B3)
Dimensionality: 2-dimensional with 3-d effects (D2)
Letter Outlines: Hard only (E1)
Linearity: Letters are created with a combination of Curved and straight lines
 (F3)
Letter Strokes: Varied (G2)
Negative Space: Exaggerated (H1)
Letter Overlap: Minimal (I2)
Use of Arrows: Integral (J1)
Letter Shape Consistency: Consistent (K1)
Fill Effects: Fades (L2)
Fill Consistency: Consistent (M1)

Predominant Characteristics

Fill Effects: While the use of Fades (L2) is a defining characteristic of the Los Angeles Cholo-based style, pieces might also have Fill shapes (L3) and/or Shines (L5)

Other Characteristics

Legibility: Pieces in the Los Angeles Cholo-based style might be Illegible (A1), Partially legible (A2), or Legible (A3)
Symmetry: Pieces can be Symmetrical (C1) or Asymmetrical (C2)

Swedish Train, C2D2H3I2J2K2

As with Silvers, Swedish Train pieces are executed quickly. As one graffiti art expert notes, "There is very little time for anything extraneous." This person also points out that the style "is very bubbly and has exaggerated proportions."

Defining Characteristics

Symmetry: Asymmetrical (C2)
Dimensionality: 2-dimensional with 3-d effects (D2)
Negative Space: Limited (H3)
Letter Overlap: Minimal (I2)
Use of Arrows: Not integral (J2) [Arrows are not associated with this style.]
Letter Shape Consistency: Inconsistent (K2)

Predominant Characteristics

Legibility: Pieces in this style are usually Legible (A3)
Number of Colors: Pieces generally have at least 3 colors (B2) but can have more than 5 (B3)
Letter Outlines: For the most part, pieces in the Swedish Train style have only Hard outlines (E1)
Linearity: Letters are often created with Curved lines only (F1)
Letter Strokes: Are usually Varied (G2)
Fill Effects: Swedish Train pieces might have any (or some combination) of the following Fill Effects: Fades (L2); Fill shapes (L3); Scrub fills (L4); Shines (L5)
Fill Consistency: Usually Inconsistent (M2)

Other Characteristics

N/A

Neo Classic American Freight, D2E1H2I3J2L5M1

As one graffiti art expert explains, this "neo classic" style emerged as "a reaction to very abstract and unreadable freight pieces that were popular in 1999–2000." The Neo Classic American Freight style "hearkens back to subway days [of] the 80's and takes shapes and connections that were popular then."

DEFINING CHARACTERISTICS

Dimensionality: 2-Dimensional with 3-d effects (D2)
Letter Outlines: Hard only (E1)
Negative Space: Standard (H2)
Letter Overlap: Standard (I3)
Use of Arrows: Arrows, when present, are Not integral (J2)
Fill Effects: Shines (L5)
Fill Consistency: Consistent (M1)

PREDOMINANT CHARACTERISTICS

Legibility: Pieces in this style are usually Legible (A3)
Number of Colors: Pieces generally have at least 3 colors (B2) but can have
 more than 5 (B3)
Linearity: Letters generally are created with a combination of Curved and
 straight lines (F3)
Letter Strokes: Are usually Uniform (G1)
Letter Shape Consistency: Can be Consistent or Inconsistent, but it is more
 often Consistent (K1)
Fill Effects: While Shines (L5) are a defining characteristic of this style, pieces
 might also have Fades (L2) and/or Fill Shapes (L3)

OTHER CHARACTERISTICS

Symmetry: Pieces can be either Symmetrical (C1) or Asymmetrical (C2)

East Coast Piecing Style, D2F3G2H3K1L2M1

As indicated by its name, the East Coast Piecing style was developed in cities in the eastern United States, including Baltimore, Washington, D.C., and Philadelphia. "This is a very complex, labor intensive style," one graffiti art expert explains. "It was born in abandoned train tunnels and warehouse walls. Writers would spend all day trying to create the most complicated stylish piece."

DEFINING CHARACTERISTICS

Dimensionality: 2-dimensional with 3-d effects (D2)
Linearity: Letters are created with a combination of Curved and straight lines
 (F3)

Letter Strokes: Varied (G2)
Negative Space: Limited (H3)
Letter Shape Consistency: Consistent (K1)
Fill Effects: Fades (L2)
Fill Consistency: Consistent (M1)

PREDOMINANT CHARACTERISTICS

Legibility: Most pieces in this style are Illegible (A1), although some might be Legible (A3)
Number of Colors: Usually at least 5 (B3)
Letter Outlines: The outlines tend to be Interrupted (E3)
Fill Effects: While the use of Fades (L2) is a defining characteristic of this style, pieces might also have Fill shapes (L3) and/or Shines (L5)

OTHER CHARACTERISTICS

Symmetry: Pieces in this style can be either Symmetrical (C1) or Asymmetrical (C2)
Letter Overlap: Letters can have either a Standard (I3) or Intertwined (I5) overlap
Use of Arrows: Arrows, when present in a piece, are Integral (J1); conversely, pieces might have no arrows at all (J2)

No-neg, D3E3F3H3J2K2M1

This style originated in Boston, Massachusetts, and its name refers to the fact the letters in No-neg pieces have little or no negative space.

DEFINING CHARACTERISTICS

Dimensionality: Relief effect (D3)
Letter Outlines: Interrupted (E3)
Linearity: Letters are created with a combination of Curved and straight lines (F3)
Negative Space: Limited (H3)
Use of Arrows: Not integral (J2) [Arrows are not associated with this style.]
Letter Shape Consistency: Inconsistent (K2)
Fill Consistency: Consistent (M1)

PREDOMINANT CHARACTERISTICS

Legibility: Pieces tend to be Partially legible (A2)
Number of Colors: No-neg pieces generally have at least 3 colors (B2) but can have more than 5 (B3)

OTHER CHARACTERISTICS

OTHER CHARACTERISTICS

Symmetry: Pieces can be either Symmetrical (C1) or Asymmetrical (C2)
Letter Strokes: Can be either Uniform (G1) or Varied (G2)
Letter Overlap: Is usually either Minimal (I2) or Standard (I3)
Fill Effects: No-neg pieces can have any (or any combination) of the follow-
 ing: Fades (L2), Fill shapes (L3), and Shines (L5); conversely, pieces can
 have no fill effects whatsoever (L6)

Dimensional, D4E2J2L1L2M1

Introduced by writers in Germany, this style reached the height of its
international popularity during the 1990s. As the name suggests, the entirety
of the letters in Dimensional pieces appear inherently 3-dimensional — a feat
achieved through a combination of directional highlights and fades. As one
graffiti art expert explains, in other styles "the 3-dimensional aspect is ... just
an effect added to more traditional letter forms."

DEFINING CHARACTERISTICS

Dimensionality: 3-dimensional (D4)
Letter Outlines: Implied (E2)
Use of Arrows: Not integral (J2) [Arrows are not associated with this style.]
Fill Effects: Directional highlights (L1) and Fades (L2)
Fill Consistency: Consistent (M1)

PREDOMINANT CHARACTERISTICS

Number of Colors: Usually at least 5 (B3)
Linearity: Letters generally are created with a combination of Curved and
 straight lines (F3)
Negative Space: The letters in Dimensional pieces usually have Limited neg-
 ative space (H3)
Letter Overlap: Is often Interlocking (I4)
Fill Effects: While the use of Directional highlights (L1) and Fades (L2) are
 defining characteristics of this style, pieces might also have Fill shapes
 (L3)

OTHER CHARACTERISTICS

Legibility: Dimensional pieces can be Illegible (A1), Partially legible (A2), or
 Legible (A3)
Symmetry: Pieces can be Symmetrical (C1) or Asymmetrical (C2)
Letter Strokes: Can be either Uniform (G1) or Varied (G2)
Letter Shape Consistency: Can be either Consistent (K1) or Inconsistent (K2)

Dortmund, E1G1M1

The succinct style notation for the Dortmund style echoes one graffiti art expert's assessment that "this is a stripped down style and there isn't much focus on parts of the letters that aren't utilitarian." Reflecting this spare aesthetic, Dortmund pieces consist of "bold shapes" that are "very graphic" in nature. Named for its provenance in Dortmund, Germany, this style is predominantly train-based.

DEFINING CHARACTERISTICS

Letter Outlines: Hard only (E1)
Letter Strokes: Uniform (G1)
Fill Consistency: Consistent (M1)

PREDOMINANT CHARACTERISTICS

Number of Colors: Usually at least 3 (B2)
Dimensionality: Pieces are often 2-dimensional with 3-d effects (D2)
Linearity: The letters in Dortmund pieces are often created with only Straight lines (F2), although it is also possible to see examples that have both Curved and straight lines (F3)
Use of Arrows: Arrows, when present, are Not integral (J2)

OTHER CHARACTERISTICS

Legibility: Pieces can be Illegible (A1), Partially legible (A2), or Legible (A3)
Symmetry: Pieces can be Symmetrical (C1) or Asymmetrical (C2)
Negative Space: Can be Exaggerated (H1), Standard (H2), or Limited (H3)
Letter Overlap: There can be no overlap at all (I1), a Minimal overlap (I2), or a Standard (I3) overlap
Letter Shape: Can be Consistent (K1) or Inconsistent (K2)
Fill Effects: Dortmund pieces can have any (or any combination) of the following: Fades (L2), Fill shapes (L3), Scrub fills (L4), and Shines (L5); conversely, pieces can have no fill effects whatsoever (L6)

Wild, E1I5J1M1

Created in 1974 by the writer Tracy 168 and named for his crew, this style has become synonymous with New York City subway writing.

DEFINING CHARACTERISTICS

Letter Outlines: Hard only (E1)
Letter Overlap: Intertwined (I5)
Use of Arrows: Integral (J1)
Fill Consistency: Consistent (M1)

Legibility: Pieces in this style are usually Partially legible (A2)

Number of Colors: Usually at least 3 colors (B2)

Symmetry: Wild style pieces are often Symmetrical (C1)

Dimensionality: Pieces usually are 2-dimensional with 3-d effects (D2) but can instead be 2-dimensional (D1)

Linearity: Letters generally are created with a combination of Curved and straight lines (F3)

Letter Strokes: Are usually Varied (G2)

Negative Space: The letters in Wild style pieces generally have a Standard amount of negative space (H2)

Letter Shape Consistency: Is usually Inconsistent (K2)

Fill Effects: Pieces might have any (or some combination) of the following Fill Effects: Fades (L2); Fill shapes (L3); Shines (L5)

OTHER CHARACTERISTICS

N/A

III. Facet and Foci Definitions

A. Legibility

This facet concerns the legibility of the word presented in the graffiti art piece. Legibility takes into account the degree to which the individual letters that form the word can be identified.

A1. Illegible: It is impossible to identify any of the letters.

A2. Partially legible: At least one of the letters can be identified, but it is impossible to identify all of the letters in the word.

A3. Legible: It is possible to identify **all** of the letters in the word.

B. Number of Colors

This facet asks you to examine the number of colors that were used to create the letter faces in the piece. In order to determine the number of colors, add together the number of colors used to create the letter outlines and the total number of colors used to create all of the letter fills. This includes letter outlines that are black or white. Likewise, include in your count both the background color of the letter fills and any colors used for patterns or shapes within the fills.

Count each color only once, but please note that variations in tone or shade should be counted as separate colors. For example, light blue, medium blue, and dark blue count as three separate colors within the same image. Do **not** include in your count any colors that are not part of the outline and fill. In situations where the date/signature of the piece falls within the letter fill, do **not** include in your count any colors that are used only for this date/signature.

B1. 2 colors

B2. At least 3 colors

B3. At least 5 colors

C. Symmetry

This facet asks you to examine whether the word depicted in the image is symmetrical. If it is symmetrical, then the contour of the left side of the word is the mirror image of the contour of the right side of the word. When determining whether the contours match, it helps to imagine "folding" the word vertically down the middle, so that the first letter of the word rests on top of the last letter. If the contours of the two halves of the word are aligned, then the word is symmetrical. In some cases, determining whether or not the left and right halves are aligned is fairly straightforward. In other cases, however, deciding just how closely aligned the two halves are, and whether this alignment produces a symmetrical word, entails a more subjective assessment.

C1. Symmetrical: The contour of the left side of the word is the mirror image of the contour of the right side of the word.

C2. Asymmetrical: The contour of the left side of the word is not the mirror image of the contour of the right side of the word.

D. Dimensionality

The concept of Dimensionality in graffiti art has two components: 1) the degree to which the letters in a piece seem to protrude from the surface on which they have been painted, and 2) whether this sense of 3-dimensionality is the result of 3-d effects outside of the letter outlines or whether it emanates from within the letter faces themselves.

Therefore, you will need to examine two distinct aspects of the piece in order to determine its dimensionality. One of these aspects is whether or not 3-d effects have been added to the letters. 3-d effects are either extensions of, or additions to, the letter outlines. Because of this connection, it is sometimes

difficult to judge whether the outlines of a piece simply vary somewhat in width (i.e., the letters are **2-dimensional**) or whether they are being used to make the letters "pop out" from the background of the piece (i.e., the letters are **2-dimensional with 3-d effects**). When making this determination, it helps to compare how wide the letter outlines are at their thickest point with how narrow they are at their thinnest point. The greater the difference between the letter outlines at their widest and narrowest points, the more the letters themselves seem to protrude.

3-d effects exist outside of, not within, the letter faces. Some types of dimensionality, however, concern the appearance of the letter faces themselves. The other aspect of the piece that you will need to examine is whether the letter faces are flat or whether they occupy multiple planes. In other words, you will need to determine whether the 3-dimensionality of the letters comes from within the letter outlines (i.e., the Letter Fill) or outside of the letter outlines.

D1. 2-dimensional: The letter faces are completely flat. Although the thickness of the letter outlines might vary in areas, thereby creating a slight shading effect, there are no pronounced 3-d effects. Therefore, the letters appear to barely protrude from the surface on which they have been painted.

D2. 2-dimensional with 3-d effects: The letter faces are completely flat. Nonetheless, the letters appear to protrude from the surface on which they have been painted. This sense of 3-dimensionality is a result of 3-d effects that exist outside of the letter faces.

D3. Relief effect: The letter faces are completely flat and the letters appear to protrude from the surface on which they have been painted. These same characteristics also define letters that are 2-dimensional with 3-d effects. Nonetheless, Relief effect letters convey a sense of depth within the piece in a distinct way. As the name suggests, Relief effect letters are shaded along their contours. Moreover, the shading of one letter simultaneously affects the sense of depth of any adjacent letter(s). Say, for example, that adjacent Letters A and B have been created with the Relief effect. As a result, Letter A will appear to be raised off the background plane of the piece, and, at the same time, Letter B will appear to be receding into the background plane of the piece. Yet, because the same shaded area abuts both letters, the reverse is also true. In other words, it is also the case that Letter B can appear to be raised off the background plane of the piece while Letter A appears to be receding into the background plane of the piece. To be sure, in any piece where letters overlap, one letter will appear to be in front or on top of an adjacent letter. In these situations, however, the reverse is not also true: the front or top letter always remains in front and the letter partially behind it always remains partially behind it. In con-

trast, Relief letters have a sense of fluidity, where a given letter can appear to both protrude from and recede into the background plane of the piece. This ability distinguishes Relief effect letters from letters that are 2-dimensional with 3-d effects.

D4. 3-dimensional: The letter faces **do not** appear to be flat. Rather, the letter faces occupy multiple planes, with the result that there appear to be "angles" or "edges" within the letter faces. These angles or edges, and the sense of 3-dimensionality that they generate, are a product of the letter fill itself. In fact, 3-dimensional is the only form of dimensionality where a sense of depth is created within the letter fill and is not a result of shading or 3-d effects along the letter outlines. As a result, these letters are considered to be *inherently* 3-dimensional. 3-dimensional letters do not have 3-d effects added to them.

E. Letter Outlines

The term "Letter Outlines" refers to the lines that demarcate the form of each letter. The Letter Outlines facet addresses the *type* of letter outlines that are present in a particular graffiti piece. An individual graffiti art piece generally will have only one type of letter outline. Sometimes, however, outlines are difficult to ascertain where letters overlap each other and where the outlines merge with 3-d effects. If there appears to be more than one type of letter outline in the image that you are examining, or if it is difficult to see the outlines on some of the letters, choose the **one** type of letter outline that best characterizes the piece as a whole.

Additionally, there might be a situation where one letter blends into another within a graffiti art piece. The area where the two letters blend together is often mistaken for an Interrupted outline. In fact, this is simply a stylistic convention that has no bearing on the selection of Letter Outline foci.

E1. Hard only: A distinct line of one or more color(s) demarcates part or all of the form of the individual letters in the piece. This line usually contrasts in color to the letter fill. For instance, if the letter fill consists of light colors, then the Hard outlines would consist of dark colors.

E2. Implied: Unlike Hard outlines, Implied outlines are actually part of the letter fill. And, as their name suggests, Implied outlines are not explicit, individual lines. Rather, they are created with variations in color, tone, and lighting effects within the letter fill. Therefore, Implied outlines are used to create "angles" or "edges" within the letter fill. Pieces can have a combination of Hard and Implied outlines or Implied outlines only. (Implied outlines occur only in conjunction with **3-dimensional** letters.)

E3. Interrupted: A distinct line of one or more color(s) demarcates the form of the individual letters in the piece, as with Hard outlines. These Hard outlines, however, are interrupted in places — specifically, in areas where there is a small, asterisk-shaped burst of light known as a "Shine." (Although Interrupted outlines are characterized by Shines, the presence of Shines does not automatically indicate Interrupted outlines.) The areas where the outline is interrupted are purposively blurred, creating a soft focus effect in the letter fill and outline at the point of the interruption. In some cases, it appears as if the fill itself is spilling out of the confines of the letter outlines. Interrupted outlines therefore produce an airy or smoky effect at distinct points within the piece. By definition, Interrupted outlines exist in conjunction with Hard outlines.

E4. None: None of the letters have outlines that fit any of the above descriptions.

F. Linearity

This facet looks at the type of lines that form the shape of the letters in a graffiti art piece. Please note that Linearity addresses the type of lines used to create the letters collectively, not individually. Therefore, select the focus that best describes the Linearity of the piece overall.

F1. Curved only: Only curved lines have been used to create the shape of the letters.

F2. Straight only: Only straight lines have been used to create the shape of the letters.

F3. Curved and straight: A combination of curved and straight lines has been used to create the shape of the letters.

G. Letter Strokes

This facet concerns the width, or thickness, of the Letter Strokes within each individual letter. Letter Strokes are what create and define letters. For example, the letter "L" consists of two strokes: one longer, vertical stroke and one shorter, horizontal stroke. For this facet, you are asked to examine whether the letter strokes within each letter of the piece are of a uniform width, or if their width varies. When letter strokes vary in width, they shift from thick to thin (or from thin to thick). The result is that the letter strokes — and the letter that these strokes form — have either a sharp, jagged appearance or a chiseled appearance, much like calligraphy.

In order to ascertain whether the letter strokes are uniform or varied, focus on a single **main** stroke within one letter. (In other words, focus on strokes that are intrinsic to the shape of the letter, not on serifs or other decorative strokes used for letter endings.) Then move on to another main stroke within that same letter to see if you arrive at the same conclusion. Do the same for a second letter. Select the focus that best describes the piece as a whole.

Please note that you are *not* being asked to determine whether the width of Stoke A is the same as that of Stroke B within a single letter. Likewise, you are not being asked whether the letter strokes in one letter are the same width as those in another letter. Rather, you are being asked whether or not the width of **individual** letter strokes within any given letter varies or stays the same.

G1. Uniform: Every main letter stroke **within each letter** is of a uniform width.

G2. Varied: One or more of the main letter strokes **within each letter** varies in width (i.e., it shifts from thick to thin or from thin to thick).

H. Negative Space

The concept of Negative Space refers to the amount of "open" space visible **within** a letter. Consider the example of the letter "O." In graffiti art styles that are characterized by large amounts of negative space, the hole in the middle of the "O" would appear exaggeratedly large in relation to the other, visible parts of the letter. This is the result of there being more negative space (i.e., space that is taken up by other components of the piece, such as the background or a 3-d effect) than positive space (i.e., space occupied by the visible parts of the letter face). Conversely, in graffiti art styles that are characterized by limited negative space, the hole in the middle of the letter "O" would appear quite small in relation to the amount of space taken up by the other, visible parts of the letter face. In fact, some graffiti styles are characterized by having letters with no negative space whatsoever. In terms of the letter "O" example, the hole would not be a hole at all, but rather an application of paint added after the letter was formed, much like a frosting rose is applied as a finishing touch on a cake. In other words, what is supposed to be open space within a letter is actually created by adding additional paint tones, meaning that absolutely no background is visible within the letters. **The letters in most graffiti art styles have a standard amount of negative space.** This means that the ratio of positive space to negative space in these letters does not appear out of the ordinary. In some graffiti art styles, however, either exaggerated or limited amount of negative space is a defining characteristic.

H1. Exaggerated: The amount of negative space within the letters, in relation to the amount of positive space, appears exaggerated. In other words, there appears to be a great deal of the background and/or 3-d effects visible within the individual letters.

H2. Standard: The amount of negative space within the letters, in relation to positive space, does not appear to be extraordinary. In other words, the amount of background and/or 3-d effects visible within the individual letters does not seem to be, on the one hand, unusually exaggerated or, on the other hand, unusually limited.

H3. Limited: Letters have been created with very little or no negative space. In other words, there is little or no background and/or 3-d effects visible within the individual letters.

I. Letter Overlap

This facet concerns how — or even whether — the individual letters overlap each other in a particular image. An individual graffiti art piece generally will have only one type of letter overlap. If there appears to be more than one type of letter overlap in the image that you are examining, choose the **one** that best describes the majority of letters in the image.

I1. None: The letters do not overlap, although they may be positioned close enough that the letters are touching.

I2. Minimal: Approximately no more than one-eighth of a given letter overlaps an adjacent letter. As a result, very little of one letter is obscured by another letter.

I3. Standard: Approximately no more than one-quarter of a given letter overlaps an adjacent letter.

I4. Interlocking: Rather than overlapping per se, the letters appear to fit together, interlocking as if each were part of a jigsaw puzzle or a set of wooden blocks.

I5. Intertwined: The letters are intertwined and layered to the extent that it is difficult to ascertain where one letter ends and the next one begins. As a result, it is impossible to distinguish individual letterforms without "unraveling" the word as a whole.

J. Use of Arrows

Arrows are a prevalent feature of graffiti art, filling a number of different roles. In some instances, they are used as ornamental letter endings at the begin-

ning and end of a word. Arrows can also assume a more structural role by connecting one letter to the next within a piece. This facet asks you to identify whether or not arrows play an integral role in the piece. Arrows that play an integral role camouflage and/or add complexity to the basic shape of the letters within the piece. Moreover, these arrows are integrated throughout the word, often serving to connect one letter to the next. This connection can be literal, with arrows creating an overlap among letters, or visual, with arrows leading the viewer's eye from one letter to the next. Please note that not all graffiti art images have arrows. If the image that you are examining does not have any arrows, select the "Not integral" focus.

J1. Integral: Arrows appear throughout the word. These arrows camouflage and/or add complexity to the basic shape of the letters, and/or they serve as a connector between letters.

J2. Not integral: Arrows do **not** appear throughout the word. Any arrows present do **not** camouflage and/or add complexity to the basic shape of the letters, nor do they serve as a connector between letters.

K. Letter Shape Consistency

This facet looks at whether the letters in an image are consistently shaped. An analogy can be made between consistently shaped letters in graffiti art and the regularity of letters in a typeface or font. There are two steps in determining Letter Shape Consistency in graffiti art pieces. First, see if the word presented in the image has any repeating letters — say, for example, two "E"s. If the second "E" is identical in shape to the first "E," then the piece is considered to have consistent letter shape. If repeating letters are not identical in shape, then the piece is considered to have inconsistent letter shape.

If you do not see any repeating letters, then the next step is to look for letters with similar contours, such as "V" and "W" or "P" and "B," to see if there is continuity in the shapes of these letters. Even if the letters are too abstract to identify as specific letters, it is still possible to examine their contours in order to detect patterns in how the letters are shaped. Please note that this facet looks at the **shape** of the letters only, not their fill.

K1. Consistent: There is continuity in the shapes of the letters, with repeating letters being identical in shape.

K2. Inconsistent: Letters, including repeating letters, appear to be randomly shaped with little or no continuity among them.

L. Fill Effects

This facet encompasses techniques that are used to create the letter fill in a graffiti art piece. Fill Effects are optional in a number of graffiti art styles. In some cases, however, one or more of these effects are essential components of particular styles of graffiti art. Please select as many of the Fill Effects defined below as you see in a particular image. Select the relevant Fill Effects even if you detect them in only one of the letters in the image.

L1. Directional highlights: Strong directional lighting used to focus light on a particular letter or letters. The "source" of these highlights is unseen, meaning that the light seems to emanate from beyond the confines of the piece. These highlights resemble gallery or museum lighting. As a result, letters on which directional highlights are trained appear to be lit in much the same way as a sculptural object or painting would be.

L2. Fades: Instances where one color or tone appears to fade or dissolve into another color or tone within the letter fill. Rather than an abrupt end and clear demarcation between color/tone A and color/tone B, Fades result in a gradual blending of one color/tone into the other.

L3. Fill shapes: Geometric shapes (circle, diamonds, or triangles, for example) or symbols (Roman numerals, lightening bolts, or musical notes, for example) that have been incorporated into the letter fill.

L4. Scrub fills: Scrub fills result from a technique that is used to create letter fills very quickly. By rapidly moving a can of spray paint back and forth, a striped effect is produced within the fill. These "stripes" are actually spaces where the paint did not completely cover the surface of the letter.

L5. Shines: Shines, like Directional highlights, are used as a lighting technique. Unlike Directional highlights, however, the "source" of the light is visible within the piece itself. Specifically, Shines appear as a small burst of light resting on the surface of the letter, usually near or on the letter outline. This burst of light is most often shaped like a small star or an asterisk or, less frequently, like a small, white dash positioned along part of a letter's contour.

L6. None: None of the above Fill Effects are present in the image.

M. Fill Consistency

This facet examines whether or not the fill pattern and/or color scheme in a piece is consistent from one letter to the next. In other words, you are looking to see if the letter fill of each letter has similar characteristics or resembles each other — if there is a decipherable internal logic to the patterns and colors as you move from letter to letter.

M1. Consistent: The background color or fill pattern is identical from letter to letter, or the letter fills represent a fixed set of colors, as evident from the word as a whole. For example, a word in which the fill color alternates green and blue from letter to letter has a consistent fill.

M2. Inconsistent: There is no noticeable, cohesive fill pattern or color scheme that runs across the word as a whole. The fill pattern from letter to letter appears to be completely random.

IV. Alphabetical Index

D3 Dimensionality: Relief effect
 No-neg Style, **D3**E3F3H3J2K2M1
D4 Dimensionality: 3-dimensional
 Dimensional Style, **D4**E2J2L1L2M1
Dimensional Style, D4E2J2L1L2M1
Dortmund Style, E1G1M1
E1 Letter Outlines: Hard only
 CTK Style, A3C2D2**E1**F3G2H2M1
 Dortmund Style, **E1**G1M1
 Los Angeles Cholo-based Style, B3D2**E1**F3G2H1I2J1K1L2M1
 Neo Classic American Freight Style, D2**E1**H2I3J2L5M1
 Semi-wild Style, B2D2**E1**F3H2I3J1K1M1
 Silvers Style, A3B1C2D1**E1**G1I2J2K1M1
 Wild Style, **E1**I5J1M1
E2 Letter Outlines: Implied
 Dimensional Style, D4**E2**J2L1L2M1
E3 Letter Outlines: Interrupted
 No-neg Style, D3**E3**F3H3J2K2M1
E4 Letter Outlines: None
East Coast Piecing Style, D2F3G2H3K1L2M1
F1 Linearity: Curved only
F2 Linearity: Straight only
F3 Linearity: Curved and straight
 Abstract Style, A1C2**F3**I5J2K2
 CTK Style, A3C2D2E1**F3**G2H2M1
 East Coast Piecing Style, D2**F3**G2H3K1L2M1
 Los Angeles Cholo-based Style, B3D2E1**F3**G2H1I2J1K1L2M1
 No-neg Style, D3E3**F3**H3J2K2M1
 Semi-wild Style, B2D2E1**F3**H2I3J1K1M1
G1 Letter Strokes: Uniform
 Dortmund Style, E1**G1**M1
 Pichador Style, A3**G1**H1I1J2K1L6M1
 Silvers Style, A3B1C2D1E1**G1**I2J2K1M1
G2 Letter Strokes: Varied
 CTK Style, A3C2D2E1F3**G2**H2M1
 East Coast Piecing Style, D2F3**G2**H3K1L2M1
 Los Angeles Cholo-based Style, B3D2E1F3**G2**H1I2J1K1L2M1
H1 Negative Space: Exaggerated
 Los Angeles Cholo-based Style, B3D2E1F3G2**H1**I2J1K1L2M1
 Pichador Style, A3G1**H1**I1J2K1L6M1
H2 Negative Space: Standard

CTK Style, A3C2D2E1F3G2**H2**M1
Neo Classic American Freight Style, D2E1**H2**I3J2L5M1
Semi-wild Style, B2D2E1F3**H2**I3J1K1M1
TFP Style, A2B3**H2**I3L3M2
H3 Negative Space: Limited
East Coast Piecing Style, D2F3G2**H3**K1L2M1
No-neg Style, D3E3F3**H3**J2K2M1
Swedish Train Style, C2D2**H3**I2J2K2
I1 Letter Overlap: None
Pichador Style, A3G1H1**I1**J2K1L6M1
I2 Letter Overlap: Minimal
Los Angeles Cholo-based Style, B3D2E1F3G2H1**I2**J1K1L2M1
Silvers Style, A3B1C2D1E1G1**I2**J2K1M1
Swedish Train Style, C2D2H3**I2**J2K2
I3 Letter Overlap: Standard
Neo Classic American Freight Style, D2E1H2**I3**J2L5M1
Semi-wild Style, B2D2E1F3H2**I3**J1K1M1
TFP Style, A2B3H2**I3**L3M2
I4 Letter Overlap: Interlocking
I5 Letter Overlap: Intertwined
Abstract Style, A1C2F3**I5**J2K2
Wild Style, E1**I5**J1M1
J1 Use of Arrows: Integral
Los Angeles Cholo-based Style, B3D2E1F3G2H1I2**J1**K1L2M1
Semi-wild Style, B2D2E1F3H2I3**J1**K1M1
Wild Style, E1I5**J1**M1
J2 Use of Arrows: Not integral
Abstract Style, A1C2F3I5**J2**K2
Dimensional Style, D4E2**J2**L1L2M1
Neo Classic American Freight Style, D2E1H2I3**J2**L5M1
No-neg Style, D3E3F3H3**J2**K2M1
Pichador Style, A3G1H1I1**J2**K1L6M1
Silvers Style, A3B1C2D1E1G1I2**J2**K1M1
Swedish Train Style, C2D2H3I2**J2**K2
K1 Letter Shape Consistency: Consistent
East Coast Piecing Style, D2F3G2H3**K1**L2M1
Los Angeles Cholo-based Style, B3D2E1F3G2H1I2J1**K1**L2M1
Pichador Style, A3G1H1I1J2**K1**L6M1
Semi-wild Style, B2D2E1F3H2I3J1**K1**M1
Silvers Style, A3B1C2D1E1G1I2J2**K1**M1
K2 Letter Shape Consistency: Inconsistent

Abstract Style, A1C2F3I5J2**K2**
No-neg Style, D3E3F3H3J2**K2**M1
Swedish Train Style, C2D2H3I2J2**K2**
L1 Fill Effects: Directional highlights
 Dimensional Style, D4E2J2**L1**L2M1
L2 Fill Effects: Fades
 Dimensional Style, D4E2J2L1**L2**M1
 East Coast Piecing Style, D2F3G2H3K1**L2**M1
 Los Angeles Cholo-based Style, B3D2E1F3G2H1I2J1K1**L2**M1
L3 Fill Effects: Fill shapes
 TFP Style, A2B3H2I3**L3**M2
L4 Fill Effects: Scrub fills
L5 Fill Effects: Shines
 Neo Classic American Freight Style, D2E1H2I3J2**L5**M1
L6 Fill Effects: None
 Pichador Style, A3G1H1I1J2K1**L6**M1
Los Angeles Cholo-based Style, B3D2E1F3G2H1I2J1K1L2M1
M1 Fill Consistency: Consistent
 CTK Style, A3C2D2E1F3G2H2**M1**
 Dimensional Style, D4E2J2L1L2**M1**
 Dortmund Style, E1G1**M1**
 East Coast Piecing Style, D2F3G2H3K1L2**M1**
 Los Angeles Cholo-based Style, B3D2E1F3G2H1I2J1K1L2**M1**
 Neo Classic American Freight Style, D2E1H2I3J2L5**M1**
 No-neg Style, D3E3F3H3J2K2**M1**
 Pichador Style, A3G1H1I1J2K1L6**M1**
 Semi-wild Style, B2D2E1F3H2I3J1K1**M1**
 Silvers Style, A3B1C2D1E1G1I2J2K1**M1**
 Wild Style, E1I5J1**M1**
M2 Fill Consistency: Inconsistent
 TFP Style, A2B3H2I3L3**M2**
Neo Classic American Freight Style, D2E1H2I3J2L5M1
No-neg Style, D3E3F3H3J2K2M1
Pichador Style, A3G1H1I1J2K1L6M1
Semi-wild Style, B2D2E1F3H2I3J1K1M1
Silvers Style, A3B1C2D1E1G1I2J2K1M1
Swedish Train Style, C2D2H3I2J2K2
TFP Style, A2B3H2I3L3M2
Wild Style, E1I5J1M1

Chapter Notes

Preface

1. Lisa Gottlieb, "Applying Panofsky's Theories of Iconographical Analysis to Graffiti Art: Implications for Access to Images of Non-representational/Abstract Art" (PhD diss., University of Toronto, 2006), DAI-A 68/01, Jul 2007, AAT NR21858.

2. The terms "graffiti artist" and "graffiti writer" are often used interchangeably. This book uses the term "graffiti writer," which tends to be preferred by members of the graffiti art community. Chapter 2 discusses the development and use of these terms.

3. City of Toronto [Ontario, Canada]. Graffiti By-law No.123-2005, Toronto Municipal Code, c.485, s.l.

4. David Gonzalez, "Walls of Art for Everyone, but Made by Not Just Anyone," *New York Times*, June 4, 2007.

5. Ibid.

6. N.R. Kleinfield, "Coming Soon to The Mall: Graffiti Artists and Bialy Makers," *New York Times*, June 19, 2001.

7. Gonzalez, "Walls of Art."

8. Ibid.

Introduction

1. James Barron, "Up from the Subway, Graffiti Heads to the Auction House," *New York Times*, June 10, 2000.

2. Helen H. Tanzer, *The Common People of Pompeii: A Study of the Graffiti* (Baltimore: The Johns Hopkins University Press, 1939).

3. Violet Pritchard, *English Medieval Graffiti* (Cambridge: Cambridge University Press, 1967).

4. Ibid.,79.

5. Nina Siegal, "For Some, Hip-Hop Show is not Hip Enough," *New York Times*, September 27, 2000.

6. Jody Rosen, "A Rolling Shout-Out to Hip-Hop History," *New York Times*, February 12, 2006.

7. Ibid.

8. James Murray and Karla Murray, *Broken Windows: Graffiti NYC* (Corte Madera, CA: Gingko Press, 2002).

9. Joe Austin, *Taking the Train: How Graffiti Art Became an Urban Crisis in New York City* (New York: Columbia University Press, 2001), 206.

10. Lauren Collins, "Banksy was Here," *New Yorker*, May 14, 2007, http://www.newyorker.com/reporting/2007/05/14/070514fa_fact_collins/ (accessed May 7, 2007), ¶7.

11. Ibid.

12. Rob Walker, "The Brand Underground," *New York Times Magazine*, July 30, 2006.

13. Simon Haupt, "Graffiti is in the Eye of Beholder," *Globe and Mail*, May 28, 2007.

14. Carol Vogel, Inside Art, *New York Times*, sec. B, September 5, 2003.

15. George Vecsey, "With Change of Scenery, a Change in Coughlin," *New York Times*, October 27, 2007.

16. Randy Kennedy, "Be Sure to Read the Handwriting on the Wall," *New York Times*, November 24, 2005.

17. Leah McLaren, "The Writing's Off the Wall," *Globe and Mail*, May 21, 2005.

18. Larry Rohter, "Brazilian Government Invests in Culture of Hip-Hop," *New York Times*, March 14, 2007.

19. Ibid.

20. Adam Sternbergh, review of *Barbershop 2: Back in Business* (movie), *National Post*, February 9, 2004.

21. Jen Gerson, "Can Graffiti Draw Tourists?" *Globe and Mail*, June 11, 2005.

22. Howard Besser, "Imaging: Fine Arts," *Journal of the American Society for Information Science* 42 (1991): 594.

23. Corinne Jörgensen, *Image Retrieval: Theory and Research* (Lanham, MD: Scarecrow Press, 2003), 12.

24. Heting Chu, "Research in Image Indexing and Retrieval as Reflected in the Literature," *Journal of the American Society for Information Science and Technology* 52 (2001): 1011.

25. A.M. Tam and C.H.C. Leung, "Structured Natural-language Descriptions for Semantic Content Retrieval of Visual Materials," *Journal of the American Society for Information Science and Technology* 52 (2001): 930.

26. Erwin Panofsky, *Studies in Iconology* (1939; repr., New York: Harper & Row, 1967), 3.

27. Ibid.

28. Ibid., 4.

29. Ibid.

30. Table 1 is adapted from the table presented in Panofsky, *Studies in Iconology*, 14–15.

31. Ibid., 16–17.

32. Angelika Grund, "ICONCLASS. On Subject Analysis of Iconographic Representations of Works of Art," *Knowledge Organization* 20, no. 1 (1993): 21.

33. Sara Shatford, "Analyzing the Subject of a Picture: A Theoretical Approach," *Cataloging & Classification Quarterly* 6, no. 3 (1986): 39–62.

34. Ibid., 43.

35. *The Concise Oxford Dictionary of Art Terms*, s.v. "abstract art" (by Michael Clarke), *Oxford Reference Online*, http://www.oxfordreference.com/views/ENTRY.html?subview=Main&entry=t4.e4 (accessed January 30, 2006).

Chapter 1

1. Sara Shatford, "Analyzing the Subject of a Picture: A Theoretical Approach," *Cataloging & Classification Quarterly* 6, no. 3 (1986): 42.

2. John P. Eakins and Margaret E. Graham, *Content-based Image Retrieval: A Report to the JISC Technology Applications Programme* (University of Northumbria at Newcastle: Institute for Image Data Research, 1999), http://www.unn.ac.uk/iidr/CBIR/report. html (accessed July 26, 2004), 9.

3. Richard Brilliant, "How An Art Historian Connects Art Objects and Information," *Library Trends* 37 (1988): 121.

4. Peter Enser, "Visual Image Retrieval: Seeking the Alliance of Concept-based and Content-based Paradigms," *Journal of Information Science* 26 (2000): 201.

5. The phrase "Panofsky/Shatford model" appears in L. Hollink et al., "Classification of User Image Descriptions," *International Journal of Human-Computer Studies* 61 (2004): 603.

6. Shatford, "Analyzing the Subject of a Picture," 39.

7. Ibid., 45.

8. Ibid.

9. Ibid., 44–45.

10. Erwin Panofsky, *Studies in Iconology* (1939; repr., New York: Harper & Row, 1967), 7.

11. Shatford, "Analyzing the Subject of a Picture," 43.

12. Ibid., 45.

13. Ibid., 47.

14. Ibid., 45.

15. Table 3 is adapted from the table presented in Shatford, "Analyzing the Subject of a Picture," 49.

16. Hollink et al., "Classification of User Image Descriptions," 605.

17. Shatford, "Analyzing the Subject of a Picture," 54.

18. Corinne Jörgensen, *Image Retrieval: Theory and Research* (Lanham, MD: Scarecrow Press, 2003), 3.

19. P.G.B. Enser, "Pictorial Information Retrieval," *Journal of Documentation* 51 (1995): 126–170.

20. Ibid., 154.

21. Ibid.

22. Ibid., 155–156.

23. Ibid., 154.

24. James M. Turner, "Determining the Subject Content of Still and Moving Image Documents for Storage and Retrieval: An Experimental Investigation" (PhD diss., University of Toronto, 1994), 5.

25. Karen Collins, "Providing Subject Access to Images: A Study of User Queries," *The American Archivist* 61 (Spring 1998): 36–55.

26. Youngok Choi and Edie M. Rasmussen, "Searching for Images: The Analysis of Users' Queries for Image Retrieval in

American History," *Journal of the American Society for Information Science and Technology* 54 (2003): 498–511.

27. Ibid., 504.

28. Ibid.

29. Enser, "Pictorial Information Retrieval," 156.

30. Deirdre C. Stam, "The Quest for Code, or A Brief History of the Computerized Cataloguing of Art Objects," *Art Documentation* 8 (Spring 1989): 8.

31. Panofsky, *Studies in Iconology*, 14.

32. Hollink et al., "Classification of User Image Descriptions."

33. Ibid., 618.

34. Corinne Jörgensen et al., "A Conceptual Framework and Empirical Research for Classifying Visual Descriptors," *Journal of the American Society for Information Science and Technology* 52 (2001): 938–947.

35. Ibid., 938.

36. Ibid., 940.

37. Ibid.

38. Ibid.

39. Choi and Rasmussen, "Searching for Images," 508.

40. Hollink et al., "Classification of User Image Descriptions," 601.

41. Howard Greisdorf and Brian O'Connor, "Modelling What Users See When They Look at Images: A Cognitive Viewpoint," *Journal of Documentation* 58 (2002): 6–7.

42. Ibid., 6.

43. Ibid., 20.

44. Enser, "Pictorial Information Retrieval," 141.

45. Jane Greenberg, "A Quantitative Categorical Analysis of Metadata Elements in Image-Applicable Metadata Schemes," *Journal of the American Society for Information Science and Technology* 58 (2001): 917–924.

46. Ibid., 918.

47. Enser, "Visual Image Retrieval," 201.

48. Greisdorf and O'Connor, "Modelling What Users See," 21.

49. Pauline Brown et al., "The Democratic Indexing of Images," *The New Review of Hypermedia and Multimedia* 2 (1996): 118.

50. Ibid., 117.

51. Ibid., 113.

52. Ethan Todras-Whitehall, "'Folksonomy' Carries Classifieds Beyond SWF and For Sale," *New York Times*, October 5, 2005.

53. Shatford, "Analyzing the Subject of a Picture," 55.

54. James Turner, "Subject Access to Pictures: Considerations in the Surrogation and Indexing of Visual Documents for Storage and Retrieval," *Visual Resources* 9 (1993): 258.

55. Turner, "Determining the Subject Content of Still and Moving Image Documents."

56. Enser, "Pictorial Information Retrieval," 154.

57. Raya Fidel, "The Image Retrieval Task: Implications for the Design and Evaluation of Image Databases," *The New Review of Hypermedia and Multimedia* 3 (1996): 181–199.

58. Ibid., 189.

59. Ibid.

60. Ibid., 181.

61. Ibid., 192.

62. Shatford, "Analyzing the Subject of a Picture," 56.

63. Frederick Hartt, *Art: A History of Painting, Sculpture, Architecture*, 3rd ed. (New York: Harry N. Abrams, 1989), 581.

64. Linda Seidel, *Jan van Eyck's Arnolfini Portrait* (Cambridge: Cambridge University Press, 1993), xiv.

65. Hartt, *Art*, 581.

66. Elaine Svenonius, "Access to Nonbook Materials: The Limits of Subject Indexing for Visual and Aural Languages," *Journal of the American Society for Information Science* 45 (1994): 602.

67. Shatford, "Analyzing the Subject of a Picture," 55.

68. Ibid., 57.

69. Collins, "Providing Subject Access to Images," 5.

70. Panofsky, *Studies in Iconology*, 8.

71. Shatford, "Analyzing the Subject of a Picture," 57.

72. Carl Landauer, "Erwin Panofsky and the Renascence of the Renaissance," *Renaissance Quarterly* 47 (1994): 260.

73. Brendan Cassidy, "Iconography in Theory and Practice," *Visual Resources* 11 (1996): 325–326.

74. Ibid., 326–327.

75. Panofsky, *Studies in Iconology*, 11.

76. Shatford, "Analyzing the Subject of a Picture," 44.

77. Hartt, *Art*, 24.

78. Landauer, "Erwin Panofsky and the Renascence," 273.

79. Shatford, "Analyzing the Subject of a Picture," 43.

80. Ibid., 45.

81. Jörgensen, *Image Retrieval*, 75.

Chapter 2

1. "GREX4" is the participant code of the graffiti art expert whose questionnaire responses are being quoted. An explanation of the participant coding system is provided in the preface to the book.

2. Buford Youthward, "Art Crimes: Philly Wickeds," http://www.graffiti.org/faq/wickeds.html (accessed May 20, 2003), ¶6, ¶3.

3. Ivor L. Miller, *Aerosol Kingdom: Subway Painters of New York City* (Jackson, MS: University Press of Mississippi, 2002), 78.

4. Ibid., 85.

5. Nicholas Ganz, *Graffiti World: Street Art from Five Continents* (London: Thames & Hudson, 2004), 9.

6. Jack Stewart, "Subway Graffiti: An Aesthetic Study of Graffiti on the Subway System of New York City, 1970–1978" (PhD diss., New York University, 1989), 161.

7. Katie Haegele, "No Rooftop was Safe," *PhiladelphiaWeekly.com*, October 24, 2001, http://www.brainsoap.com/archives/article.asp?ArtID=730 (accessed May 24, 2003), ¶14.

8. Ibid., ¶19.

9. Stewart, "Subway Graffiti," 161.

10. James Barron, "Up from the Subway, Graffiti Heads to the Auction House," *New York Times*, June 10, 2000.

11. Neil Gladstone, "The Writer's Art," review of *The Art of Getting Over*, by Stephen Powers, *Philadelphia citypaper.net*, June 17–24, 1999, Book Quarterly section, http://citypaper.net/articles/061799/bq.graffiti.shtml (accessed May 24, 2003), ¶3.

12. Joe Austin, "Knowing Their Place: Local Knowledge, Social Prestige, and the Writing Formation in New York City," in *Generations of Youth: Youth Cultures and History in Twentieth-century America*, ed. Joe Austin and M.N. Willard (New York: New York University Press, 1998), 243.

13. Ibid., 242.

14. Stewart, "Subway Graffiti," 234–235.

15. Ibid., 161, 167.

16. Joe Austin, *Taking the Train: How Graffiti Art Became an Urban Crisis in New York City* (New York: Columbia University Press, 2001), 47.

17. Ibid., 117.

18. Michael Mandelbaum, *The Meaning of Sports: Why Americans Watch Baseball, Football, and Basketball and What They See*

When They Do (New York: PublicAffairs, 2004), 246.

19. Charles Isherwood, "The Graffiti of the Philanthropic Class," *New York Times*, December 2, 2007.

20. Ibid.

21. Austin, *Taking the Train*, 39.

22. Stewart, "Subway Graffiti," 162.

23. Richard Goldstein, "This Thing Has Gotten Completely out of Hand," *New York*, March 26, 1973, 35–36.

24. Austin, *Taking the Train*, 40.

25. Miller, *Aerosol Kingdom*, 4.

26. Steve Grody, *Graffiti L.A.: Street Styles and Art* (New York: Abrams, 2007), 116.

27. Craig Castleman, *Getting Up: Subway Graffiti in New York* (Cambridge, MA: MIT Press, 1982), 25.

28. Richard Lachmann, "Graffiti as Career and Ideology," *American Journal of Sociology* 94 (1988): 229–250.

29. Ibid., 237.

30. Austin, *Taking the Train*, 183.

31. Stewart, "Subway Graffiti," 292.

32. Goldstein, "This Thing Has Gotten Completely out of Hand," 38.

33. Ibid., 38, 39.

34. T. Creswell, "The Crucial 'Where' of Graffiti: A Geographical Analysis of Reactions to Graffiti in New York," *Environment and Planning D: Society and Space* 10 (1992): 339.

35. Susan Stewart, "Ceci Tuera Cela: Graffiti as Crime and Art," in *Life after Postmodernism: Essays on Value and Culture*, ed. John Fekete (Houndmills, Basingstoke, Hampshire: Macmillan Education, 1988), 172.

36. Creswell, "The Crucial 'Where' of Graffiti," 338.

37. Ibid.

38. Austin, *Taking the Train*.

39. Goldstein, "This Thing Has Gotten Completely out of Hand," 36.

40. Ibid.

41. Stewart, "Subway Graffiti," 325.

42. Austin, *Taking the Train*, 71.

43. Stewart, "Subway Graffiti," 327.

44. Lachmann, "Graffiti as Career and Ideology," 248.

45. John Frow, *Cultural Studies and Cultural Value* (Oxford: Clarendon Press, 1995), 149.

46. Austin, *Taking the Train*, 71.

47. Miller, *Aerosol Kingdom*, 158.

48. Leonhard Emmerling, *Jean-Michel Basquiat*, trans. Nicholas Levis (Cologne: Taschen, 2006), 12.

49. Ibid.

50. Stewart, "Subway Graffiti," 342.

51. Ibid., 292.

52. Miller, *Aerosol Kingdom*, 128.

53. Austin, *Taking the Train*, 170.

54. Miller, *Aerosol Kingdom*, 133.

55. Grody, *Graffiti L.A.*, 244.

56. James Murray and Karla Murray, *Broken Windows: Graffiti NYC* (Corte Madera, CA: Gingko Press, 2002), 95.

57. Austin, *Taking the Train*, 61.

58. Grody, *Graffiti L.A.*, 44.

59. Ibid.

60. Austin, *Taking the Train*, 112.

61. Frow, *Cultural Studies*, 147.

62. Jason Dax Woodward, "How to Read Graffiti," June 13, 1999, http://www.oneeightthree.com/html/ kasinomasterpaper/paper.htm (accessed May 17, 2003): ¶62, 64.

63. Miller, *Aerosol Kingdom*, 78.

64. Heinrich Wölfflin, *Principles of Art History: The Problem of the Development of Style in Later Art*, trans. M.D. Hottinger (New York: Dover, 1950), 10.

65. Ibid.

66. Ibid., 27.

67. Ibid., 76.

68. Ibid., viii.

69. Ibid., viii–ix.

70. Austin, *Taking the Train*, 113.

71. Elaine Svenonius, "Access to Nonbook Materials: The Limits of Subject Indexing for Visual and Aural Languages," *Journal of the American Society for Information Science and Technology* 45 (1994): 602.

72. Erwin Panofsky, *Studies in Iconology* (1939; repr., New York: Harper & Row, 1967), 5.

73. Ibid., 6.

74. Wölfflin, *Principles of Art History*, 6.

75. Ibid.

76. Catherine M. Soussloff, *The Subject in Art: Portraiture and the Birth of the Modern* (Durham, NC: Duke University Press, 2006), 5.

77. Ibid., 8.

78. Frederick Hartt, *Art: A History of Painting, Sculpture, Architecture*, 3rd ed. (New York: Harry N. Abrams, 1989), 581.

79. Panofsky, *Studies in Iconology*, 6.

80. Hartt, *Art*, 581.

81. Douglas Keister, *Stories in Stone: A Field Guide to Cemetery Symbolism and Iconography* (Salt Lake City, UT: Gibbs Smith, 2004), 72.

82. Vincent Scully, *New World Visions of Household Gods & Sacred Places: American Art 1650–1914* (Boston: Little, Brown/New York Graphic Society, 1988), 48.

83. Keister, *Stories in Stone*, 283.

84. Ibid., 57.

85. Ibid., 43.

86. Ibid., 86.

87. Panofsky, *Studies in Iconology*, 7.

88. Ibid., 4.

89. Ibid., 11.

90. Ibid., 14.

91. Stephen Little, *...isms: Understanding Art* (New York: Universe, 2004).

92. Ibid., 7.

93. Ibid.

94. Lauren Collins, "Banksy was Here," *The New Yorker*, May 14, 2007, http://www.newyorker.com/reporting/2007/05/14fa_fact_collins?printable=true (accessed May 7, 2007).

95. Creswell, "The Crucial 'Where' of Graffiti," 340.

96. Stewart, "Ceci Tuera Cela," 173.

97. Norman Mailer, *The Faith of Graffiti* (New York: Praeger, 1974), 48.

98. Stewart, "Ceci Tuera Cela," 172.

99. Ibid.

100. Woodward, "How to Read Graffiti," ¶7.

101. Miller, *Aerosol Kingdom*, 20.

102. Stewart, "Ceci Tuera Cela," 164.

103. Little, *isms*, 7.

104. Stewart, "Subway Graffiti," 327.

105. Little, *isms*, 7.

Chapter 3

1. Henri van de Waal, *ICONCLASS: An Iconographic Classification System*, vol. 2–3 (Amsterdam: North-Holland Publishing, 1974), ix.

2. Angelika Grund, "ICONCLASS. On Subject Analysis of Iconographic Representations of Works of Art," *Knowledge Organization* 20, no.1 (1993): 20–29.

3. Van de Waal, *ICONCLASS*, ix.

4. J.P.J. Brandhorst, "Quantifiability in Iconography," *Knowledge Organization* 20, no.1 (1993): 13.

5. Ibid.

6. L.D. Couprie, "Iconclass: An Iconographic Classification System," *Art Libraries Journal* 8 (1983): 43.

7. Ibid., 43–44.

8. Van de Waal, *ICONCLASS*, x.

9. Brendan Cassidy, "Iconography in

Theory and Practice," *Visual Resources* 11 (1996): 325.

10. Karen Markey, *Subject Access to Visual Resources Collections: A Model for Computer Construction of Thematic Catalogs* (New York: Greenwood Press, 1986), 3.

11. Cassidy, "Iconography," 337.

12. Sara Shatford, "Analyzing the Subject of a Picture: A Theoretical Approach," *Cataloging and Classification Quarterly* 6, no. 3 (1986): 47.

13. John P. Eakins and Margaret E. Graham, *Content-based Image Retrieval: A Report to the JISC Technology Applications Programme* (University of Northumbria at Newcastle: Institute for Image Data Research, 1999), http://www.unn.ac.uk/iidr/CBIR/report.html (accessed July 26, 2004), 9.

14. Markey, *Subject Access*, 9.

15. Ibid., 82.

16. Karen Markey, "Access to Iconographical Research Collections," *Library Trends* 37 (1988): 154–174.

17. Helene E. Roberts, "A Picture is Worth a Thousand Words: Art Indexing in Electronic Databases," *Journal of the American Society for Information Science and Technology* 52 (2001): 915.

18. Cassidy, "Iconography," 325.

19. Erwin Panofsky, *Studies in Iconology* (1939; repr., New York: Harper & Row, 1967), 4.

20. Markey, *Subject Access*, 15.

21. Couprie, "Iconclass," 45, 40.

22. Ibid., 40–41.

23. Art Crimes, "Graffiti Q & A," 1994, http:www//graffiti.org/faq/graffiti_questions.html (accessed November 29, 2000), ¶23.

24. Jack Stewart, "Subway Graffiti: An Aesthetic Study of Graffiti on the Subway System of New York City, 1970–1978" (PhD diss., New York University, 1989).

25. Art Crimes, "Graffiti Q & A."

26. Steve Grody, *Graffiti L.A.: Street Styles and Art* (New York: Abrams, 2007), 203.

27. Nicholas Ganz, *Graffiti Woman: Graffiti and Street Art from Five Continents* (London: Thames & Hudson, 2006).

28. Ibid., 10.

29. Henry Evelyn Bliss, *The Organization of Knowledge in Libraries and the Subject-Approach to Books* (New York: H.W. Wilson, 1933), 42.

30. Henry Evelyn Bliss, *The Organization of Knowledge and the System of the Sciences* (New York: Henry Holt, 1929), 16.

31. Ibid., 186.

32. Harold A. Linstone and Murray Turoff, eds., *The Delphi Method: Techniques and Applications* (Reading, MA: Addison-Wesley, 1975), 3.

33. Ian A. Mitroff and Murray Turoff, "Philosophical and Methodological Foundations of Delphi," in *The Delphi Method: Techniques and Applications*, ed. Harold A. Linstone and Murray Turoff (Reading, MA: Addison-Wesley, 1975), 22.

34. B.C. Vickery, *Faceted Classification: A Guide to Construction and Use of Special Schemes* (London: Aslib, 1960), 12.

35. Ibid.

36. S.R. Ranganathan, *Prolegomena to Library Classification*, 3rd ed. (New York: Asia Publishing House, 1967), 402.

37. Ibid.

38. Ibid., 83.

39. Vickery, *Faceted Classification*, 12.

40. Heinrich Wölfflin, *Principles of Art History: The Problem of the Development of Style in Later Art*, trans. M.D. Hottinger (New York: Dover, 1950), viii.

41. Eleanor Rosch, "Principles of Categorization," in *Cognition and Categorization*, ed. Eleanor Rosch and Barbara B. Lloyd (Hillsdale, NJ: Lawrence Erlbaum Associates, 1978), 29.

42. Jen Gerson, "Can Graffiti Draw Tourists?" *Globe and Mail*, June 11, 2005.

Chapter 4

1. Louise Spiteri, "A Simplified Model for Facet Analysis: Ranganathan 101," *Canadian Journal of Information and Library Science* 23, nos. 1–2 (1998): 3.

2. According to one of the experts who discussed this style, the term "Silvers" (plural) is used to describe the style in general. Conversely, the term "Silver" (singular) is used to describe individual examples of the style (i.e., a "Silver piece" or "Silver pieces").

3. *Style Wars* is a 1983 documentary directed by Tony Silver and produced by Henry Chalfant. Broadcast on public television stations, it introduced the general public to the world of graffiti writers.

4. Joe Austin, *Taking the Train: How Graffiti Art Became an Urban Crisis in New York City* (New York: Columbia University Press, 2001), 111.

5. Nicholas Ganz, *Graffiti World: Street Art from Five Continents* (London: Thames & Hudson, 2004), 10.

6. Steve Grody, *Graffiti L.A.: Street Styles and Art* (New York: Abrams, 2007), 18.

7. Jack Stewart, "Subway Graffiti: An Aesthetic Study of Graffiti on the Subway System of New York City, 1970–1978" (PhD diss., New York University, 1989), 441.

8. Ivor Miller, *Aerosol Kingdom: Subway Painters of New York City* (Jackson, MS: University Press of Mississippi, 2002), 35.

9. Ganz, *Graffiti World*, 10.

10. Eleanor Rosch, "Principles of Categorization," in *Cognition and Categorization*, ed. Eleanor Rosch and Barbara B. Lloyd (Hillsdale, NJ: Lawrence Erlbaum Associates, 1978), 30–31.

11. Ibid., 32.

12. Ibid.

13. Ibid., 30.

14. Ganz, *Graffiti World*, 303.

15. S.R. Ranganathan, *Prolegomena to Library Classification*, 3rd ed. (New York: Asia Publishing House, 1967), 427.

16. Ibid., 425.

17. B.C. Vickery, *Faceted Classification: A Guide to Construction and Use of Special Schemes* (London: Aslib, 1960), 41.

18. Erwin Panofsky, *Studies in Iconology* (1939; repr., New York: Harper & Row, 1967), 7.

19. Rosch, "Principles," 29.

20. Vickery, *Faceted Classification*, 63.

21. Ibid., 67.

Chapter 5

1. Karen Markey, *Subject Access to Visual Resources Collections: A Model for Computer Construction of Thematic Catalogs* (New York: Greenwood Press, 1986), 15.

2. Ibid.

3. Carla Conrad Freeman and Barbara Stevenson, eds., *The Visual Resources Directory: Art Slide and Photograph Collections in the United States and Canada* (Englewood, CO: Libraries Unlimited, 1995).

4. The sampling strategy was a partially randomized incomplete block design. Greater detail is provided in: Lisa Gottlieb, "Applying Panofsky's Theories of Iconographical Analysis to Graffiti Art: Implications for Access to Images of Non-representational/Abstract Art" (PhD diss., University of Toronto, 2006), DAI-A 68/01, Jul 2007, AAT NR21858.

5. Marvin W. Acklin et al., "Interobserver Agreement, Intraobserver Reliability, and the Rorschach Comprehensive System," *Journal of Personality Assessment* 74 (2000): 15–47.

6. Ibid., 18–19.

Chapter 6

1. Erwin Panofsky, *Studies in Iconology* (1939; repr., New York: Harper & Row, 1967), 7.

2. Ibid., 15.

3. Comment made by GREX9.

4. Josephine Noah, "Street Math in Wildstyle Graffiti Art," 1997, http://www.graffiti.org/faq/streetmath.html (accessed May 8, 2003), ¶23.

5. Ibid.

6. Panofsky, *Studies in Iconology*, 9.

7. Elaine Svenonius, "Access to Nonbook Materials: The Limits of Subject Indexing for Visual and Aural Languages," *Journal of the American Society for Information Science and Technology* 45 (1994): 600.

8. Panofsky, *Studies in Iconology*, 7.

9. Ibid.

10. Frederick Hartt, *Art: A History of Painting, Sculpture, Architecture*, 3rd ed. (New York: Harry N. Abrams, 1989), 941–42.

11. Magdalena Holzhey, *Victor Vasarely*, trans. John Gabriel (Cologne: Taschen, 2005), 48.

12. Hartt, *Art*, 869.

13. Holzhey, *Victor Vasarely*, 51.

14. Ibid., 7.

15. Ibid.

16. Hartt, *Art*, 942.

17. Holzhey, *Victor Vasarely*, 60.

18. Both of these examples can be seen in Vasarely's *Alphabet V.R.*, an acrylic on canvas painting from 1960.

19. Holzhey, *Victor Vasarely*, 8.

20. Ibid., 51.

21. Hartt, *Art*, 941.

22. Holzhey, *Victor Vasarely*, 8.

23. Panofsky, *Studies in Iconology*, 15.

24. Hartt, *Art*, 941.

25. Holzhey, *Victor Vasarely*, 51.

26. Camilla Gray, *The Russian Experiment in Art, 1863–1922*, revised and enlarged by Marian Burleigh-Motley (1962; repr., London: Thames and Hudson, 1986), 141; 96. Citations are to the 1986 edition.

27. Holzhey, *Victor Vasarely*, 65.

28. Hartt, *Art*, 908.

29. Gray, *The Russian Experiment*, 139–140.

Chapter 7

1. Rick Hampson, "More Complain about Cities Used as a Canvas," *USA Today*, July 18, 2007.

2. Atari, "Getting Up: Contents Under Pressure" (overview of video game), 2005, http://www.atari.com/us/games/getting_up/ playstation2 (accessed June 11, 2007).

3. Ibid.

4. Ibid.

5. Ibid.

6. Claudia Walde, *Sticker City: Paper Graffiti Art* (London: Thames & Hudson, 2007), 9.

7. Ibid.

8. Ibid., 56.

9. Jim Byers, "Cut Graffiti by Restricting Sale of Paint, Councillor Says," *Toronto Star*, June 23, 2007.

10. Graffiti Research Lab, "The Graffiti Research Lab," http://graffitiresearchlab.com/ ?page_id=5 (accessed June 11, 2007).

11. Graffiti Research Lab, "The Electro-Graf," http://graffitiresearchlab.com/?page_id=13 (accessed June 11, 2007).

12. Graffiti Research Lab, "LED Throwies," http://graffitiresearchlab.com/ ?page_id=6 (accessed June 11, 2007).

13. Geeta Dayal, "High-Tech Graffiti: Spray Paint is So 20th Century," *New York Times*, June 25, 2006.

14. David Fusaro, "Graffiti Artists Ditch Spray Paint for Lasers and Magnetized Light Bulbs," Columbia News Service, February 27, 2007, http://jscms.jrn.columbia.edu/cns/ 2007-02-27/fusaro-graffiti (accessed June 11, 2007).

15. Ibid.

16. Walde, *Sticker City*, 9.

17. Atari, "Getting Up."

18. David Gonzalez, "Remembering and Defending Subway Graffiti," *New York Times*, November 16, 2004.

19. Brooklyn Museum, "Graffiti June 30-September 3, 2006," http://www.brooklyn-museum.org/exhibitions/graffiti/ (accessed January 3, 2008).

20. Dayal, "High-Tech Graffiti."

21. Ibid.

22. Walde, *Sticker City*, 68.

23. Erwin Panofsky, *Studies in Iconology* (1939; repr., New York: Harper & Row, 1967), 3.

24. Ibid., 16–17.

Selected Bibliography

Listed below are the books and journal articles used in the completion of this book. Citations for materials that appeared in newspapers, magazines, or on web sites are contained in the relevant chapter notes.

Acklin, Marvin W., Claude J. McDowell II, Mark S. Verschell, and Darryl Chan. "Interobserver Agreement, Intraobserver Reliability, and the Rorschach Comprehensive System." *Journal of Personality Assessment* 74 (2000): 15–47.

Austin, Joe. "Knowing Their Place: Local Knowledge, Social Prestige, and the Writing Formation in New York City." In *Generations of Youth: Youth Cultures and History in Twentieth-century America*, edited by Joe Austin and M.N. Willard, 240–252. New York: New York University Press, 1998.

_____. *Taking the Train: How Graffiti Art Became an Urban Crisis in New York City.* New York: Columbia University Press, 2001.

Besser, Howard. "Imaging: Fine Arts." *Journal of the American Society for Information Science* 42 (1991): 589–596.

Bliss, Henry Evelyn. *The Organization of Knowledge and the System of the Sciences.* New York: Henry Holt, 1929.

_____. *The Organization of Knowledge in Libraries and the Subject-Approach to Books.* New York: H.W. Wilson, 1933.

Brandhorst, J.P.J. "Quantifiability in Iconography." *Knowledge Organization* 20, no.1 (1993): 12–19.

Brilliant, Richard. "How An Art Historian Connects Art Objects and Information." *Library Trends* 37 (1988): 120–129.

Brown, Pauline, Rob Hidderley, Hugh Griffin, and Sarah Rollason. "The Democratic Indexing of Images." *The New Review of Hypermedia and Multimedia* 2 (1996): 107–121.

Cassidy, Brendan. "Iconography in Theory and Practice." *Visual Resources* 11 (1996): 323–348.

Castleman, Craig. *Getting Up: Subway Graffiti in New York.* Cambridge, MA: MIT Press, 1982.

Choi, Youngok, and Edie M. Rasmussen. "Searching for Images: The Analysis of Users' Queries for Image Retrieval in American History." *Journal of the American Society for Information Science and Technology* 54 (2003): 498–511.

Chu, Heting. "Research in Image Indexing and Retrieval as Reflected in the Literature." *Journal of the American Society for Information Science and Technology* 52 (2001): 1011–1018.

Collins, Karen. "Providing Subject Access to Images: A Study of User Queries."

The American Archivist 61 (Spring 1998): 36–55.

Couprie, L.D. "Iconclass: An Iconographic Classification System." *Art Libraries Journal* 8 (1983): 32–49.

Creswell, T. "The Crucial 'Where' of Graffiti: A Geographical Analysis of Reactions to Graffiti in New York." *Environment and Planning D: Society and Space* 10 (1992): 329–344.

Eakins, John P., and Margaret E. Graham. *Content-based Image Retrieval: A Report to the JISC Technology Applications Programme.* University of Northumbria at Newcastle: Institute for Image Data Research, 1999. http://www.unn.ac.uk/iidr/CBIR/report.html (accessed July 26, 2004).

Emmerling, Leonhard. *Jean-Michel Basquiat.* Translated by Nicholas Levis. Cologne: Taschen, 2006.

Enser, Peter. "Pictorial Information Retrieval." *Journal of Documentation* 51 (1995): 126–170.

_____. "Visual Image Retrieval: Seeking the Alliance of Concept-based and Content-based Paradigms." *Journal of Information Science* 26 (2000): 199–210.

Fidel, Raya. "The Image Retrieval Task: Implications for the Design and Evaluation of Image Databases." *The New Review of Hypermedia and Multimedia* 3 (1996): 181–199.

Freeman, Carla Conrad, and Barbara Stevenson, eds. *The Visual Resources Directory: Art Slide and Photograph Collections in the United States and Canada.* Englewood, CO: Libraries Unlimited, 1995.

Frow, John. *Cultural Studies and Cultural Value.* Oxford: Clarendon Press, 1995.

Ganz, Nicholas. *Graffiti Woman: Graffiti and Street Art from Five Continents.* London: Thames & Hudson, 2006.

_____. *Graffiti World: Street Art from Five Continents.* London: Thames & Hudson, 2004.

Gottlieb, Lisa. "Applying Panofsky's Theories of Iconographical Analysis to Graffiti Art: Implications for Access to Images of Non-representational/Abstract Art." PhD diss., University of Toronto, 2006.

Gray, Camilla. *The Russian Experiment in Art, 1863–1922.* Revised and enlarged by Marian Burleigh-Motley. 1962. Reprint, London: Thames and Hudson, 1986.

Greenberg, Jane. "A Quantitative Categorical Analysis of Metadata Elements in Image-Applicable Metadata Schemes." *Journal of the American Society for Information Science and Technology* 58 (2001): 917–924.

Greisdorf, Howard, and Brian O'Connor. "Modelling What Users See When They Look at Images: A Cognitive Viewpoint." *Journal of Documentation* 58 (2002): 6–29.

Grody, Steve. *Graffiti L.A.: Street Styles and Art.* New York: Abrams, 2007.

Grund, Angelika. "ICONCLASS. On Subject Analysis of Iconographic Representations of Works of Art." *Knowledge Organization* 20, no. 1 (1993): 20–29.

Hartt, Frederick. *Art: A History of Painting, Sculpture, Architecture.* 3rd ed. New York: Harry N. Abrams, 1989.

Hollink, L., A.Th. Schreiber, B.J. Wielinga, and M. Worring. "Classification of User Image Descriptions." *International Journal of Human-Computer Studies* 61 (2004): 601–626.

Holzhey, Magdalena. *Victor Vasarely.* Translated by John Gabriel. Cologne: Taschen, 2005.

Jörgensen, Corinne. *Image Retrieval: Theory and Research.* Lanham, MD: Scarecrow Press, 2003.

Jörgensen, Corinne, Alejandro Jaimes, Ana B. Benitez, and Shih-Fu Chang. "A Conceptual Framework and Empirical Research for Classifying Visual Descriptors." *Journal of the American Society for Information Science and Technology* 52 (2001): 938–947.

Keister, Douglas. *Stories in Stone: A Field Guide to Cemetery Symbolism and Iconography.* Salt Lake City, UT: Gibbs Smith, 2004.

Lachmann, Richard. "Graffiti as Career

and Ideology." *American Journal of Sociology* 94 (1988): 229–250.

Landauer, Carl. "Erwin Panofsky and the Renascence of the Renaissance." *Renaissance Quarterly* 47 (1994): 255–281.

Linstone, Harold A., and Murray Turoff, eds. *The Delphi Method: Techniques and Applications*. Reading, MA: Addison-Wesley, 1975.

Little, Stephen. ...*isms: Understanding Art*. New York: Universe, 2004.

Mailer, Norman. *The Faith of Graffiti*. New York: Praeger, 1974.

Mandelbaum, Michael. *The Meaning of Sports: Why Americans Watch Baseball, Football, and Basketball and What They See When They Do*. New York: PublicAffairs, 2004.

Markey, Karen. "Access to Iconographical Research Collections." *Library Trends* 37 (1988): 154–174.

_____. *Subject Access to Visual Resources Collections: A Model for Computer Construction of Thematic Catalogs*. New York: Greenwood Press, 1986.

Miller, Ivor L. *Aerosol Kingdom: Subway Painters of New York City*. Jackson, MS: University Press of Mississippi, 2002.

Mitroff, Ian A., and Murray Turoff. "Philosophical and Methodological Foundations of Delphi." In *The Delphi Method: Techniques and Applications*, edited by Harold A. Linstone and Murray Turoff, 17–36. Reading, MA: Addison-Wesley, 1975.

Murray, James, and Karla Murray. *Broken Windows: Graffiti NYC*. Corte Madera, CA: Gingko Press, 2002.

Panofsky, Erwin. *Studies in Iconology*. 1939. Reprint, New York: Harper & Row, 1967.

Pritchard, Violet. *English Medieval Graffiti*. Cambridge: Cambridge University Press, 1967.

Ranganathan, S.R. *Prolegomena to Library Classification*. 3rd ed. New York: Asia Publishing House, 1967.

Roberts, Helene E. "A Picture is Worth a Thousand Words: Art Indexing in Electronic Databases." *Journal of the*

American Society for Information Science and Technology 52 (2001): 911–916.

Rosch, Eleanor. "Principles of Categorization." In *Cognition and Categorization*, edited by Eleanor Rosch and Barbara B. Lloyd, 27–48. Hillsdale, NJ: Lawrence Erlbaum Associates, 1978.

Scully, Vincent. *New World Visions of Household Gods & Sacred Places: American Art 1650–1914*. Boston: Little, Brown/New York Graphic Society, 1988.

Seidel, Linda. *Jan van Eyck's Arnolfini Portrait*. Cambridge: Cambridge University Press, 1993.

Shatford, Sara. "Analyzing the Subject of a Picture: A Theoretical Approach." *Cataloging & Classification Quarterly* 6, no. 3 (1986): 39–62.

Soussloff, Catherine M. *The Subject in Art: Portraiture and the Birth of the Modern*. Durham, NC: Duke University Press, 2006.

Spiteri, Louise. "A Simplified Model for Facet Analysis: Ranganathan 101." *Canadian Journal of Information and Library Science* 23, nos. 1–2 (1998): 1–30.

Stam, Deirdre C. "The Quest for Code, or A Brief History of the Computerized Cataloguing of Art Objects." *Art Documentation* 8 (Spring 1989): 7–15.

Stewart, Jack. "Subway Graffiti: An Aesthetic Study of Graffiti on the Subway System of New York City, 1970–1978." PhD diss., New York University, 1989.

Stewart, Susan. "Ceci Tuera Cela: Graffiti as Crime and Art." In *Life after Postmodernism: Essays on Value and Culture*, edited by John Fekete, 161–180. Houndmills, Basingstoke, Hampshire: Macmillan Education, 1988.

Svenonius, Elaine. "Access to Nonbook Materials: The Limits of Subject Indexing for Visual and Aural Languages." *Journal of the American Society for Information Science* 45 (1994): 600–606.

Tam, A.M., and C.H.C. Leung. "Struc-

tured Natural-language Descriptions for Semantic Content Retrieval of Visual Materials." *Journal of the American Society for Information Science and Technology* 52 (2001): 930–937.

Tanzer, Helen H. *The Common People of Pompeii: A Study of the Graffiti.* Baltimore: The Johns Hopkins University Press, 1939.

Turner, James M. "Determining the Subject Content of Still and Moving Image Documents for Storage and Retrieval: An Experimental Investigation." PhD diss., University of Toronto, 1994.

_____. "Subject Access to Pictures: Considerations in the Surrogation and Indexing of Visual Documents for Storage and Retrieval." *Visual Resources* 9 (1993): 241–271.

Van de Waal, Henri. *ICONCLASS: An Iconographic Classification System.* Vol. 2–3. Amsterdam: North-Holland Publishing, 1974.

Vickery, B.C. *Faceted Classification: A Guide to Construction and Use of Special Schemes.* London: Aslib, 1960.

Walde, Claudia. *Sticker City: Paper Graffiti Art.* London: Thames & Hudson, 2007.

Wölfflin, Heinrich. *Principles of Art History: The Problem of the Development of Style in Later Art.* Translated by M.D. Hottinger. New York: Dover, 1950.

Index